The Lorette Wilmot Library
Nazareth College of Rochester

MONTAGE And Modern Life

1919—1942

MONTAGE

And Modern Life
1919–1942

EXHIBITION CURATORS Maud Lavin

Annette Michelson

Christopher Phillips

Sally Stein

Margarita Tupitsyn

EDITOR Matthew Teitelbaum

The MIT Press

Cambridge, Massachusetts and London, England

The Institute of Contemporary Art

Boston

Montage and Modern Life: 1919–1942
has been funded in part by grants from the
National Endowment for the Arts, a federal
agency, and the LEF Foundation.
Additional support has been provided by
Subtractive Technology.

The catalogue has been funded in part
by the Goethe-Institut Boston. Additional
support has been provided through
The ICA Publication Fund established by
General Cinema Corporation and
The Neiman Marcus Group.

Exhibition Tour:

The Institute of Contemporary Art, Boston
April 7 – June 7, 1992

Vancouver Art Gallery, Canada
August 19 – October 18, 1992

Les Expositions du Palais des Beaux-Arts /
De Tentoonstellingen van het Paleis voor
Schone Kunsten, Brussels
November 3, 1992 – January 3, 1993

Edited by Matthew Teitelbaum,
with Lisa Freiman
Designed by Glenn Suokko, Woodstock,
Vermont
This book was printed and bound in the
United States of America.

Library of Congress
Cataloging-in-Publication Data

Montage and modern life, 1919–1942 /
Maud Lavin ... [et al.], exhibition curators;
 Matthew Teitelbaum, editor.
 p. cm.
 Includes bibliographic references.
 ISBN 0–262–20091–0
1. Composite photography—Exhibitions.
 I. Lavin, Maud.
 II. Teitelbaum, Matthew.
TR685.M65 1992
779'. 09' 041074—dc20 92–2572
 CIP

CONTENTS

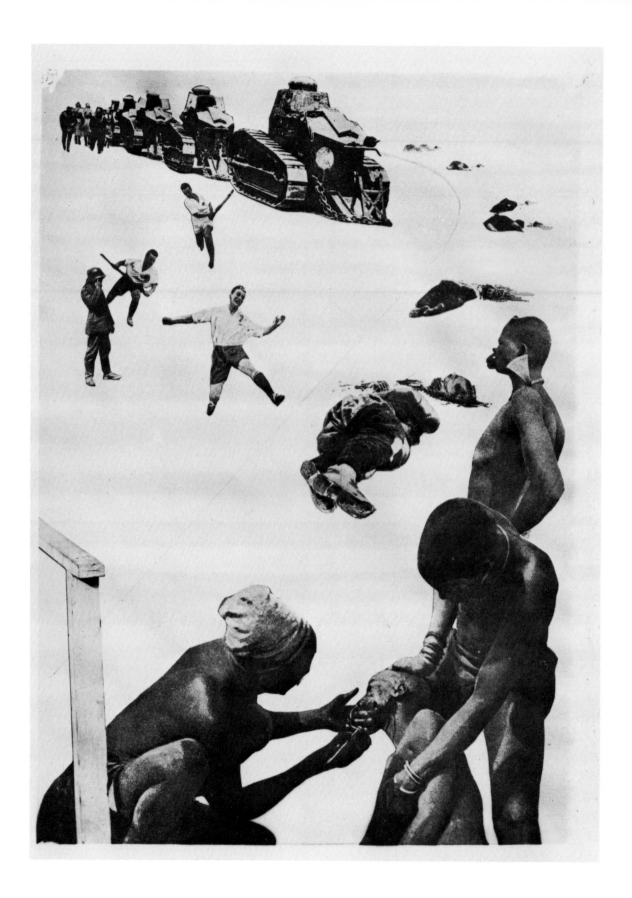

Preface

Matthew Teitelbaum

"Montage and Modern Life" is, as its title suggests, an exhibition about the modern age. It is an exhibition about an aesthetic practice of combination, repetition, and overlap, which links the worlds of art, design and film. Over 400 objects are gathered together to suggest a new way of seeing—not merely a new way of sighting such traditional subjects as the figure, the urban locale, or the domestic space—but a new way of perceiving culture. It is by placing advertising copy alongside fine art photographs and newspapers beside movie posters that the complicated relations between the creation, production, and utilization of images are revealed. "Montage and Modern Life" looks at montage practice between the two World Wars in an attempt to suggest the complexity of relations between art, mass media, and everyday life.

Through images that at times integrate text, often conjure unreal space, and always incorporate a degree of narrative breakdown, "Montage and Modern Life" invokes the discontinuous and the ruptured as the talisman of our century. While highlighting images with radical distortions of scale and jarring incorporation of text, "Montage and

Laszlo Moholy-Nagy
Militarism 1924
gelatin silver montage 7 1/16 x 5 1/16"
Courtesy of the J.P. Getty Museum, Malibu, California; Arnold H. Crane Collection

[1] See Benjamin Buchloh "From Faktura to Factography." *October*, no. 30, 1984, pp. 82–119.

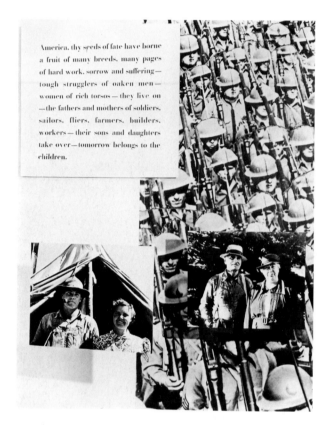

America, thy seeds of fate have borne a fruit of many breeds, many pages of hard work, sorrow and suffering— tough strugglers of oaken men— women of rich torsos— they live on —the fathers and mothers of soldiers, sailors, fliers, farmers, builders, workers— their sons and daughters take over—tomorrow belongs to the children.

Albert Fenn
detail of an installation view of the exhibition
Road to Victory, organized by Edward
Steichen and designed by Herbert Bayer,
May 21–October, 1942.
The Museum of Modern Art New York
Courtesy of The Museum of Modern Art,
New York

Leni Riefenstahl
"Untitled," centerfold in *Illustrierier Film
Kurier*, special issue, "Triumph of the Will,"
Autumn 1936

Modern Life" argues that montage practice sought not merely to represent the real (as Cubism did through the integration of new material) but, also, to extend the idea of the real to something not yet seen. Montage offers a kaleidoscopic expanded vision which, by collapsing many views into one, suggests an experience of unfolding time. In effect, montage replaces the image of a continuous life glimpsed through a window frame—the heritage of the fine arts since the Renaissance—with an image, or set of re-assembled images, that reflect a fast-paced, multifaceted reality seamlessly suited to a synthesis of twentieth century documentary, desire and utopian idealism. When consumer objects, industrial images, and political leaders are enlarged in scale and placed in the foreground of a composition, for example, their importance in the pictorial narrative is underlined. The compositional device of dramatic foregrounding provokes the viewer to re-think the relations between objects, to re-establish a hierarchy of correspondences. In this sense, among others, montage practice is about radical realignments of power. In escaping the 'limits' of the straight photograph by dramatically repositioning various figures and objects, montage suggests new paradigms of authority and influence.

"Montage and Modern Life" elucidates moments in the USSR, Germany, the Netherlands, and the United States at the point when an established modernist avant-garde was challenged by the need to reach a mass audience. This type of crisis is well described by the critic and art historian Benjamin H.D. Buchloh when he writes about a "crisis of audience relationships, a moment in which the institutionalization of the avant-garde had reached its peak of credibility, from which legitimation was only to be obtained by a redefinition of its relationship with the new urban masses and their cultural demands."[1] In the Soviet Union, the photomontage of El Lissitzky and Aleksandr Rodchenko fused the formal discoveries of Constructivism with the potential of photography and cinema to reach a mass audience in order to fulfill the political imperatives of a new, industrialized society. In Germany, Dadaists such as John Heartfield used photomontage as a means of challenging the assumptions of bourgeois society. Subsequently, in the

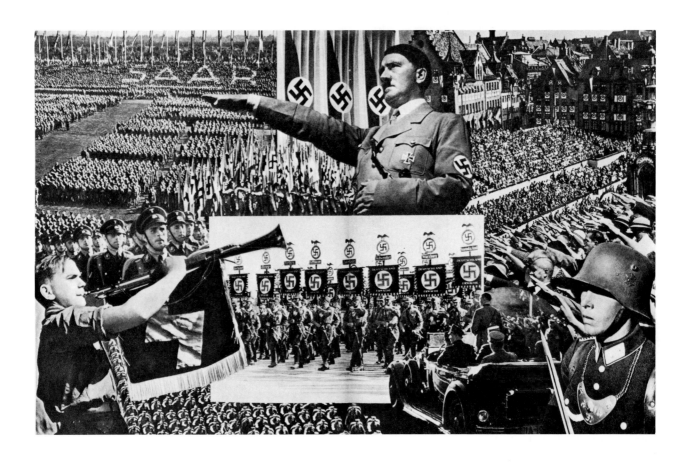

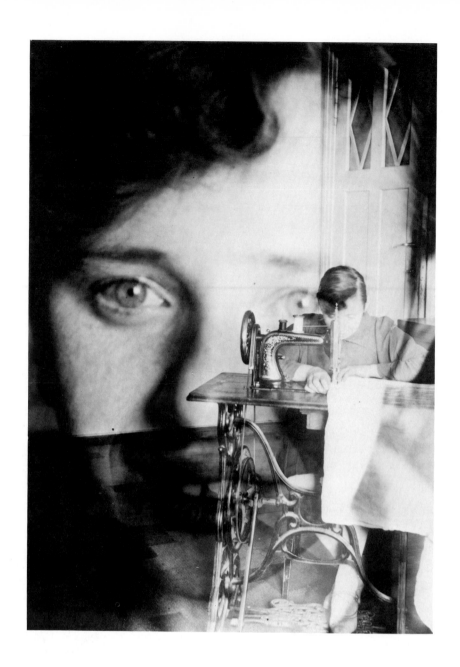

Alice Lex Nerlinger
Seamstress c. 1930
gelatin silver print 6 1/2 x 4 3/4"
Courtesy of The Art Institute of Chicago,
The Julien Levy Collection,
Gift of Jean Levy and the Estate of
Julien Levy

Walker Evans
Portrait of Berenice Abbott c. 1930
vintage gelatin silver print 4 1/4 x 2 1/2"
Courtesy of The Art Institute of Chicago,
Gift of David C. and Sarajean Ruttenberg

United States, photomontage was used as a central method in the increasingly sophisticated practice of advertising.

"Montage and Modern Life" attempts to establish an historical precedent for such an interchange between avant-garde and mass culture. It cites those historical forces that have had an acknowledged influence on a generation of artists working in the 1980s and early 1990s—including, for example, Barbara Kruger, Pat Ward Williams, David Wojnarowicz, Gilbert and George, Krzysztof Wodiczko, and Klaus Staeck. At its core, and at the center of the Institute of Contemporary Art's commitment to the project, is the belief that the relationship between contemporary art and the mass media—the links between fine art and popular culture—is surely rooted in montage practice of the 1920s and 1930s. At the unspoken center of this exhibition lie the various ways contemporary artists have acknowledged two related goals of montage techniques in the 1920s: the goal of finding a means to represent the new modern metropolis developing at that time, and the goal of building a mass media culture designed for consumption by growing urban classes. The search for a means to reflect and complicate our understanding of the realities of a modern, urban lifestyle, and the search for a means to play with the fantasy and desire of a consumer age is fundamental to this investigation.

"Montage and Modern Life" was developed in its preliminary stages around three thematic groupings—the representation of work and industry, the individual, and the state. These large thematic headings suggested an early organizational structure under which disparate work from Germany, the Soviet Union, and the United States could comfortably be grouped. Reflecting the intricate relations between works, the exhibition has been refined and, finally, organized into nine smaller groupings, each of which highlights a dominant concern for subject in montage practice of the 1920s and 1930s. The groupings are: Speed Up: Modern Industrial Assembly; War Machines; The City, Rapid Transit/Global Visions; The New Woman and the Rationalization of Everyday Life; The Artists' Engagement with the Mass Media; The Body Refigured; The Political Spectrum of Montage; and a final section on film related imagery. The installation has been designed to place art objects in

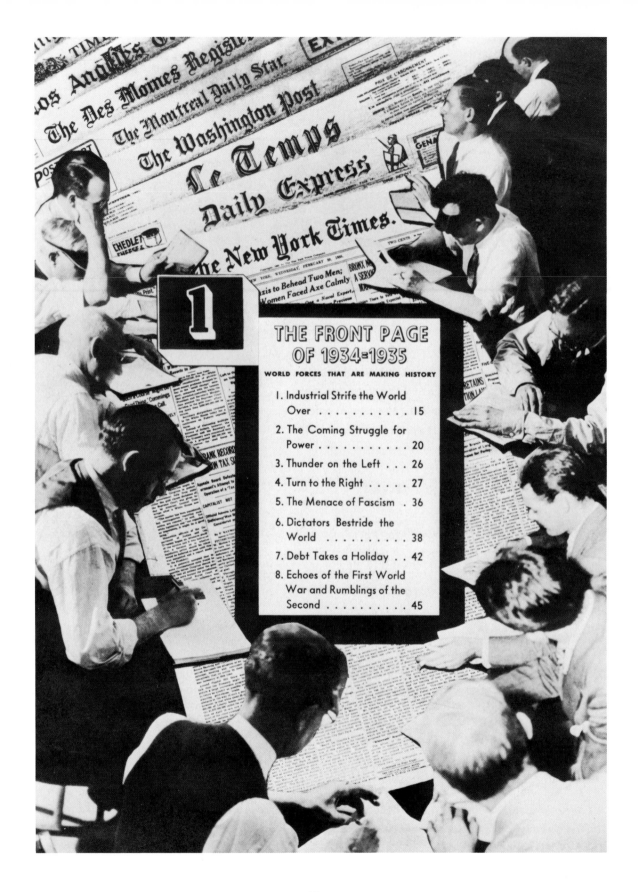

THE FRONT PAGE
OF 1934=1935
WORLD FORCES THAT ARE MAKING HISTORY

13. März 1932
9. Jahrgang / Nr. 11

Münchner
Illustrierte Presse

Verlag Knorr & Hirth, G.m.b.H., Münch

Preis: 20 Pfennig
Öfterr.: 40 Grofch. / Tfchechofl.: 2 Kron.
Schweiz: 30 Rappen / Italien: 1,50 Lire
Frankreich: 1,50 Frs. / Holland: 20 Cer.
Jugoflavien: 4 Dinar

Blutgruppe A
Der Prozeß gegen Prof. Lewald

Der neue Roman beginnt in dieser Nummer

Die verlorenen Stimmen

7 758 413 waren es bei der letzten Wahl. Diesmal darf keine Stimme fehlen

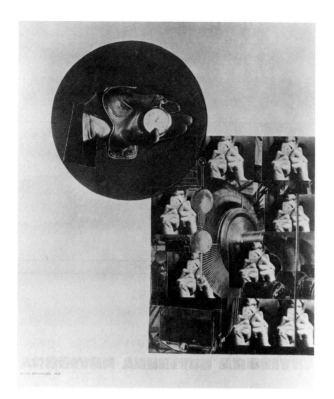

Alice Lex Nerlinger
Arbeiten, Arbeiten, Arbeiten (Work, Work,
Work) 1928
gelatin silver print 8 x 6 3/4"
Courtesy of the San Francisco Museum of
Modern Art
Gift of Robert Shapazian

page 12
Designer unknown
"The Front Page of 1934–1935:
World Forces that are Making History,"
in M. Lincoln Schuster (editor), *Eyes on the
World* (New York: Simon and Schuster,
1935), p. 13
Private Collection

page 13
Designer unknown
"Die verlorenen Stimmen" (The Lost Votes)
cover for *Münchner Illustrierte Presse*, 13
March, 1932, vol. 9, no. 11
Courtesy of Institut für Zeitungsforschung
Dortmund

the exhibition—including photographic works by El Lissitzky, Aleksandr Rodchenko, John Heartfield, Herbert Bayer, Berenice Abbott and Edward Steichen, and montage compositions by Raoul Hausmann, Hannah Höch, and Gustav Klutsis—in the complex and stimulating context of those film posters, advertising ephemera, popular magazines, general interest books and photographic and archival reproductions to which they are so directly related. Of importance to our presentation of "Montage and Modern Life" is the inclusion of a series of 34 films that pioneered the montage technique, including *October* by Sergei Eisenstein, *The Man with a Movie Camera*, by Dziga Vertov, *Uberfall* by Erno Metzner, and *Blue Express*, by Ilya Trauberg.

In the number of objects gathered together, and the generous loans made by private and public collections around the world, "Montage and Modern Life" is the most ambitious exhibition the ICA has yet undertaken. It is the product of more than three years planning, first initiated by my predecessor, David Joselit, who conceived of and developed the exhibition in its early stages. Without his vision, this exhibition would not have begun. The five curators who have worked with The ICA on this project from its inception, and who have all contributed to this catalogue, are Maud Lavin, Annette Michelson, Christopher Phillips, Sally Stein, and Margarita Tupitsyn. They have worked tirelessly on this project, refining its focus, while constantly adding to and modifying the exhibition checklist to ensure that complementary and fascinating relations would be revealed by seemingly disparate material. Their dedication, and that of Benjamin Buchloh, who was involved at the project's inception as a project advisor, has meant a lot to The ICA, and to me. "Montage and Modern Life" benefited from the early encouragement and commitment of former ICA Director, David A. Ross, and former ICA Chief Curator, Elisabeth Sussman who, with David Joselit, first conceived of a series of three exhibitions which would focus on the cross-fertilization of art and mass culture. The first of these exhibitions, *on the Passage of a few people through a rather brief moment in time: the Situationist International 1957–1972*, opened in Boston in October of 1989. The third of these related exhibitions, examining the movements of populations from

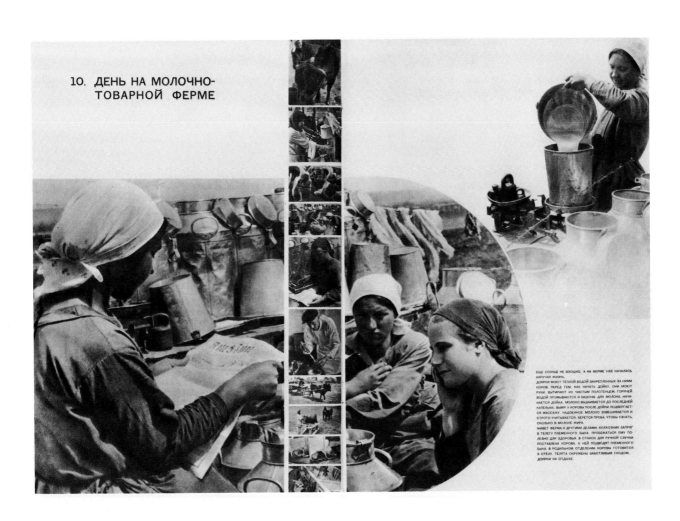

Designer unknown
"One Day on the Milk Farm," in *MTS*,
no. 12, 1935, pp. 28–9
Courtesy of Sergei Bugaev

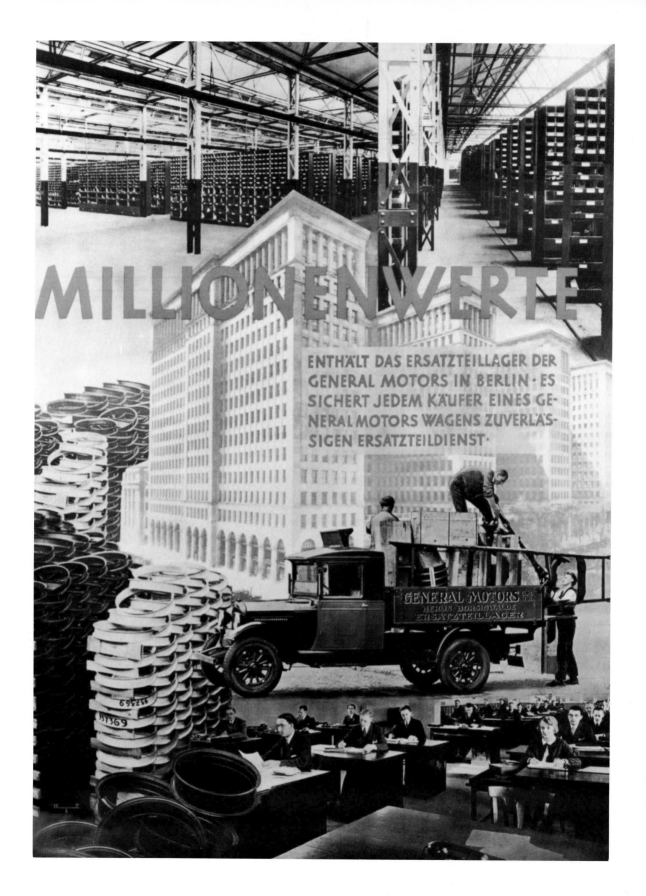

MILLIONENWERTE

ENTHÄLT DAS ERSATZTEILLAGER DER
GENERAL MOTORS IN BERLIN · ES
SICHERT JEDEM KÄUFER EINES GE-
NERAL MOTORS WAGENS ZUVERLÄS-
SIGEN ERSATZTEILDIENST·

Designer unknown
Oregon or Bust c.1935
FSA information panel
Courtesy of Division of Prints and
Photographs, Library of Congress,
Washington, D.C.

Designer unknown
Millionenwerte (Worth Millions) c. 1925
poster 32 5/8 x 23 3/4"
Courtesy of Merrill C. Berman

one metropolitan space to another, is planned to open at The ICA in 1994. That "Montage and Modern Life" has become a reality is a testimony to many of my colleagues at The ICA who have given unstintingly to this project—among them Teil Silverstein, whose graceful texts elicited for this project its continuing support from a variety of generous funders; Matthew Seigal, whose interest in the design of the installation is matched by a real sensitivity to the diversity of its materials; Lia Gangitano, whose commitment to this project, and care on all items of the checklist—a care unequalled in my experience—has ensured the exhibition's completeness; and Lisa Freiman, who has in addition to research and checklist inquiries, coordinated all aspects of catalogue production with remarkable sensitivity and thoroughness. The curatorial department was assisted at various crucial junctures by a group of exceptional interns and support staff, a group that has included: Anne Fleder, Kimberly Campbell, Charity Snider, Susan Landesman, Sarah Dwyer, Tania Nadal, Catherina Lauer, Julie Moffat, Kinsey Katchka, Marina Veronica, Paul Eaton, Christine La Monica, Irenie Poitras, Briana Beukenkamp, Matthew Woods, and Leigh Raben. This list of acknowledgments would not be complete, however, without noting that, in various ways, all of The ICA staff have contributed to the realization of this project. To all of them, thanks.

Hans Richter
vintage film still from *Inflation* 1928
Courtesy of Robert Shapazian

vintage film still from *Ghosts Before Breakfast* 1927/28
Courtesy of Robert Shapazian

vintage film still from *Film Study* 1926
Courtesy of Robert Shapazian

Matthew Teitelbaum is a curator at The Institute of Contemporary Art, Boston. A graduate of the University of London's Courtauld Institute, he moved to Boston from his position as Chief Curator at the Mendel Art Gallery in Saskatoon, Canada.

Acknowledgements

In the course of organizing *Montage and Modern Life: 1919–1942*, the ICA has benefited from the support of many individuals. Our gratitude is expressed to:

Helen Adkins; Sergei Bugaev; Alexander Alland, Jr.; Pierre Aproxine; Ellen Auerbach; Merrill C. Berman; Mrs. M.A. Bolliger; Flip Bool; Robert Brand; Kees Broos; Stephen Callis; Elaine Lustig Cohen; Keith de Lellis; Natan Fedorowskij; Pat Moore; Peter Nisbet; Eva Riehl; Eva-Maria and Heinrich Roessner; Robert Shapazian; Burkhard Sülzen; Brian Wallis; Stephen White; Phillipe-Guy E. Woog; Prof. Dr. Piet Zwart.

Michael Krejsa, Beate Reisch: Akademie der Künste zu Berlin; Mr. Rangmick: AEG Firmenarchiv; Julie Causey, Thomas Southall: Amon Carter Museum; J. Russell Harris, Mary Mulhern, Paula Pergament, Lieschen Potuznik, David Travis: The Art Institute of Chicago; Erna Haist: Institut für Auslandsbeziehungen; Dr. Bothe, Dr. Magdalena Droste, Dr. Peter Hahn, Silvia Krankemann: Bauhaus-Archiv; Bettina Beher: Herbert Bayer Archive; Phillip M. Johnston, Cheryl Saunders: The Carnegie Museum of Art; Terry Pitts, Amy Rule: Center for Creative Photography; Dr. Gabel: Universitäts-und Stadtbibliothek Köln; Helaine Pardo: Commerce Graphics, Ltd, Inc.; Michael Dawson: Dawson's Book Shop; Gwen Chanzit: Denver Art Museum; Ann McCabe, Will Stapp: George Eastman House; John T. Hill: Walker Evans Estate; Michael Sheehe: Ex Libris; Dr. James Fraser, Steve Heller: Fairleigh Dickinson University; Cynthia Read-Miller: Henry Ford Museum; Barry Friedman, Glenn A. Spellman: Houk Friedman Gallery; Antonia Gmurzynska: Galerie Gmurzynska; Donald Anderle: The Getty Center; Joan Gallant Dooley, Weston Naef: The J. Paul Getty Museum; Andreas Brown: Gotham Book Mart; P. Lorié, Peter Loorij, Dr. J. J. Th. Sillevis: Haags Gemeentemuseum; Barbara Dames: Harvard College Library; Dr. Gabriele Toepser-Zeigert: Institut für Zeitungforschung der Stadt Dortmund; Anna Lundgren, Douglas Walla, Jeanne Marie Wasilik: Kent Gallery; Dr. Bernd Evers, Dr. Adelheid Rasche: Kostumbibliothek; Tambra Johnson, Kathlee Tobin: Library of Congress; Dr. Alfred M. Fischer, Dr. Siegfried Gohr: Ludwig Museum; Suzanne Boorsch, Colta Ives: The Metropolitan Museum of Art; Jennifer Banks: MIT Library; Olle Garnath, Nina Ohman: Moderna Museet; Eileen Bowser, Miki Carpenter, Nicole Fielder, Ena Giurescu, Susan Kismaric, Matilda McQuaid, Clive Phillpot, Richard L. Tooke: The Museum of Modern Art, New York; Peter C Marzio, Ann Tucker, Linda Wilhelm: The Museum of Fine Arts, Houston; Ute Eskildsen, Robert Knodt: Museum Folkwang; Linda Brown, Trudy Huskamp Peterson: National Archives; Dr. Alexander Dückers: Nationalgalerie Berlin; Eugene Ostroff, Faith Ruffins: National Museum of American History; R. Russell Maylone, Carol Turner: Northwestern University Library; Howard Greenberg, Carrie Springer: Photofind Gallery; Mrs. I. Th. Leyerzapf, Dr. Herman J. Moeshart: ‚Prentenkabinet der Rijksuniversiteit Leiden; Bevin Maguire: Rockefeller Group; Nikolai Semenovich Kartoshov, John R. Lane, Sandra Phillips: San Francisco Museum of Modern Art; Dr. Regina Mahlke: Staatsbibliothek, Staatliche Museen Preußischer Kulturbesitz; Dr. Ulrike Gauss: Staatsgalerie Stuttgart; Claire Bellanti, Anne Caiger, Raymond Reece, David Zeidberg: University of California, Los Angeles; Cynthia Wayne: University of Maryland at College Park; R. Neil Fulghum, Harry McKown: University of North Carolina, Chapel Hill; Joseph Walker, Chris Ursitti, Paul McGinniss: Walker, Ursitti, McGinniss.

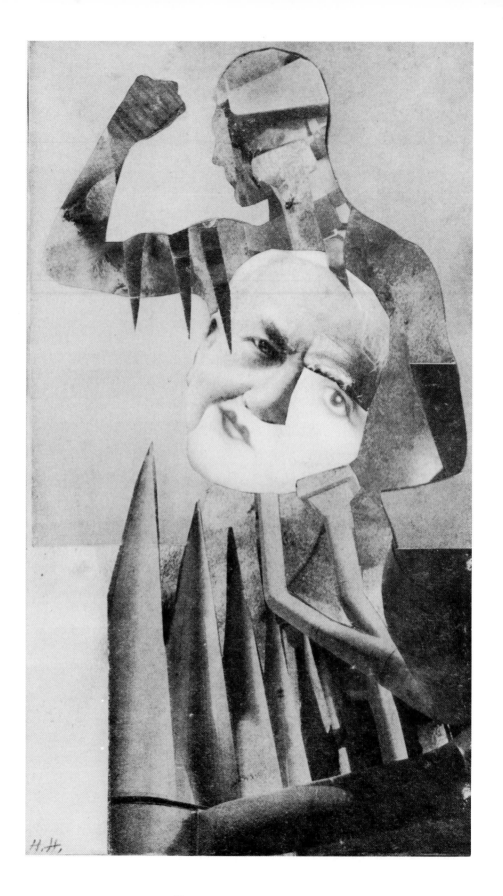

Introduction

Christopher Phillips

The term montage has been used to refer to the formal principle at work in many of the most distinctive cultural products of the early decades of the twentieth century: the hybrid Dada images of George Grosz, John Heartfield, Hannah Höch, and Raoul Haussman; the fragmented literary narratives of Dos Passos's *Manhattan Transfer* and Doblin's *Berlin Alexanderplatz*; the cinematic editing techniques of Dziga Vertov, Sergei Eisenstein, and Walter Ruttman; the episodic theatrical structure of Erwin Poscator's *Trotz Alledam*; the mutilayered exhibition spaces conceived by Frederick Kiesler, El Lissitzky, and Herbert Bayer; and the multiple-exposure photographs of Edward Steichen and Barbara Morgan. This exhibition does not claim to present a comprehensive survey of the myriad uses of montage devices. Rather, it concentrates on photographic and cinematic montage. It limits its scope to work produced between 1919 and 1942 in three countries, Germany, the USSR, and the United States thus leaving aside the parallel developments in montage in countries such as Italy, France, Spain, Czechoslovakia, Hungary, and Poland. Nor does this exhibition propose a broad reassessment of the accom-

Hannah Höch
Die Starken Männer (The Strong Man)
1931
collage 9 5/8 x 5 1/4"
Courtesy of Institute für
Auslandsbeziehungen, Stuttgart

[1] See for example, Alfred Henry Forrestier's *Bill Poster Effects*, ca. 1840, in the Victoria and Albert exhibition catalogue *English Caricature, 1620 to the Present*, (London, Victoria and Albert Museum, 1984), catalogue entry 158.

Luke Swank
Untitled (Industry-Steel Mill Triptych)
c.1935
photographic mural 7 3/4 x 4 3/4"; 9 1/2 x 7 5/8"; 7 11/16 x 4 1/2"
Courtesy of the Carnegie Museum of Art, Pittsburgh; Gift of the Carnegie Library of Pittsburgh, 1983

plishments of individual photomontagists and filmmakers, even though it gives considerable attention to such well-known figures as Heartfield, Höch, and Rodchenko.

Instead "Montage and Modern Life: 1919–1942" sets out to explore a hypothesis: that for much of the first half of this century, montage served not only as an innovative artistic technique but functioned, too, as a kind of symbolic form, providing a shared visual idiom that more than any other expressed the tumultuous arrival of a fully urbanized, industrialized culture. The exhibition thus brings together an unprecedented variety of montage work, encompassing original art works produced by recognized artists as well as a panoply of popular, commercial, and political montages that often sprang from unknown hands. These objects include commercial and political posters, book jackets and illustrations, magazine covers and page layouts, advertisements, maquettes for photomurals, exhibition catalogues, industrial-product brochures, department-store pamphlets, film publicity montages, and documentation of exhibition installations utilizing montage effects. Further, in an accompanying film program organized by Annette Michelson, a variety of approaches to cinematic montage—in German, American, and Soviet feature-length productions as well as in newsreels, experimental shorts and documentaries—are brought together for comparison.

Of course, it should be emphasized at the outset that the visual devices employed in montage during this period represented no absolute novelty; in many cases, they predate the appearance of photography itself. By 1840, for example, British caricaturists already employed as a stock theme the comic mismatching of heads and bodies that resulted from the tearing of billboard posters by passersby.[1] By the 1850s–60s, early examples of composite photographic imagery had already emerged in private, artistic, and commercial spheres. One can find in family scrapbook albums, for example, instances of cut-out photographic portraits capriciously combined with whimsical drawings. Simultaneously, there appears in the well-known work of such professional artist-photographers as H.P. Robinson and O.G. Rejlander the practice of combination printing—the making of a single photographic print from a number

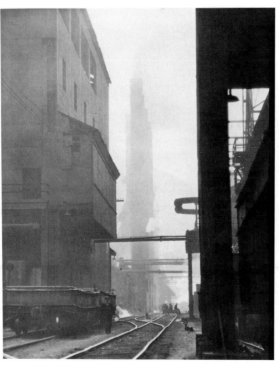

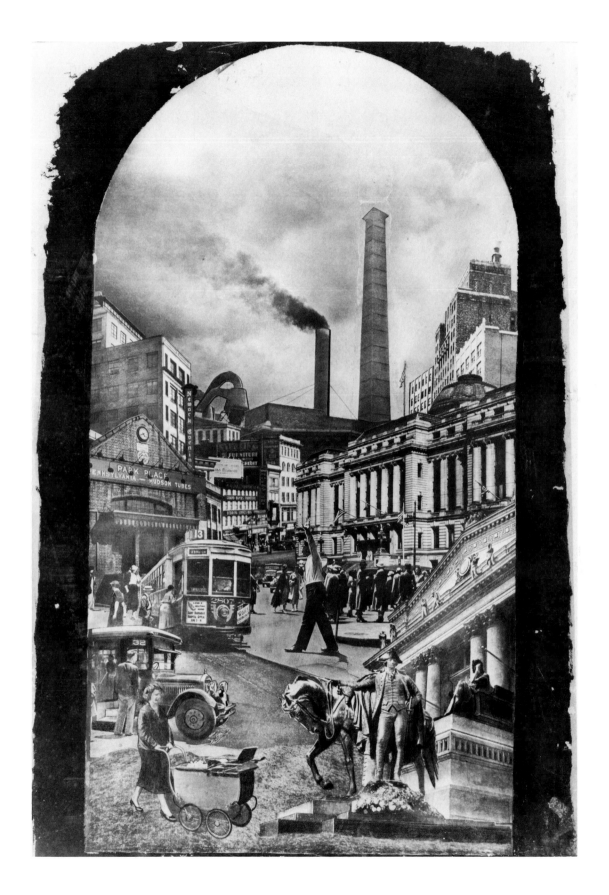

[2] See Robert Sobieszek, "Composite Imagery and the Origins of Photomontage," *Artforum*, (September 1978, pp. 58–65, and October, 1978), pp. 40–45.

[3] See the many examples in C. Lauterbach and A. Jakovsky, *Postkarten-Album*, (Cologne, DuMont, 1960); and in Robert Lebeck, *Angeberpostkarten*, (Dortmund, Harenberg Kommunikation 1979).

4. See, for example, Richard Hiepe's essay in the catalogue, *Die Fotomontage: Geschichte und Wesen einer Kunstform*, (Ingolstadt, Kunstverein Ingolstadt, 1969); and Charlotte Irene Lusk, *Montagen in Blaue: Laszlo Moholy Nagy; Fotomontagen und Collagen, 1922–1943*, (Giessen, Anabas Verlag, 1980), pp. 13–17.

John Heartfield
"Jedermann sein eigner Fussball" (Everyone His Own Soccerball), cover for
Illustrierte Halbmonatsschrift vol. 1, no. 1,
15 February 1919
Collection of Merrill C. Berman

page 24
Alexander Alland
Newark of the Past 1936
photomontage on board, study for larger mural 38 1/2 x 22 1/2"
Courtesy of the Estate of Alexander Alland, Sr.

page 25
Alexander Alland
Newark of the Present 1936
photomontage on board, study for larger mural 38 1/2 x 21"
Courtesy of the Estate of Alexander Alland, Sr.

of different negatives. Also, in the growing commercial image industry, a popular *carte de visite* format involved using the cut-and-paste method to group a host of celebrity portraits into a tightly packed single-frame image.[2]

These were all fairly limited and specialized practices, however. The spread of montage imagery began in earnest after the 1880s and the advent of the half-tone process, which allowed photographically derived images to be reproduced in ink on the same presses as type. By the first decade of the twentieth century, photomontage imagery, albeit of a fairly primitive kind, could be found in advertisements in popular illustrated magazines like *Colliers*. At the same time, the now still familiar genre of "tall tale" photomontage postcards appeared in the United States, featuring fanciful scenes involving outlandishly sized farm animals or vegetables as proof of the claim that "we grow them bigger out here."[3] In Europe, montage postcards from the years before World War I regularly caricatured the leading political personalities of the day; some of Heartfield's earliest montages, such as his satire of a group of German political figures in the 1919 *Jedermann sein eigner Fussball*, grew directly out of this popular vein of montage.

As these precedents suggest, the later disputes among figures like George Grosz, John Heartfield, Raoul Haussman, and Gustav Klutsis about who "invented" photomontage should be understood as having mainly to do with the introduction of a specifically modernist visual idiom into montage. In this regard, the wide artistic interest awakened by the Cubist collage techniques pioneered by Picasso and Braque around 1912, as well as the influential adaptations of collage by the Italian futurists and the early Russian avant-gardists, should also be seen as crucial sources for the subsequent development of photomontage. One result of this mixed ancestry of photomontage has been a lasting confusion of terminology, with attempts to make general formal distinctions between *papier collé*, *Klebebild*, *Fotoklebebild*, *Wirklichkeitsausschnitt*, photocollage, and photomontage yielding little in the way of helpful clarification.[4]

For the purpose of this exhibition, a more useful starting point is that provided by the German art historian Franz Roh in 1925. Roh described montage as a precari-

Einzelnummer: 30 Pf., zugestellt 40 Pf.,
Abonnement: Quartal (6 Nummern incl.
Zustellung) 2 Mark. Vorzugs-Ausgabe:
100 numm. Exemplare 1-20 sign. auf echt
Zanders Bütten à 10 M., 21-100 à 3 M.

Preis 30 Pf.
Durch Post und Buchhandel
40 Pf.

Anzeigenpreise: 1 Quadratzenti-
meter 0,50 Mark, einmal wiederholt 10%,
Rabatt, zweimal wiederholt 20%, Rabatt.
Exzentrischer Satz: 1 Quad-atzentimeter
1,00 Mark, bei gleichen Rabattsätzen.

"Jedermann sein eigner Fussball"

Illustrierte Halbmonatsschrift

1. Jahrgang Der Malik-Verlag, Berlin-Leipzig Nr. 1, 15. Februar 1919

Sämtliche Zuschriften betr. Red. u. Verl. an: Wieland Herzfelde, Berlin-Halensee, Kurfürstendamm 76. Sprechst.: Sonntags 12—2 Uhr

Preisausschreiben!
Wer ist der Schönste??

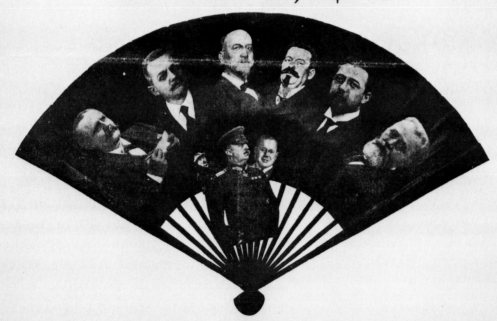

Deutsche Mannesschönheit 1 (Vergl. Seite 4)

Die Sozialisierung der Parteifonds

Eine Forderung zum Schutze vor allgemein üblichem Wahlbetrug

(Diese Ausführungen sollen den Unfug unserer Nationalversammlung selbst vom Gesichtspunkt der Demokraten aus illustrieren, jener Leute, die meinen, ein Volk dürfe keine Regierung besitzen, deren Niveau dem seines eigenen Durchschnitts überlegen ist.)

Man mag Demokrat sein, deutsch-sozialistischer Untertan oder Kommunist, man mag mit Schiller sagen: Verstand ist stets bei wenigen nur gewesen oder behaupten auf jede Stimme komme es (sogar mit Recht) an, die Tatsache wird man nicht bestreiten: Wahlen gehören zu den ge-

ous synthesis of the two most important tendencies in modern visual culture, extreme fantasy and extreme sobriety—or, put another way, the pictorial techniques of modernist abstraction and the realism of photographic fragment.[5] Equally helpful in beginning to approach the perhaps daunting assortment of montage material presented in this exhibition is the definition of photomontage advanced in the 1930s by the Soviet critic Sergei Tretyakov. Writing about Heartfield, Tretyakov proposed that photomontage begins whenever there is a conscious alteration of the obvious first sense of a photograph—by combining two or more images, by joining drawing and graphic shapes to the photograph, by adding a significant spot of color, or by adding a written text. All of these techniques serve to divert the photograph from what it "naturally" seems to say, and to underscore the need for the viewer's active "reading" of the image. In this exhibition, such decipherment is equally called for in Steichen's multi-photograph portrait of Charles Chaplin; in Lewis Hine's combination of a complex photo-mosaic with the written slogan "Some Children Who Work in Your State;" and in the covers of *AIZ* magazine by Heartfield and Karl Vanek, where the montage image is itself inextricably intertwined with elaborate accompanying captions and texts.

I have already indicated that the aim of this exhibition is not to offer another art historical survey of montage styles or montagists. Instead, by bringing together for comparison some of the most sophisticated and the least cultivated examples of montage, it hopes to demonstrate the way a common set of social and cultural themes was articulated across a broad range of work. In Germany, the USSR, and the United States this was a period of heightened awareness of being caught up in an epoch of accelerated transformation. This period marked the culmination of a series of irreversible passages: the passage from the seasonal rhythms of a rural society to the frenzied tempo of an urban culture; the passage from national economies based on the land and on the artisanal occupations to industrial economies driven by machine technology; the passage from a social life rooted in traditional family life and local communities to the larger, more impersonal aggregations of mass society. In addition, as the abundant material presented in

5 Franz Roh, *Nachexpressionismus*, (Leipzig, Klinckhardt und Biermann, 1925), pp. 45–46.

Lewis Hine
Some Children Who Work in Your State
1910
modern print from archival negative
Courtesy of Prints and Photographs
Division, Library of Congress

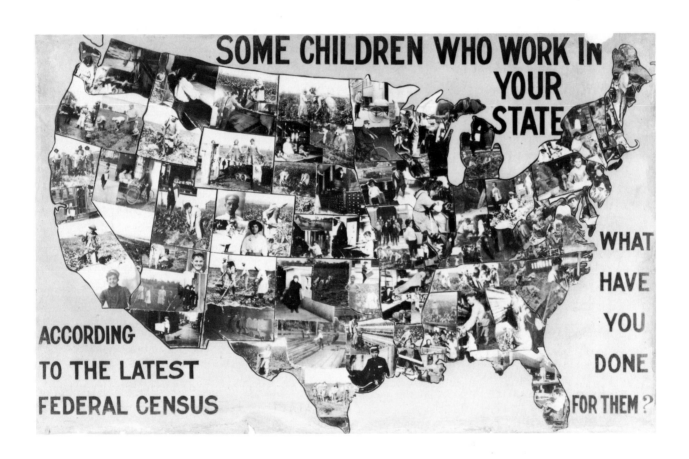

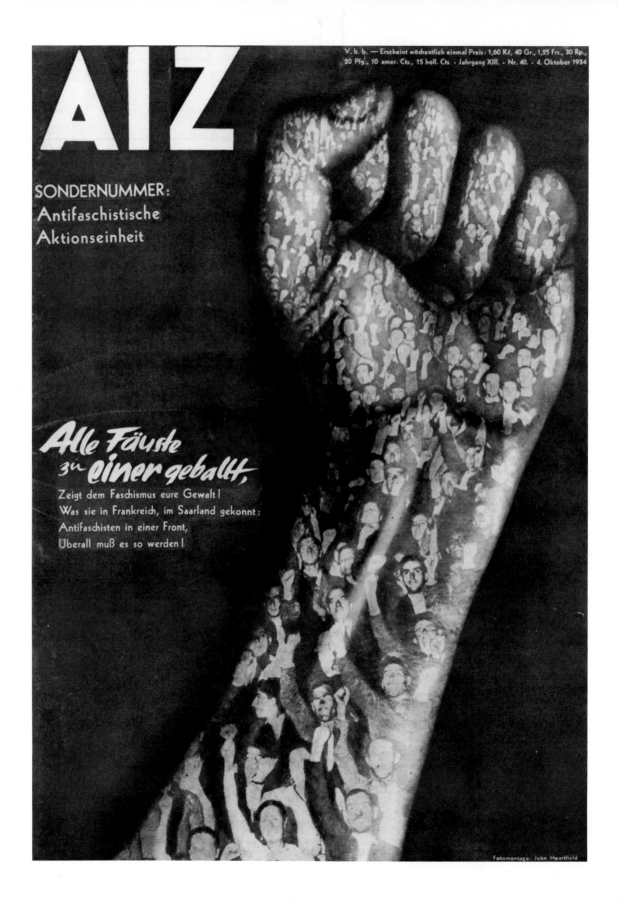

AIZ

V. b. b. — Erscheint wöchentlich einmal Preis: 1,60 Kč, 40 Gr., 1,25 Frs., 30 Rp., 20 Pfg., 10 amer. Cts., 15 holl. Cts · Jahrgang XIII. · Nr. 40. · 4. Oktober 1934

SONDERNUMMER:
Antifaschistische
Aktionseinheit

Alle Fäuste
zu einer geballt,
Zeigt dem Faschismus eure Gewalt!
Was sie in Frankreich, im Saarland gekonnt:
Antifaschisten in einer Front,
Überall muß es so werden!

Fotomontage: John Heartfield

this exhibition of the New Woman of the 1920's reflects, this era saw the passage from a social order in which women's lives were largely circumscribed by the roles of wife and mother to a world in which women were offered a place— to be sure, in the office and factory—as well as a previously unknown personal autonomy. Montage, then, is examined for its power to register something of the shock of these transitions. It serves as a sign of an old world shattered and a new world self-consciously in construction, of the fragmentation of the once reigning unities of life and an everyday reality that has suddenly burst the frame of experience.

Within this general framework, the essays in this catalogue address some of the significances that montage took on according to country and circumstance. Certainly contributing to the growing interest in photomontage was the rapid evolution, in the 1920s and 1930s, of an extremely sophisticated theory and practice of film montage. In "The Wings of Hypothesis: Montage and the Theory of the Interval," Annette Michelson explores a little-remarked aspect of the cinematic montage theory of these years. In considering the sources of early Soviet speculation about montage, and in particular the impact of Einstein's ideas about relativity, Michelson examines the way that the compositional use of the temporal interval—the nonrealistic handling of film time—entered into cinematic thought. Looking at Eisenstein's adoption of interval metaphors derived from music and Vertov's use of an interval model taken from advanced mathematics, Michelson demonstrates the way that experiments with film time led in turn to a more sophisticated understanding of the ties between filmic structure and spectator affect.

Maud Lavin, in "Photomontage, Mass Culture and Modernity," shows that one should not exclusively identify German photomontage between the wars with heroic figures like Heartfield. She argues that for many of the German avant-gardists who came after Dada, photomontage figured primarily as a much-sought-after entry point into the emerging media of mass culture. Lavin focuses on the *ring neue werbegestalter* (Circle of New Advertising Designers), the group of avant-garde commercial designers organized by

John Heartfield
"Alle Fäuste einer geballt" (All Fists Clenched into One), in *AIZ*, vol. 13, no. 40, 4 October 1934, p. 633.
newspaper photomontage 14 1/8 x 11 1/8"
Courtesy of The Museum of Fine Arts, Houston; Museum Purchase with funds provided by Isabell and May Herzstein

Kurt Schwitters in the late 1920s. Lavin explores the seeming paradox that within this circle—whose members included figures like Willi Baumeister, Piet Zwart, and César Domela—left-wing political convictions were able to co-exist with the search for commissions from abashedly capitalist enterprises. Pointing out a surprising absence from the graphic work produced by the *ring*—the absence of the New Woman who elsewhere figured so prominently as a symbol of the emerging consumer culture—Lavin is able to proceed to a striking reinterpretation of the *ring*'s predilection for gridlike compositions, stark clarity of design, and photographic images of technological instruments.

Margarita Tupitsyn, in "From the Politics of Montage to the Montage of Politics: Soviet Practice 1919 through 1937," directs special attention to the example of Gustav Klutsis, the Constructivist artist who by the late 1920s had become the most outspoken advocate of agit-prop photomontage. Klutsis's enthusiasm for what he called "a new kind of agitational art" arose from his conviction that while the single photograph was an insufficient vehicle for visual propaganda, it might well be the starting-point for a larger, "constructed" message. A sharp critic of Rodchenko and Lissitzky, Klutsis also expressed reservations about the work of Heartfield, in whose montages he found worrisome traces of Dada's anarchic spirit. Tupitsyn clarifies the perplexing path that led Klutsis by the early 1930s to be considered one of the chief elaborators of the mythic iconography associated with Stalin's rule.

Efforts to explain the seeming absence of American interest in montage during this period have typically referred to an historically deep-seated American preference for objective, realistic imagery and single-frame pictures. Sally Stein, in "'Good fences make good neighbors': American Resistance to Photomontage between the Wars," looks closely at the question of the supposed non-existence of American montage. She considers the sources and limits of the American attachment to the "straight" photograph during the 1920's, 1930s, and 1940s, in comparison with the more widespread European utilization of montage. Stein discovers the existence of a surprising range of American montage work—found, for example, in advertising, photo-

Paul Citröen
Metropolis 1923
modern print from archival negative
Collection Prentekabinet der Rijksuniveritat
Leiden, Nederland

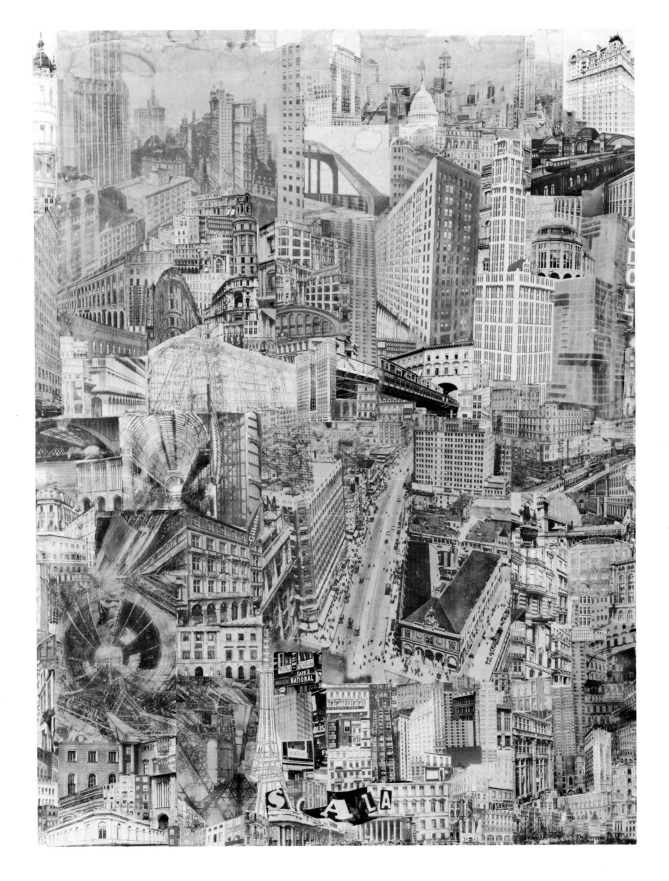

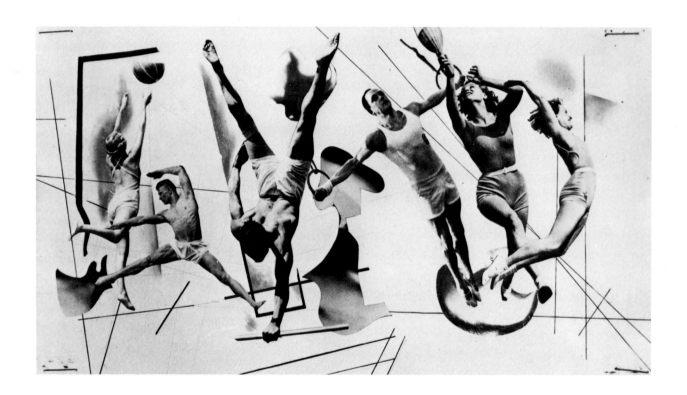

Leo Lances
Gymnastics (photomural for the WPA
community and health building at the
World's Fair, New York) 1939
modern print from archival negative
Courtesy of National Archives,
Washington, D.C.

mural commissions, and New Deal public information campaigns—and develops a striking thesis about the use of photomontage during moments of American social crisis. She looks in particular at the "graphic assemblages" of New Deal-era government agencies as attempts to fashion a pictorial rhetoric more expansive, and of a greater mobilizing power, than the individual photograph.

In the essays of Stein and Tupitsyn we can begin to see why, by the end of the late 1930s in both the United States and Europe, montage appeared an increasingly domesticated and no longer shocking visual form. By the time of the 1937 Paris Exposition Universelle, observers like the photographer Gisele Freund and the painter Amadée Ozenfant noted the number of national pavilions employing photomontage installations—and their sheer banality.[6] By the same time in the United States, montage was more and more recognized not as a means to evoke the flux and discontinuity of the modern world, but as a way to represent a dominant social theme in late-Depression America: the idea of the "unity in diversity" of all classes and ethnic groups.

Writing still later, after the Second World War and at a time when the artistic revival of earlier collage and montage practices was beginning to attract wide notice, Theodor Adorno ventured a skeptical assessment of the continued esthetic vitality of montage. "The principle of montage," he wrote, "was supposed to shock people into realizing just how dubious any organic unity was. Now that the shock has lost its punch, the products of montage revert to being indifferent stuff or substance. The method of montage no longer succeeds in triggering a communicative spark between the aesthetic and the extra-aesthetic; the interest in montage has therefore been neutralized. ..."[7] Today, approaching the end of the twentieth century, montage may in fact no longer offer the most satisfying or audacious way to represent our own "culture of fragments." Yet, if the passage of time has inevitably altered, it has not necessarily diminished the significance of the works gathered in this exhibition. For those ready to look, think, and make connections, they retain the power to suggest new ways of conceiving the relation between visual culture and the social forms through which it is constantly redispersed.

[6] Gisele Freund, "La photographie à l'Exposition," *Arts et métiers graphiques*, (no. 62, March 1938), pp. 37–41; Ozenfant's remarks on the 1937 exhibition appear in *Cahiers d'Art*, 1937, p. 242.

[7] Theodor Adorno, *Aesthetic Theory*, trans. C. Lenhart, (London and New York, Routledge & Kegan Paul, 1984), p. 223.

Christopher Phillips is Associate Editor at *Art in America*. He is the editor of the anthology *Photography in the Modern Era* (New York: Metropolitan Museum of Art, 1989.)

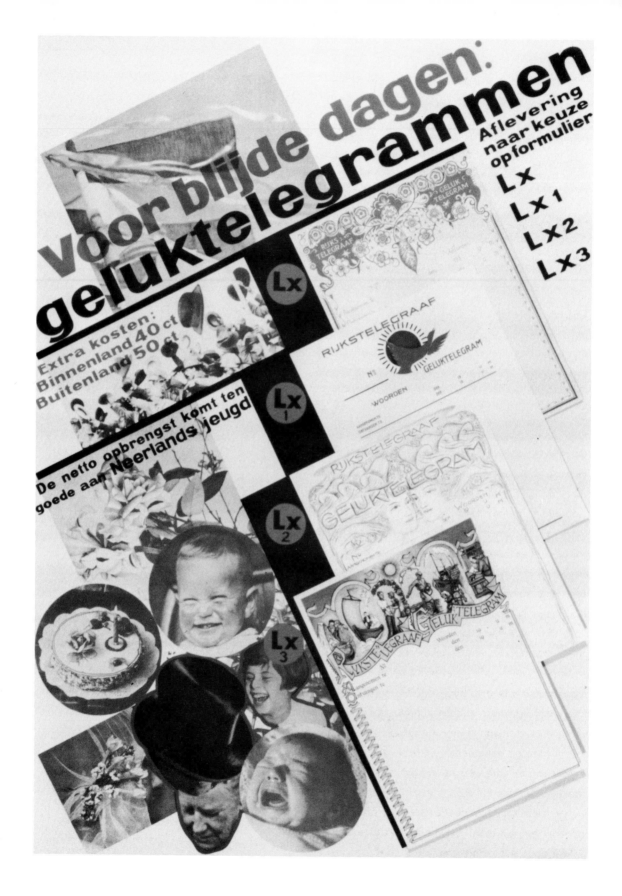

Photomontage, Mass Culture, and Modernity

UTOPIANISM IN THE CIRCLE OF NEW ADVERTISING DESIGNERS

Maud Lavin

I am writing this essay in October, 1990, the month when the much heralded reunification of Germany has finally taken place, a time when almost immediately, German celebrations of unity have been overshadowed by anxiety about its cost. Unemployment in the East and financial drain in the West have become unification's reality test. These tensions between the dream and the reality of one Germany have stirred debates about the country's public policies. Previously, in the helter-skelter rush to unification in the East, those urging an embrace of capitalism temporarily silenced those whose voices were bent on preserving the tightly woven safety net of social services that were established under communism. Now the silence has already been broken, and at issue once more is the uneasy mix of hard-core capitalism and German democratic socialism. Heated debates have erupted about such social services as day care, unemployment benefits, and health care—particularly the right to abortion.

Germany's current political debates about economic and social issues are strangely reminiscent of tensions during the Weimar Republic, the only other time in Germany's history

Piet Zwart
Voor biljde dagen gejuktelegrammen
graphics for PTT (The Dutch Telephone and Telegraph Company)
photomontage c. 1929
Courtesy of Ex Libris Gallery, New York

37

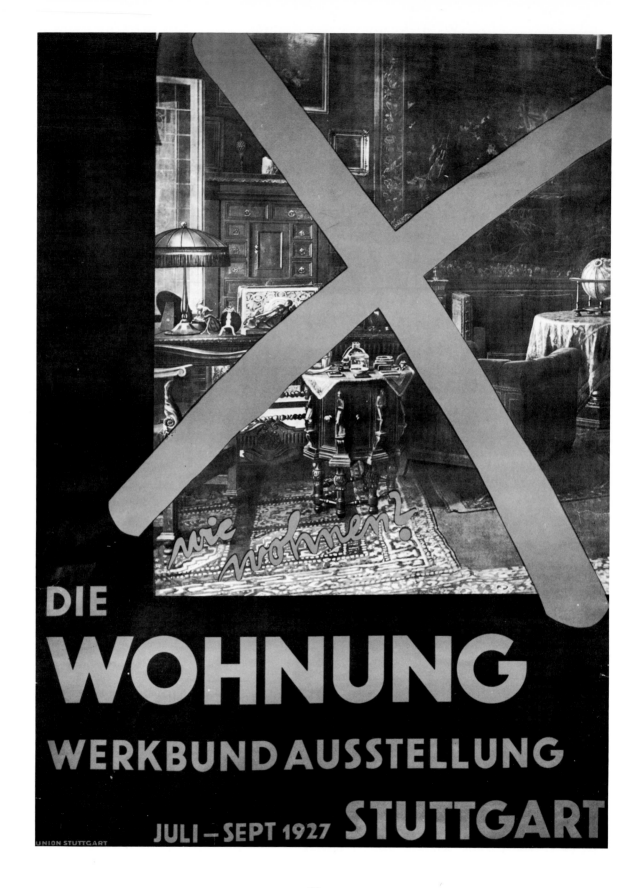

when the country was unified and democratic. During the Weimar years (1918–33), Germans expressed great interest in the political economies of both the Soviet Union and the United States. At that time, for many self-proclaimed modernists, there was a utopian and sometimes contradictory enthusiasm for elements of both capitalism and socialism, a desire to have the best of both worlds. This desire often played out in romantic images of technology and industry as societal curatives. Cutting across the Weimar political spectrum, this technological romanticism is central to Germany's political heritage, and the visual expression of these technological utopias has been a legacy for us in the United States as well, in terms of the way capitalism and corporations are represented and sold. We need only think of our most common corporate identity programs, such as Paul Rand's logo and graphics for IBM, to see how pervasive modernist utopian design has become. In this essay, I examine the utopian images and the politics of modernist advertising designers in the Weimar Republic, in particular, the practices of one leading trade group, the Circle of New Advertising Designers, as they called themselves—NWG or *ring "neue werbegestalter."*[1]

Founded by Kurt Schwitters in 1928, the *neue werbegestalter* included artists who, like Schwitters, are known today through their fine arts: Willi Baumeister, Walter Dexel, the de Stijl painter Friedrich Vordemberge-Gildewart, the Dutch painter and photomontagist César Domela. All of these artists were deeply committed as well to commercial design work. Also in the group were artists well-known as designers: Jan Tschichold (Swiss-born but working then in Munich), Max Burchartz, Georg Trump, Hans Leistikow, Robert Michel, and the leading Dutch modernists Piet Zwart and Paul Schuitema.

Schwitters energetically propagated advertising design in general and the works of *neue werbegestalter* members in particular. From 1928 through 1931, members of the *ring* seem to have been exhibiting constantly; they usually had two collections of works touring Germany and the Netherlands. For example, in 1928 one collection went from Köln to Wiesbaden to Barmen to Bochum to Hannover and another traveling exhibition went from Hamburg to

[1] *"ring 'neue werbegestalter'"* is the spelling and capitalization used by the group, as evidenced by their letterhead, designed by Kurt Schwitters.

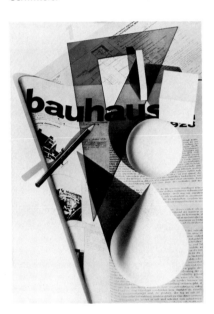

Herbert Bayer
cover for *Bauhaus*, no. 1, 1928
Courtesy of Bauhaus-Archiv, Berlin

Willi Baumeister
Die Wohnung (The Home) 1927
offset lithograph 44 3/4 x 32 3/8"
Courtesy of The Museum of Modern Art, New York. Gift of Philip Johnson

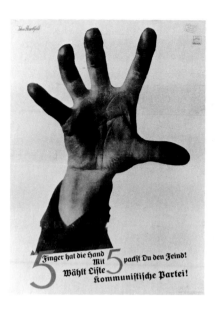

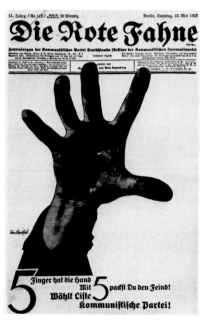

John Heartfield
Five finger hat die hand (Five Fingers
has the Hand) 1928
poster 38 1/2 x 29 1/4"
Courtesy of Merrill C. Berman

John Heartfield
"Five Finger hat die hand" (Five Fingers
has the Hand), cover for D*ie Rote Fahne*,
13 May 1928
17 3/4 x 12 1/4 x 2"
Courtesy of Institut für Zeitungsforschung,
Dortmund

Rotterdam to Halle.[2] In addition to these core sets of graphics, Schwitters would write members to send additional and up-to-date works to various stops. Although Schwitters seems to have been the driving organizational force, all matters were scrupulously decided by group votes through the mail. Designers petitioning to join the *ring* would submit ten works that would circulate by post among the far-flung group. Then a vote would be taken. The group was, generally, inclusive, and although there was some wariness of being seen as an adjunct association of the Bauhaus, it often invited Bauhaus members to exhibit with them such as Laszlo Moholy-Nagy, Herbert Bayer, and Joost Schmidt. Other guests included John Heartfield from Berlin and Karl Tiege from Prague.[3]

Stylistically, the *ring* graphics are marked by a devotion to new typography and photomontage. Whereas in the early Weimar years photomontage was employed most often as a technique by the Berlin Dadaists (with a few, toned-down examples in commercial advertising), by the late 1920s it was widely used in the mass media and had become a sign of the most modern style in graphics. By the late Weimar period the combination of modernist typography and photomontage in utilitarian design had several functions: an association with high art, an evocation of rationalization, and an alliance with internationalism. Photomontage in its various guises in high and mass culture was believed to represent a specifically modernist practice of seeing and experiencing.

With prostyletizing zeal, *ring* members published in the modernist periodicals *Form* and *neue frankfurt*, where functionalist advertising design was promoted along with functionalist architecture. The *ring* "neue werbegestalter" was involved, too, in the formulation of the major 1931 international *Fotomontage* exhibition in Berlin, which included the former Berlin Dadaists John Heartfield, Hannah Höch, and Raoul Hausmann and the key Soviet photomontagists. It was organized by *ring* member César Domela, who remarked about the oppurtunity the role provided him to invite the Soviets, Germans, and Dutch to exhibit together.[4] The *NWG* was also behind the publication of the 1930 book *Gefesselter Blick* (meaning literally "chained gaze"

or, more metaphorically, "a fascinated and firmly focused gaze"). *Gefesselter Blick* was edited by the brothers Heinz and Bodo Rasch, and it can be seen as the most important survey of both advertising design and the accompanying manifestos of the period.[5]

Given the central, even pivotal, role of the *ring* in Weimar visual culture and its bridge position between high and low culture—avant-garde and mass culture—it is surprising how much the *ring "neue werbegestalter"* has been written out of art history. However, given traditional art history's function in the devaluing of mass culture and in the shoring up of an elite art market, and given leftist art history's tendency to look for pure and idealized heroes like John Heartfield, it is perhaps not so surprising. The *ring* makes an unlikely group of heroes or villains. The members' lives and production cannot be so reductively described. They were negotiating meaning and representation within several major arenas: capitalist advertising, mass communications, and, for some, leftist activism. This broad and sometimes contradictory range of activity is precisely why they are a significant object of study and questioning. The practices of different members varied. Some espoused left radical politics, many admired and borrowed from Russian Constructivism—and at the same time served capitalist industry with great enthusiasm. Theirs were cultural practices within the *non*-revolutionary societies of 1920s Holland and Germany. Their utopian visions, infused with a technological romanticism, espoused rationalized production and communication techniques. These visions dovetailed with a common desire among artists of the time to work hand-in-hand with an enlightened proletariat to build a greatly improved, more equitable society with a truly modern standard of living.

In fact, European culture in general in the 1920s demonstrated high expectations—across the political spectrum—for the societal effects of scientific management and technology. Postwar Europe embraced Taylorism, the time and labor efficiency tenets propagated by Frederick W. Taylor in the United States before World War I. As historian Charles Maier explains, "by the 1920s, scientific management—which extended the original approaches of Taylorism into all areas

[2] A complete list of the exhibitions of the *ring neue werbegestalter* was compiled in the exhibition catalogue *"Typografie kann unter Umständen Kunst sein": Ring 'neue werbegestalter' Die Amsterdamer Ausstellung 1931* (Wiesbaden:Landesmuseum Wiesbaden, 1990), 141: 25.3–22.4.1928 Kunstgewerbemuseum Köln; Juni 1928 Museum Wiesbaden; Sept./Okt. 1928 Kunstverein Barmen; Okt. 1928 Museum für Kunst und Gewerbe, Hamburg; Dez. 1928 Bochum; Dez. 1928 Academie van Beeldende Kunsten, Rotterdam Anfang 1929 Halle; Jan. 1929 Provinzialmuseum Hannover; 10.3–23.3.1929 Haghaus, Bremen; 20.4–20.5.1929 Staatliche Bibliothek, Berlin; 21.4–29.4.1929 Neue Kunst Fides, Dresden; Mai 1929 Kunstverein Heilbronn; 18.5–7.7.1929 Stuttgart; 3.8–19.8.1929 Ausstellungshalen am Adolf-Mittag-See, Magdeburg; 22.9–[unknown] 1929 Museum Folkwang, Essen 8.–11.2.1930 Stuttgart; 30.3–27.4.1930 Gewerbemuseum Basel; 3.4–6.4.1930 Graphische Gesellschaft, München; o. D. 1930 Kopenhagen; o. D. 1930 Aarau 3.–6.4.1931 Stockholm; 30.5–5.6.1931 Ausstellungshallen, Essen; 20.6–12.7.1931 Stedelijk Museum, Amsterdam.

[3] See circular and personal letters from Kurt Schwitters to Piet Zwart, archive number 850831, Archives of the History of Art, The Getty Center for the History of Art and the Humanities, Los Angeles. I would like to thank Pamela Johnston of the Archives for making these accessible to me. The letters are published in part in the Wiesbaden *neue werbegestalter* catalogue.

[4] César Domela letter to the author, Paris, Dec. 12, 1989.

[5] *Gefesselter Blick: 25 Kurze Monografien und Beiträge über neue Werbegestaltung,* ed. Heinz and Bodo Rasch (Stuttgart: Verlag Dr. Zaugg & Co., 1930).

Gefesselter Blick

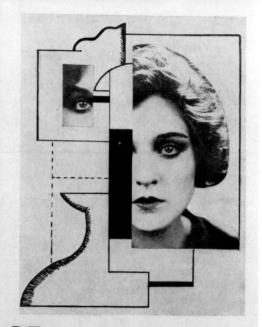

25 kurze Monografien und Beiträge über neue Werbegestaltung

Otto Baumberger
Willi Baumeister
Bill
Max Burchartz
Johannes Canis
Cyliax
Walter Dexel
Cesar Domela
Hermann Elias
Werner Gräff
John Heartfield
Franz Krause
Geschwister Leistikow
El Lissitzky
Robert Michel
Moholy-Nagy
Brüder Rasch
Hans Richter
Paul Schuitema
Kurt Schwitters
Mart Stam
Karel Teige
G. Trump
Jan Tschichold
Vordemberge-Gildewart
Piet Zwart

Mit Unterstützung des „Ringes der Werbegestalter des Schweizer Werkbundes" u. a.

herausgegeben und mit einer Einleitung versehen von
Heinz und Bodo Rasch

140 Abbildungen

Wissenschaftlicher Verlag Dr. Zaugg & Co., Stuttgart

Gefesselter Blick

25 kurze Monografien und Beiträge über neue Werbegestaltung

Mit Unterstützung des „Ringes der Werbegestalter des Schweizer Werkbundes" u. a.

herausgegeben und mit einer Einleitung versehen von
Heinz und Bodo Rasch

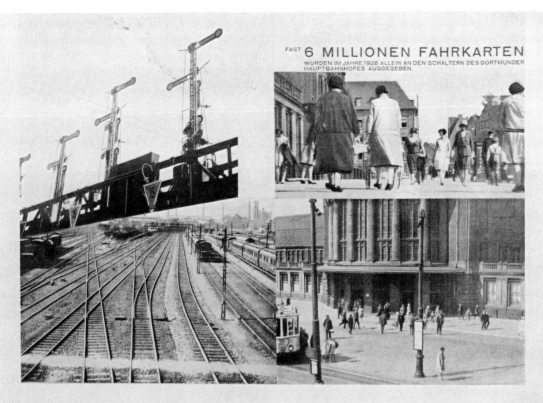

FAST **6 MILLIONEN FAHRKARTEN**
WURDEN IM JAHRE 1928 ALLEIN AN DEN SCHALTERN DES DORTMUNDER HAUPTBAHNHOFES AUSGEGEBEN.

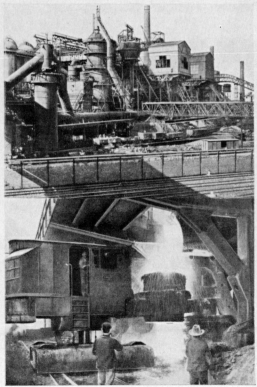

prospekt für die stadt dortmund. ifotomontagen. blick über die bahnanlagen. durch einen ausschnitt der signalbrücke erhält der gleispark eine viel größere tiefe, das auge wird konzentriert. es wird aber nicht krampfhaft versuchen, eine naturalistisch getreue übereinstimmung der signalbrücke mit dem gleisbild zu geben, sondern nur ein illusionistischer zusammenhang für das auge. das auge kontrolliert ja nie perspektivische richtigkeiten, sondern empfängt nur eindrücke der nähe, der ferne, der helligkeit, des dunkels, oben und unten, bewegung und ruhe, mannigfaltigkeit oder einfachheit.

29

max burchartz

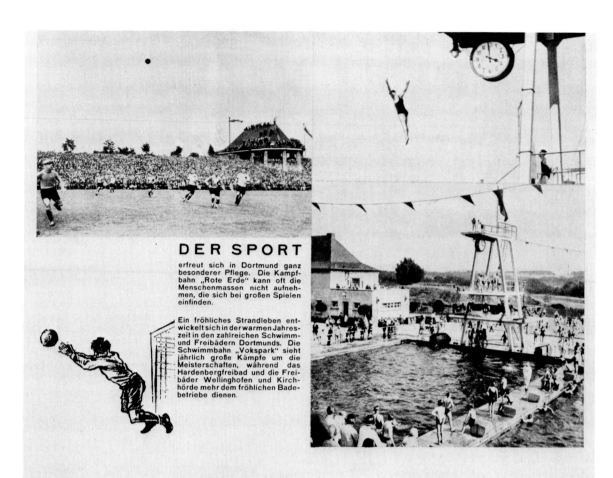

DER SPORT

erfreut sich in Dortmund ganz besonderer Pflege. Die Kampfbahn „Rote Erde" kann oft die Menschenmassen nicht aufnehmen, die sich bei großen Spielen einfinden.

Ein fröhliches Strandleben entwickelt sich in der warmen Jahreszeit in den zahlreichen Schwimm- und Freibädern Dortmunds. Die Schwimmbahn „Vokspark" sieht jährlich große Kämpfe um die Meisterschaften, während das Hardenbergfreibad und die Freibäder Wellinghofen und Kirchhörde mehr dem fröhlichen Badebetriebe dienen.

prospekt stadt dortmund. die bildzusammenstellungen des prospektes sind nur steigerungen der bildinhalte und der optischen bildwirkungen auf den beschauer, vergleiche den springer, der vom turm in das schwimmbassin zu springen scheint: einfach 2 verschiedene fotos aus dem gleichen bild übereinandergeklebt. Der gleiche effekt wie bei der fotomontage baumeister auf seite 22. in gleicher weise die rennpferde und die zuschauer auf der tribüne.

31

max burchartz

of labor productivity, technological efficiency, and even corporate organization—evoked enthusiasm among European emulators as 'a characteristic feature of American civilization.'"[6] Scientific management promised the elimination of scarcity through surplus productivity, and this vision of plenty was quickly incorporated into both right-wing authoritarian models for government and socialist dreams for a classless society and individual welfare.[7] In the Soviet Union, Lenin early endorsed Taylorism, claiming rationalized labor was not exploitative if workers themselves profited.[8] In Germany, liberals such as Walter Rathenau and Georg Bernhard were interested in applying rationalization to government supervision of capitalist industry—efficiently yet autocratically setting prices, allocating raw material, and so on. Ultimately this found its way into the 1919 Weimar constitution in a compromised form as an advisory board, the *Reichswirtschaftsrat* (Reich Economic Council).[9] During the period of economic stabilization (1923–28), German industry became occupied with reorganizing the productive process through installing assembly lines and using advertising to aim at a mass consumer market.

With rationalization of production bearing the stamp of both U.S. and Soviet practice, the representation of rationalized technology in German culture often avoided any explicit political identification and, instead, focused on the technical apparatus. In addition, divisions between workers and management were elided by the mythic creation of the celebrated engineer, an amalgam of labor and management: creator, producer, thinker, doer, above all— the efficient man.

Graphic designer and *ring* member Jan Tschichold introduces his influential 1928 book *Die Neue Typographie* by lauding the new man. He writes:

> ... the works of today, untainted by the past, primary shapes which identify the countenance of our time: Car Airplane Telephone Radio Neon New York! These objects have been created by a new kind of man: *the engineer!*
>
> This engineer is the creator of our time. To characterize his works: economy, precision, composition from pure, constructive forms whose shape corresponds to function. Nothing is more characteristic of our time then these witnesses to the inventive

[6] Charles S. Maier, "Between Taylorism and Technocracy: European ideologies and the vision of industrial productivity in the 1920s," *The Journal of Contemporary History* vol 5, no. 2 (1970): 27.

[7] For an examination of technological romanticism on the right, see Jeffrey Herf, *Reactionary Modernism: Technology, Culture, and Politics in Weimar and the Third Reich* (Cambridge: Cambridge University Press, 1984).

[8] Scientific management was an idea that took deep root in the Soviet Union and was abused in the First Five Year Plan, implemented in 1928, with its excessive production quotas. Judith A. Merkle, *Management and Ideology: The Legacy of the International Scientific Management Movement* (Berkeley: University of California Press, 1980), 121–24.

[9] Charles S. Maier, "Between Taylorism and Technocracy: European ideologies and the vision of industrial productivity in the 1920," *The Journal of Contemporary History* vol 5, no. 2 (1970): 51.

Max Burchartz
"Der Sport—Prospekt Fürdie Stadt Dortmund" (brochure for the city of Dortmund), in Heinz and Bodo Rasch, eds., *Gefesselter Blick*, (Stuttgart: Verlag Dr. Zaugg and Co., 1930) p. 31
Courtesy of Kunstbibliothek, Staatliche Museen, Preußischer Kulturbesitz, Berlin

page 42
Willi Baumeister
Heinz and Bodo Rasch, eds., cover for *Gefesselter Blick*, (Stuttgart: Verlag Dr. Zaugg and Co., 1930) 10 1/4 x 8 3/8"
Courtesy of the Haags Gemeentemuseum, Den Haag, The Netherlands

page 43
Max Burchartz
"6 Millionen Fahrkarten—Prospect für die Stadt Dortmund" (Six Million Tickets) (brochure for the city of Dortmund), in Heinz and Bodo Rasch, eds., *Gefesselter Blick*, (Stuttgart: Verlag Dr. Zaugg and Co., 1930) p. 29 10 1/4 x 8 3/8"
Collection of Elaine Lustig Cohen

genius of the engineer: Airport, Factory, Subway-car. These are standard forms: Typewriter, Lightbulb or Motorcycle.[10]

Tschichold, Weimar Germany's most well known promoter of New Typography, equates standardization and geometric form:

> The constructive building of engineer-works and standard products led, of necessity, to the use of exact geometric forms. The final and most pure form of a necessary item is always constructed of geometric shapes.[11]

Thus geometric form and grid composition in 1920s German graphics connoted such admiration of rationalization and technology, and a belief in the supreme importance of industry to society (almost irrespective of form of government). The focus on form paralleled the fascination with means of production and both, it seems, worked together to block discussion among cultural modernists about industrial ownership, labor practices, and profits. This elision is particularly striking—and with hindsight, curious—among those who were actually producing advertisements for industry.

Jan Tschichold offers an interesting case of such omissions and contradictions. The designer, who admired the Soviet revolution to the point of signing his 1920s work Ivan (or Iwan) Tschichold, and who was influenced formally by Russian Constructivism, could enthuse about the engineer and standardization and could analyze the formal aspects of modern design and new typography without asking the attendant sociological questions about the function of his own corporate advertising within capitalism.[12] However, the focus on form during the 1920s was not about willful ignorance or disinterest in social issues, but rather part of inflated hopes for the ability of new technology (as it functioned in industry) and the new man (as personified by the engineer) to provide a new, more equitable society.

Maier asserts that the balloon of these dreams was punctured by the harsh conditions of the worldwide Depression and that disillusionment with rationalization followed. But this cannot be seen in German Depression advertising. Quite the contrary—the claims became even more utopian, one could say grandiose, and the promotion of rationalization more strenuous.[13] And it is in this context

[10] Ihr stehen heute jene Werke gegenüber, die, unbelastet durch Vergangenheit, primäre Erscheinungen, das Antlitz unserer Zeit bestimmt haben: Auto Flugzeug Telephon Radio Warenhaus Lichtreklame New York! Diese neuen Menschentyp geschaffen worden: *Dem Ingenieur!*
Dieser Ingenieur ist der Gestalter unseres Zeitalters. Kennzeichnen seiner Werke: Ökonomie, Präzision, Bildung aus reinen, konstruktiven Formen, die der Funktion des Gegenstands entsprechen. Nichts, das bezeichnender für unsere Zeit wäre, als diese Zeugen des Erfindergeistes der Ingenieure, seien es Einzelleistungen: Flugplatz, Fabrikhalle, Triebwagen der Untergrund; seien es Standardformen: Schreibmaschine, Glühbirne oder Motorrad.
Jan Tschichold, *Die Neue Typografie* (1928) (Berlin: Brinkmann & Bose, 1987), 11.

[11] Der konstruktive Aufbau der Ingenieurwerke und Standardprodukte hat mit Notwendigkeit zum Gebrauch der exakten geometrischen Formen geführt. Die letzte und reinste Form eines Gebrauchsgegenstandes baut sich immer aus geometrischen Gebilden auf.
Jan Tschichold, *Die Neue Typografie* (1928) (Berlin: Brinkmann & Bose, 1987), 12.

[12] For biographical details, see Ruari McLean, *Jan Tschichold: Typographer* (Boston: David Godine, 1975), 35–37.

[13] Maud Lavin, "Ringl + Pit: The Representation of Women in German Advertising, 1929–33," *The Print Collector's Newsletter* vol. 16, no. 3 (July/August 1985), 89–93.

Jan Tschichold
Die Frau ohne Namen (The Woman without a Name) 1927
offset lithograph poster 48 3/4 x 34"
Collection of Merrill C. Berman

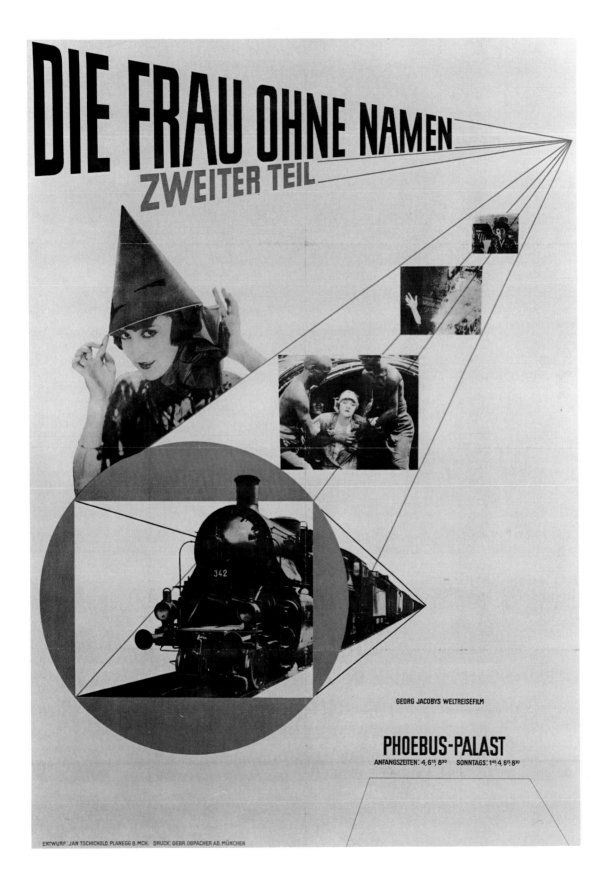

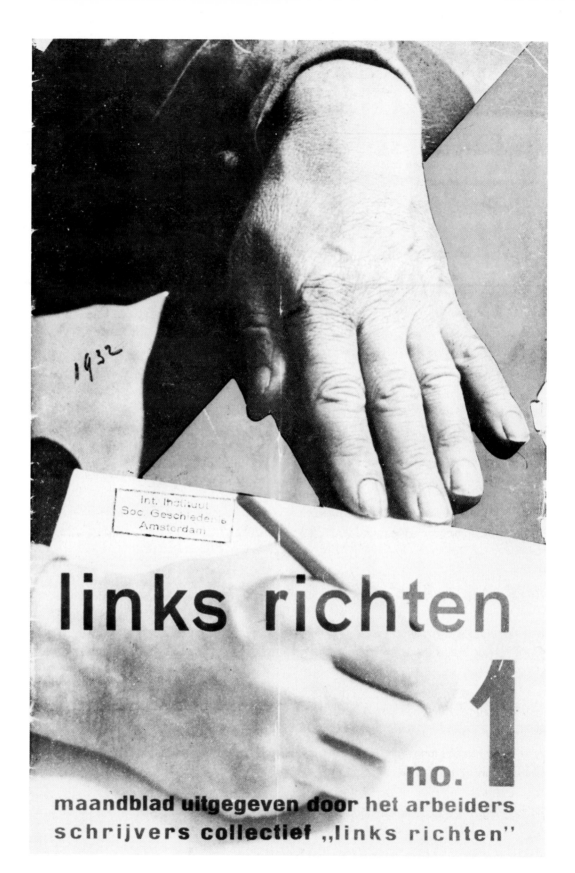

links richten

no. 1

maandblad uitgegeven door het arbeiders
schrijvers collectief „links richten"

that one should view the popularity of the *neue werbegestalter* designers with their industrial clients (be they producers of steel, communications, stationery, or storage tanks). The status of *ring* designers can be quickly conveyed by citing examples of high visibility clients such as Kurt Schwitters' client, the city of Stuttgart; Max Burchartz's Bochumer Verein steel works; César Domela's the city of Hamburg; Willi Baumeister's the cultural magazine *Der Querschnitt;* and Piet Zwart's the Dutch postal service. In addition to industrial and government clients, *NWG* designers were also frequently hired by museums, exhibition halls, and art book publishers. In the *neue werbegestalter* graphics that used images, the common style was to enclose photomontage within a Constructivist grid, thus eliciting—yet firmly and "scientifically" containing—the speed and blur of an experience of modernity, the everyday assimilation of modern urban and technological imagery.

In the work of the Dutch designers Paul Schuitema and Piet Zwart, one can see how apparently conflicting political practices are reconciled through a utopian belief in rationalized technology. Schuitema and Zwart's activism in left politics has been well documented by the Dutch scholar Flip Bool.[14] The two photographer/designers, both based in Rotterdam, were members of the Union of Worker Photography. Both documented workers' demonstrations and clashes between workers and police.[15] Schuitema designed new typography and photomontage covers for the periodicals *Links Richten* and *De Wapens Neder,* Zwart for leftist books such as *Wij slaven van Suriname* by the revolutionary Anton de Kom. In addition, Schuitema, wrote pseudonymously for *Links Richten*, most notably in his February, 1933, article "Photography as a weapon in class war."[16]

Oddly, Schuitema uses the same language—that of rationalization—both to promote the training of worker-photographers and to extol advertising for capitalist industry. A reading of this language illustrates his elision of the contradictions of his two practices. On worker-photography, he writes: "No romanticism, no art, rather *sachlich,* glaringly suggestive propaganda: aligned tactically with the class war, technically with the trade."[17] On advertising he writes in *Gefesselter Blick*: "Advertising should be: real, direct,

[14] Flip Bool, "Paul Schuitema und Piet Zwart: Die Neue Typografie und die Neue Fotografie im Dienste der Industrie und des politischen Kampfes," in *Avant Garde und Industrie,* ed. Stanislaus von Moos and Chris Smeenk (Delft: Delft University Press, 1983), 121–33.

[15] A contextual note about Dutch economics and politics in the 1920s: At this time, the Netherlands was a parliamentary democracy with a constitutional monarchy (as it still is today). Like Germany, it was undergoing modernization, but at a slower pace. Although in 1917 some labor reforms had been enacted such as the eight-hour workday, the fluctuating economy during the 1920s required continued labor vigilance and activism. The Netherlands was hard-hit by the Depression.

[16] S. Palsma, "Foto als wapen in de klassestrijk," *Links Richten* (Feb. 1933).

[17] As quoted and translated by Flip Bool in "Paul Schuitema und Piet Zwart: Die Neue Typografie und die Neue Fotografie im Dienste der Industrie und des politischen Kampfes" in *Avant Garde und Industrie,* ed. Stanislaus von Moos and Chris Smeenk (Delft: Delft University Press, 1983), 122: Keine Romantik, keine Kunst, sondern sachliche, grell suggestive Propaganda: Taktisch auf den Klassenkampf, technisch auf das Fach ausgerichtet.

Paul Schuitema
Workers' Demonstration c. 1932
vintage photograph 8 x10"
Courtesy of Prof. Dr. Piet Zwart, Jr.

Paul Schuitema
cover for *Links Richten,* no. 1, 1932
Private Collection

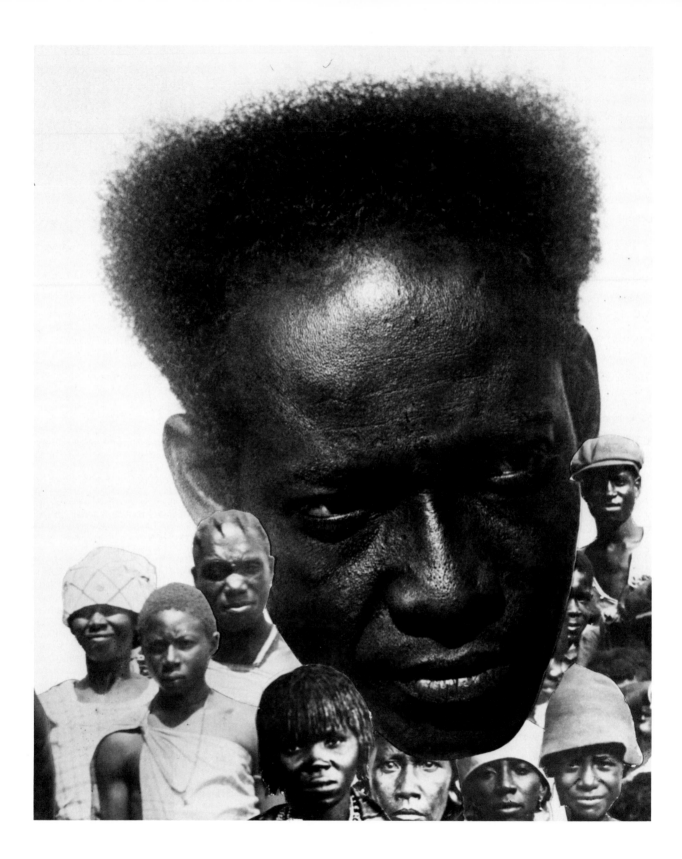

sachlich, competitive, argumentative, active, contemporary, functional, practical, and technical—not art, but rather reality!" He continues in what seems to be an effort to unify different kinds of propaganda: "Advertising is neither art nor design. ... It has no other purpose than to propagate man's material as well as spiritual production."[18]

What Schuitema's attitudes toward the workers' movement and toward industrial advertising had in common was that he considered the rationalized means of production to be progressive and the communication process to be a natural extension of factory production. That the factories were owned by capitalists and that advertising contributed to their profits was completely left out of his and other *ring* designers's writings. The focus of the discourse was on the means of modern mass communication, not on what was communicated. At the time, the only periodical in which these contradictions were pointed out was *Der Arbeiter-Fotograf* (The Worker-Photographer), in which the critic Alfred Kémeny protested the seemingly apolitical nature of advertising photomontages and labeled the images as "outright propaganda for the capitalist system."[19] Kémeny's article is one of a number in *Der Arbeiter-Fotograf* that sought to distinguish revolutionary photomontage, particularly John Heartfield's, from voguish photomontage in commercial advertising.

The close relationship Schuitema desired between his own designs and rationalized production can be illustrated by the artist's working method, which he attempted to make systematic, impersonal, and closely connected to mechanical production. In the Leiden University Print Cabinet, there are scrapbooks full of industrial photographs taken by Schuitema.[20] When he received an advertising commission from a company, as for example the scale manufacturer Toledo-Berkel, he would document as thoroughly as possible all steps of production using unpopulated shots of machinery. He would then select from among these photographs the raw material for his advertising photomontages. These were not New Vision photographs but rather straight, mid-range shots with a semblance of objectivity. The photomontages were to be a technical achievement, a modern filmic series of visual juxtapositions, not

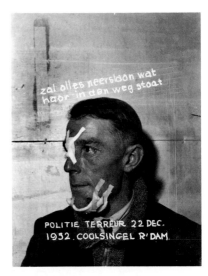

[18] As quoted in *Gefesselter Blick*, ed. Heinz and Bodo Rasch (Stuttgart: Verlag Dr. Zaugg & Co., 1930): ... reklame [sic] soll sein: reell, direkt, sachlich, konkurrenzfähig, argumentierend, aktiv, aktuell, funktionell, praktisch und technisch. keine Kunst, sondern Wirklichkeit! ... Reklame ist weder Kunst noch Gestaltung. ... sie hat kein andern Zweck als materielle sowie geistige Produktion des Menschen zu propagieren.

[19] Kémeny applies this criticism to a photomontage captioned "Hamburg, Germany's gate to the world." He does not name the artist who created the photomontage, but it was probably done by Domela who produced propaganda for the city of Hamburg. Alfred Kémeny wrote pseudonymously as Durus. Durus, "Fotomontage, Fotogramm," *Der Arbeiter-Fotograf* 5, no. 7 (1931): 166–68 in *Photography in the Modern Era*, ed. Christopher Phillips (New York: The Metropolitan Museum of Art/Aperture, 1989): 183.

[20] Leiden University Print Cabinet, Paul Schuitema Book 1: PS1–178.

Paul Schuitema
1932, *Opfer vom Polizeivorgehen gegen die Protestkundgebung von Arbeitsen in Rotterdam*, (Victims of Police Brutality Against the Protests of the Unemployed in Rotterdam) 22 December 1932
photograph 8 x 10"
Collection Prentenkabinet der Rijksuniveritat Leiden, Nederland

Piet Zwart
Umschlagentwurf für Anton de kom Wij slaven von Suriname 1934
photocollage 11 x 7 3/4"
Courtesy of the Haags Gemeentemuseum, Den Haag, The Netherlands

DIE GUTE REKLAME IST BILLIG.

Ein geringes Maß hochwertiger Reklame, die in jeder
Weise Qualität verrät, übersteigt an Wirkung eine vielfache
Menge ungeeigneter, ungeschickt organisierter Reklame.
<div align="right">Max Burchartz.</div>

MERZ

11

RED. MERZ, HANNOVER, WALDHAUSENSTR. 5ᴵᴵ.

TY PO

RE KLA ME

EINIGE THESEN ZUR GESTALTUNG DER REKLAME VON MAX BURCHARTZ:

Die Reklame ist die Handschrift des Unternehmers. Wie die Handschrift ihren Urheber, so verrät die Reklame Art, Kraft und
Fähigkeit einer Unternehmung. Das Maß der Leistungsfähigkeit, Qualitätspflege, Solidität, Energie und Großzügigkeit eines Unter-
nehmens spiegelt sich in Sachlichkeit, Klarheit, Form und Umfang seiner Reklame. Hochwertige Qualität der Ware ist erste Bedingung
des Erfolges. Die zweite: Geeignete Absatzorganisation; deren unentbehrlicher Faktor ist gute Reklame. Die gute Reklame verwendet
moderne Mittel. Wer reist heute in einer Kutsche? Gute Reklame bedient sich neuester zeitgemäßer Erfindungen als neuer Werk-
zeuge der Mitteilung. Wesentlich ist die Neuartigkeit der Formengebung. Abgeleierte banale Formen der Sprache und künstlerischen
Gestaltung müssen vermieden werden. Zitiert aus Gestaltung der Reklame, Bochum, Bongardstrasse 15.

K. SCHWITTERS.
Signetentwurf für Adolf
Rothenberg

DIE GUTE REKLAME

ist sachlich, ist klar und knapp, verwendet moderne Mittel, hat Schlagkraft der Form, ist billig.
<div align="right">MAX BURCHARTZ.</div>

WERBEN SIE BITTE FÜR MERZ. *Pelikan*-Nummer.

Merzrelief von Kurt Schwitters siehe Seite 91

personal expression.

Talking of artists's intentions and discussing their formal products are, of course, two separate and different analyses. Elsewhere I have written about the reified utopianism of Schwitters' designs with their adherence to the asymmetric block composition of International Constructivism and their representation of the future as an antiseptic version of the present.[21] To analyze the question of utopianism in conjunction with the *ring*'s formal designs, I use Ernst Bloch's definition of utopianism as "anticipatory consciousness," or traces (*Spuren*) found in the present that inspire images of a desired future, a sort of epistemological montage. In Bloch's terms, then, visual montage is an appropriate vehicle for representing utopianism since its juxtaposition of fragments allows for a blossoming of allegory—providing multiple jumping-off points in the present from which to imagine a better future.[22] Nevertheless, it could be argued that many of the montages of the *neue werbegestalter*, however imaginative and technically proficient they may be, are limited in the types of allegories they allow to flower: these images prompt fables of zeppelins, bridges, linoleum rolls, and machine parts. The viewing subject extrapolated from the many viewpoints is merely a rationalized viewer of narrowly defined modern scenes and goods.

At this point one might ask cynically if all the exhibiting, promoting, and fervent talk about the blessings of advertising on the part of the *ring* artists was not simply a desperate attempt to earn a living at commercial graphics during the worldwide Depression. This, after all, is how "traditional" art histories have described the involvement of a fine artist like Schwitters in commercial advertising. However, one has only to read the *ring* members' published statements and their letters to one another to realize how much more than money was at stake: these documents are evidence of a serious desire to contribute to mass culture, to sway it toward functionalism, rationality, and a glorifying of production. Within this essay, I want to develop a history of the *ring* and its colleagues that concentrates on these issues of intentionality, since they help to define the *neue werbegestalter* and to make sense of the group's undocu-

[21] Maud Lavin, "Advertising Utopia: Schwitters as Commercial Designer," *Art in America* vol. 73, no. 10 (Oct. 1985): 134–39, 169.

[22] Ernst Bloch, *The Utopian Function of Art and Literature*, trans. Jack Zipes and Frank Mecklenburg (Cambridge: MIT Press, 1988).

Kurt Schwitters
Merz 11, Typoreklame 1924
magazine cover
Courtesy of Ex Libris Gallery, New York

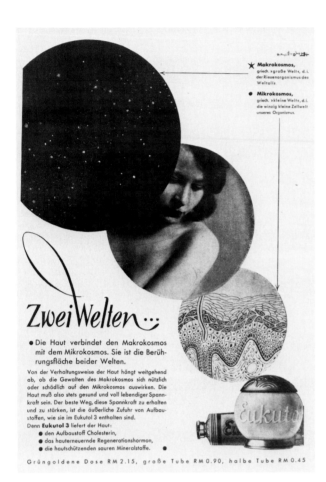

Designer unknown
"Zwei Welten . . ." (Two Worlds), advertisement for Eukotol Skin Cream in *Münchner Illustrierte Presse*, no. 5, 31 January 1932, p. 105.
14 1/2 x 10 3/4 x 2 2/5"
Courtesy of Institut für Zeitungsforschung Dortmund

mented primary sources. Most important, a greater insight into their self-definitions will bring us to a revised understanding of the term "historical avant-garde."

The belief system of the group as a whole can be quickly surveyed by analyzing their manifesto-like statements in the book *Gefesselter Blick*. There the ideal of rationalized production is applied to modern seeing; thus, the creation and viewing of photomontages is described as an intelligent assembling of parts to allow for a rational, efficient consumption. Walter Dexel writes that modern man has the right to expect communications in the shortest possible time. Willi Baumeister points out that photomontage is efficient, allowing for the quick grasp of several images at once. The Rasch brothers in their introduction cite rationalization as the paradigm for advertising. Dexel insists on creating clarity, not beauty. It seems ironic that in a search for rationality and clarity these designers should end up with photomontage and its kaleidoscopic imagery. Domela uses a travel analogy as well as a filmic one to describe his photomontages. Similarities between photomontage and film are often emphasized, with photomontage being considered a quicker, more efficient medium. Finally, the overriding message of the manifestos in *Gefesselter Blick* is the enthusiasm for advertising, new technology, and mass communication.

To consider the specific utopianism of the *neue werbegestalter* is to analyze a set of images that represent certain processes of modernization during the Weimar period. These are utopian representations of rationalization and its effects. Images closely tied to the factory (images of mass production, advanced technology, new possibilities of scale) are combined with other images meant to suggest the interiorization of rationalization in the viewer, or, simply put, man as machine. This, in turn, leads to new possibilities for perception. Yet, certain images common to Weimar consumer culture, those associated with women, are, for the most part, left out of *ring* images.

In the 1920s, mass culture, particularly film and advertising, was considered the province of women. In Germany, as in the United States, most advertising was aimed at women who, it was widely acknowledged, did most of the

purchasing of goods. Mass cultural products such as the illustrated newspapers that depended on consumer advertising were full of images of Weimar's New Woman, a multifaceted symbol of modernity. In general, much mass cultural imagery represented and/or was aimed at women. New Woman images often connoted gender ambiguity and the possibility of change in traditional gender roles. (In fact, the term "New Woman" was not just a symbolic one. The Weimar woman differed from her pre-World War I counterpart in that she now held the vote and probably had fewer children; in addition, she was more likely to be working for a wage, to have had an illegal abortion, to be married, to work in a pink collar position or in a newly rationalized industry, and to live in a city.)

But the New Woman is hardly evident in the advertising of the *neue werbegestalter*, which tends to focus on production and modes of perception, rather than on consumption. The *neue werbegestalter* graphics generally offer many of the familiar signs of modernity—the grid; photomontage; new typography; images of up-to-date, mass produced objects—but usually omit the ubiquitous image of the New Woman and, indeed, almost all images of people. The designers' intention—one paralleled by their clients' interests—was to promote technology and a rationalized modernity.[23] Their clients were primarily heavy industry like steel, or communications systems like the post office, and were not likely to include producers of clothes, food, personal hygiene items, or domestic goods.

The *ring*'s approach is a particularly masculinist approach to photomontage and mass culture, de-emphasizing ambiguity, identifying heavily with mechanical production, ignoring almost completely the feminine-gendered world of consumerism, and, not incidentally, accepting no women as members of the *ring*, not even Grete Leistikow who often worked collaboratively with her brother Hans, a member. While contemporaneous artists such as Hannah Höch used ambiguity in their photomontages to construct allegories and confound fixed notions of gender, and theorists such as Ernst Bloch stressed connections between montage, allegory, and ambiguity, the *neue werbegestalter* in their writings emphasized their desire for just the

[23] Today, designers have much less say in the content and style of advertising than did *ring "neue werbegestalter"* designers. It would be inappropriate, therefore, in any discussion of contemporary advertising to focus so much on the designers's intentions as I do in this essay; a cultural history project would be better informed by examining the corporate clients' desires. However, the *neue werbegestalter* were considered advertising artists. Their work was exhibited in museums. They seem to have had a great deal of say about the look and content of their commercial work, as evidenced in part by quite similar images produced for different clients.

opposite characteristic in their montages: clarity.

Within this masculinist frame of reference, how is clarity attributed to photomontage? Above all, this connection is established through analogies to science and technology. (Although some Weimar cultural representations like the film *Metropolis* show technology as *embodied* by woman, most often the *employment* of technology is gendered as masculine.) Clarity, for the *NWG*, is not reduction, but instead high quality production. It is offering a smorgasbord of modern imagery so that the viewer can assimilate it with sophisticated speed. Perhaps there is an unspoken desire for ambiguity as well; both Burchartz and Domela value the opportunity that photomontage offers to provide multiple viewpoints. Burchartz asserts that his works do not provide a controlled perspective but instead survey a rapid journey of urban impressions. However, these multiple viewpoints are contained and controlled by the compositional grid inspired by Constructivism and the stark legibility demanded by advertising, so the modernism of the *neue werbegestalter* did not so much suggest change and flexibility as it did a rigid and anesthetized version of the future, offering through advertising and mass communications a masculinist avant-garde utopia for the masses.

In conclusion, I want to use this understanding of the *ring* to consider and revise a current definition of the historical avant-garde. Peter Bürger, in his *Theory of the Avant-Garde*, defines the 1920s European avant-garde by contrasting it to a previous tradition of aestheticism.[24] He calls this aestheticism "modernism." However, by the 1920s, the term "modernism" was no longer restricted to meaning a hermetic aestheticism. Culturally, "modernism" could refer to earlier art-for-art's-sake movements; but, also, in Weimar Germany the term *Modernismus* had more powerful connotations due to its association with the words *moderne* (modern, contemporary, fashionable) and *Modernität* (modernity, the experience of modernization). Although *Modernismus* could refer to an art movement such as Expressionism, it had a double use; it could also mean the culture of contemporary life and the experience of technology, electricity, urbanism, speed, mass media, and consumerism. For our purposes in considering the relationship

[24] Peter Bürger, *Theory of the Avant-Garde*, trans. Michael Shaw (Minneapolis: University of Minnesota Press, 1984).

César Domela
cover for *Fotomontage* Berlin, 1931
exhibition catalogue 9 1/2 x 6 1/5"
Collection of Flip Bool

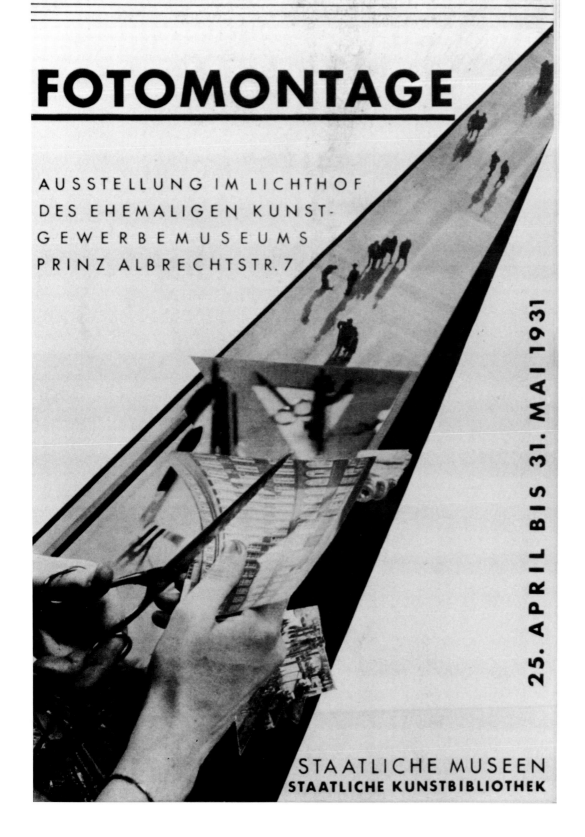

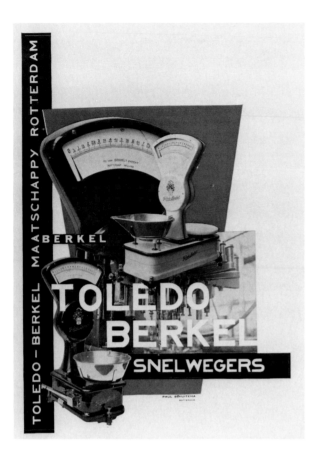

Paul Schuitema
"Proefdruk adresboek, Toledo-Berkel Mij,"
in series of advertisements for *Berkel*, p. 293
undated
bookprint 9 1/2 x 6 1/5"
Courtesy of Haags Gemeentemuseum,
Den Haag, The Netherlands

between artists and mass culture, the multiple use of the term is significant.

As literary critics Andreas Huyssen and David Bathrick have argued, Bürger's theory "represses the largest truth about modernism itself—namely ... the heterogeneity of its response to the maelstrom of modernization."[25] Still, Bürger is correct when he contrasts an avant-garde group like Berlin Dada with earlier aesthetic movements; or to be more precise, Burger's definition echoes their intentions. The avant-garde's goal, Bürger claims, was to rebel against the institutionalization of art in order to re-engage art with life. Applying his definition to German culture, one finds that it functions as an apt, if incomplete, description of Berlin Dada with the latter's emphasis on provocative photomontage, anarchic performance, inclusive exhibitions, and political publications. However, Berlin Dada was a short-lived moment in the formation of the German avant-garde. The movement was completely over by 1922, and the burning issue for the German avant-garde from 1922 until Hitler's seizure of power in 1933 was not at all a rebellion against art institutions, but rather a serious and prolonged engagement with mass culture. This engagement was inspired in part by the practices of the much-admired Russian Constructivists. Photobooks, photographs for illustrated newspapers, trade-fair-like exhibitions, commercial design, book design, film—all these were not sidelines for the avant-garde but primary objects of production. And in this the artists of the *ring "neue werbegestalter"* are emblematic.

To exclude this involvement with mass communications from art history, as has been common practice, is to create a history in which artists and intellectuals are sequestered from the majority of society—from societal evolution, discourse, and change. It is, as in Kurt Schwitters's case, to mask an elaborate engagement with mass culture as merely a function of personal finances. To write such a repressed history is to suggest that artists have been and should be restricted to producing only for one another and in reaction to one another. Such isolation was not the condition of a 1920s avant-garde deeply occupied with mass cultural production. Nor need isolation from mass culture and its societal issues be a scholarly or artistic condition

today. Connotatively, *ring "neue werbegestalter"* images evoke a political admixture of capitalism and socialism, promote a technological romanticism, often convey a corporate identity, and imply a masculine experience. The historical avant-garde of which they were a part, then, should be understood not solely in terms of politically heroic figures such as John Heartfield. Instead, a more nuanced cultural history is called for, one that recognizes that these and other 1920s artists endeavored for ideological and financial reasons to reach a mass audience and to participate fully in modern means of communication. To focus as a cultural historian on the political and formal ambiguities of their project is to open the door to a fuller understanding of the historical avant-garde's contemporary legacy, encompassing as it does extremely diverse utopias and images. Contemporary marriages of artists' and design projects are quite disparate and can be analyzed not reductively in terms of adding to the canon of artistic heroes, but in terms of large cultural and sociological issues—the functions and efficacy of the graphics. Consider the different audiences and different means of presentation of feminist artists from the last decade, such as Barbara Kruger, who have employed mass media images to explore issues of identity and address; of media-wise activist graphics such as the AIDS images of Gran Fury, which are so effective at reaching a mass audience; and of the rationalized corporate identity programs that so flood our culture, such as Chermayeff/ Geismar's anesthetized graphics for Mobil Corporation. Unlike elitist art histories that, when they address mass culture at all, focus narrowly on fine artists who take their "inspiration" from mass culture, I would like to direct cultural criticism to these areas where the intersection of art and mass culture carries with it issues of societal urgency and engagement.

[25] Andreas Huyssen and David Bathrick, "Modernism and the Experience of Modernity," in *Modernity and the Text: Revisions of German Modernism*, ed. Andreas Huyssen and David Bathrick (New York: Columbia University Press, 1989), 8.

A writer and cultural historian, Maud Lavin is the author of *Cut with the Kitchen Knife: The Weimar Photomontages of Hannah Höch*, forthcoming from Yale University Press.

The Wings of Hypothesis

ON MONTAGE AND THE THEORY OF THE INTERVAL

Annette Michelson

The eye must learn from reason. — Johannes Kepler

Within the corpus of montage theory in the period now termed "classical" there is inscribed a grand floating signifier known as The Theory of the Interval. Shadowy, ambiguous, quite generally unexplored within the literature of historical and theoretical analysis, it nevertheless bears, as such ambiguous constructs often will, the connotation of a certain privileged status. Any attempt at clarification must first abandon the notion of a unified construct, however subtle or complex. Rather, we must acknowledge it as volatile and polysemic. Encountering it primarily in the theoretical writings of Eisenstein [1] and Vertov [2], we can reconstruct two distinct, if overlapping models for its elaboration. In so doing, we may locate the line that separates these two representatives of the post-revolutionary film in the Soviet Union in both theory and practice. Their celebrated opposition may then be seen as more than a struggle for dominance, a battle of persons, factions or genres (those of fiction and of documentary film); we come to understand the opposition as grounded in and determined by, differing meta-theo-

[1] Eisenstein introduced the concept of the interval in "A Dialectic Approach to Film Form." He wrote: "I also regard the inception of new concepts and viewpoints in the conflict between customary conception and particular representation as synamic- as a dynamization of the 'traditional view' into a new one. *The quantity of interval determines the pressure of the tension.* (See in music, for example, the concept of intervals. There can be cases where the distance of separation is so wide that it leads to a break—to a collapse of the homogeneous concept of art. For instance, the 'inaudibility' of certain intervals.) *The spatial form of this dynamism is expression. The phases of tension: rhythm.* This is true for every art form, and, indeed, for every kind of expression." Sergei Eisenstein, *Film Form: Essays in Film Theory*, ed. and trans. by Jay Leyda, (New York: Harcourt Brace and World, 1949), p. 47.

[2] The theory of the interval, which was to be more elaborately and explicitly developed by Dziga Vertov, is announced in the early text, *We: Variant of a Manifesto*, as follows: "*Intervals* (the transition from one movement to another) are the material, the elements of the art of movement, and by no means the movements themselves. It is they (the intervals) which draw the movement to a kinetic resolution." Dziga Vertov, *Kino-Eye: The Writings of Dziga Vertov*, ed. by Annette Michelson, trans. by Kevin O'Brien (Berkeley: University of California Press, 1984), p. 8.

retical models. And this requires a prior understanding of the period in which the work of montage theory evolved (roughly between 1924 and 1930) as singular within the medium's history.

Following the first World War and the Bolshevik Revolution, the reorganization and consolidation of the film industries within the European and Soviet economies acted as a powerful stimulus to theoretical production. This was the period in which the film-maker, recruited largely from the intelligentsia of the European bourgeoisie, assumed the burden of legitimizing the cinematic project. In France, Jean Epstein and Louis Delluc; in England, the writers and film-makers grouped about the journal *Close-Up*; in Holland, Joris Ivens; in Germany, Hans Richter and Bela Balasz; and in the Soviet Union the representatives of the immediately post-revolutionary period, worked toward constructing a theory of cinematic practice.

This work, involving differences of method, was driven and sustained by an underlying hypothesis and by an aim, both generally shared. That western man now disposed of a new and powerful cognitive instrument which gave him access to a clearer and fuller understanding of existence in the world: such was the general hypothesis. For Jean Epstein, the world was that of spatio-temporality, the categories of knowledge; for the British it was, in large part, that of the human psyche within the social formation; for the Dutch and Soviets, it was that of historical process.

The general aim was no less than the transformation of the human condition through a cinematic intensification of cognitive accuracy, analytic precision, and epistemological certitude. Such were the promise and the burden of what came to be termed in Eisenstein's phrase, "intellectual cinema," and its effective agent was that of montage. It is within this period of intensive effort, speculation and anticipation, within this climate of a general epistemological euphoria, that the notion of the interval appears as an advanced stage in the theorization of montage technique.

It was then, as well, that the major theoretical systems of modernity became the focus of cinematic projects. Marxism, psychoanalysis, and the general theory of relativity were concretely considered for cinematic articulation. There

is, in fact, a sense in which we may view an important segment of subsequent film history as that of "intellectual cinema" and its vicissitudes. My present focal point is the unexplored area of this theoretical triad: the project of the filmic exposition of Einsteinian thought.

Intellectual cinema, Eisenstein asserts, is at the center of his enterprise. Indeed, his production is inflected by the telos of a cinema whose analytic powers could serve Marxism; the rhythms of his montage patterns offer a visual *ostinato* constructed as a rehearsal of the dialectic. The *locus classicus* of Eisenstein's "intellectual cinema" is the celebrated sequence of *October* (1929), known as *For God and Country*, which dramatizes Kornilov's march on Petrograd.[3]

Eisenstein's own description of the sequence begins by stressing its cognitive function—the presentation of premises for spectatorial deduction.

> Maintaining the denotation of "God," the images increasingly disagree with our concept of God, inevitably leading to individual conclusions about the true nature of all deities...a chain of images attempted to achieve a purely intellectual resolution, resulting from a conflict between a preconception and a gradual discrediting of it in purposeful steps.
>
> Step by step...power is accumulated behind a process that can be formally identified with that of a logical deduction. The decision to release these ideas, as well as the method used, is already intellectually conceived. The conventional descriptive form for film leads to the formal possibility of a kind of filmic reasoning. While the conventional film directs emotions, this suggests an opportunity to encourage and direct the whole thought process as well.[4]

And later, citing Marx: "Not only the result , but the road to it is also part of the truth. The investigation of truth must itself be true, true investigation is unfolded truth, the disjunct members of which unite in the result."[5]

Furthermore,

> the strength of montage resides in this, that it involves the creative process, the emotions and mind of the spectator. The spectator is compelled to proceed along that selfsame creative path that the author traveled in creating the image (idea). The spectator not only sees the represented elements of the finished work, but also experiences the dynamic process of the emer-

[3] For a detailed analysis of the deductive structure of this sequence, see Noel Carroll, "For God and Country," *Artforum*, January, 1973.

[4] Eisenstein, "A Dialectic Approach to Film Form," in *Film Form: Essays in Film Theory*, p. 62.

[5] Eisenstein, "Word and Image," in *The Film Sense*, ed. and trans. by Jay Leyda (New York:1942), p. 32. Eisenstein is quoting Marx. Leyda gives the following source: *Bemerkungen über die neueste preussische Zensurinstruktion*, Von ein Rheinlander. In Karl Marx, *Werke und Schriften. Bis Anfang 1844, nebst Briefen und Dokumenten*. Berlin, Marx-Engels Gesamtausgabe. Section 1, Vol. 1, semi-volume 1.

gence and assembly of the image (idea) just as it was experienced by the author.[6]

This aim was to find its ultimate articulation in Eisenstein's plan for a film "version" of *Capital*.[7] If, however, any member of the revolutionary generation can be said to have produced a full filmic articulation of a Marxist text, it was Vertov in the production that stands as the summa of the silent cinema, *The Man with the Movie Camera* (1929). When closely analyzed, it presents in astonishing detail a contemporary reading of *The German Ideology*.[8] *Capital*, later joined by Joyce's *Ulysses*, was nevertheless to remain one of the two utopian projects which define the limits of Eisenstein's enterprise.[9]

The fate of psychoanalysis in the cinema was, of course, to be radically different. Its vulgarization throughout Hollywood production of the past four decades provides, perhaps, the surest confirmation of Freud's intimation, expressed while on his way to the Conference of 1908 at Clark University, that he and his colleagues were bringing the "plague" to the new world. The early attempts at psychoanalytically inspired film, which resulted in the production of Pabst's *Geheimniss einer seele*, have been abundantly documented by recent scholarship.[10] The published correspondence between Freud and Karl Abraham regarding the project initially proposed by Goldwyn demonstrates Freud's distaste for the project. This distaste is marked by his insistence that the cinema is ill-suited for the projection of "abstract ideas," such as those of psychoanalytic theory, to a general public.[11]

Nevertheless, upon reflection, we can discern a congruence of cinema's epistemological euphoria with the fascination exerted by the analytic systemics of Freud, Marx and Einstein. Although Benjamin had thought cinema capable of introducing "the psychoanalysis of optics,"[12] and for Eisenstein, Marx had provided, as it were, the text for the articulation of cinema's cognitive potential, it was, perhaps, in the fascination with the Theory of Relativity that we may locate their most intimate link, the ground of that euphoria.

In his Tarner Lectures of 1956, Erwin Schrödinger attempted to account for the intensity of interest and attraction that the theory of relativity awakened in both the general

[6] Ibid.

[7] Eisenstein, "Notes for a Film of 'Capital'," *October* No. 2, Summer 1976, pp. 3–26. For a discusion of this text, see Annette Michelson, "Reading Eisenstein Reading 'Capital'," *October* No. 2, Summer 1976, pp. 27–38 and *October* No. 3, Spring 1977, pp. 82–88.

[8] An analysis of Vertov's filmic articulation of *The German Ideology* is offered in my introduction to *Kino-Eye: The Writings of Dziga Vertov*. See especially pp. xxxv–xl.

[9] For a discussion of this project, see Annette Michelson, "Reading Eisenstein Reading 'Ulysses': The Claims of Subjectivity," *Art and Text*, Spring 1989, pp. 64–77.

[10] A detailed account of this project is presented by Patrick Lacoste in *L'étrange cas du Professeur M.: Psychanalyse à l'ecran* (Paris: Editions Gallimard, 1990), pp. 9–128.

[11] This project is discussed in *A Psycho-Analytic Dialogue: The Letters of Freud and Abraham, 1907–1926* (New York: 1962), pp. 382–85, 388–89 and 392.

[12] Walter Benjamin, "The Work of Art in the Art of Mechanical Reproduction," in *Illuminations: Essays and Reflections*, ed. with an introduction by Hannah Arendt (New York: Schocken Books, 1969), p. 237.

public and in philosophers. He emphasized its spatio-temporal transformations. The theory

> meant the dethronement of time as a rigid tyrant imposed on us from outside, *a liberation from the unbreakable rule of "before and after"* (italics mine). "For indeed time is our most severe master by ostensibly restricting the existence of each of us to narrow limits—seventy or eighty years, as the Pentateuch has it. To be allowed to play about with such a master's programme believed unassailable until then, to play about with it albeit in a small way, seems to be a great relief, it seems to encourage the thought that the whole "timetable" is probably not quite as serious as it appears at first sight.[13]

And Schrödinger concluded by remarking that "this thought is a religious thought, nay I should call it *the* religious thought."[14]

One wants, upon reflection, to say that the theory consoled and, in part at least, reaffirmed a sovereignty that had had, as we know, to withstand the blows to human narcissism inflicted by Galilean, Darwinian and Freudian thought. One might further claim that this sovereignty was nowhere more powerfully or more immediately expressed than in the filmmaker's ludic reinvention of spatio-temporality at the editing table. The manner in which film's elementary optical processes produced, through the use of acceleration, deceleration, freeze-frame and reverse motion, the visible suspension of causal relations within the phenomenal world gave hope that the cinema could be the articulate medium of the master theoretical systems of modernity: of psychoanalysis, historical materialism, Einsteinian physics.

Although, in the late 1920s, psychoanalysis and Marxism were to find their first, faltering articulation in the work of Pabst and Eisenstein, the Theory of Relativity had preceded them. For it was in 1923, on his return to Berlin from his first tour of America, that Einstein discovered that a film had indeed been produced.

> Made by a Professor Nicolai and a Herr Kornbaum, it consisted of four parts. The first showed the familiar experiment of an object falling first from a car in motion and then from a car in rest; the second, the contradictions met within the accepted theory of light. The third part tried to show how relativity solved

[13] Quoted in Ronald Clark, *Einstein, the Life and Times* (New York: Avon Books, 1971), pp. 309–10.

[14] Clark, p. 310.

[15] Clark, p. 357–358.

[16] Clark, p. 358.

[17] Morris R. Cohen, "Einstein in the Movies: A Note on the Exposition in the Films of the Theory of Relativity," *Vanity Fair*, August, 1923, pp. 48 and 96.

[18] Ibid.

[19] Ibid.

[20] Ibid.

[21] Ibid.

these problems in terms of space and time, while the last dealt with the deflection of starlight revealed by the British expedition of 1919.[15]

Ronald Clark concludes that "the film was ingenious, but it took for granted that the audience had a working knowledge of physics, and thus failed to achieve a complete success in a complicated problem."[16]

Morris Raphael Cohen, the distinguished philosopher who had translated Einstein's lectures at the City College of New York was commissioned by *Vanity Fair* to review the film. His account opens with words that recall those of Freud, for the mere idea of putting Einstein's theory into film had struck Cohen as "indecorous."[17] Impelled by his eleven-year-old son's delight in the film to see it for himself, Cohen then discovered "how much more suitable moving pictures are than mere words or fixed diagrams to represent physical happenings. The linearity of print, the two-dimensionality of diagrams are enhanced by the temporality of the medium which thus affords a more adequate representation of actual physical events."[18]

Cohen then makes clear that it is impossible to explain to those who do not understand the old Newtonian principle of relativity the way in which Einstein has modified and extended this principle. And he warns that "so many popular accounts of the theory of relativity speak of how the phenomena appear to different observers that it is natural to fall into the error that the theory is concerned with the way phenomena merely appear, as distinct from the way in which they actually occur. This is a natural but by no means justifiable error."[19] The logician continues: "The theory of relativity has nothing whatever to do with the deception of our senses (indeed our senses never do really deceive us; it is only false inferences that can mislead us.)"[20]

It is the possibility of a "new vision , of enlargement, of our freeing and liberation from the prisonhouse of the humdrum actual, and the exhilaration of that liberation."[21] that accounts for the generalized interest of the public in the Theory of Relativity and that accounts, as well, for the interest generated by this particular film.

This enthusiasm, this sense of liberation, shared by artists and intellectuals, informs the rhetoric of both Eisenstein

and Vertov; both refer to what had become the widespread, if somewhat cavalier, invocation of the Theory and of the fourth dimension. And it is within this framework that the notion of the "interval" makes its appearance. It is, however, important that we understand the differences of models and of paradigms at work within their respective formulations. Most succinctly put, it is the difference between those of music and of mathematics.

II

For Eisentein , the notion of the interval crystallizes in 1928–29 in connection with this work on *The General Line*, a filmic celebration of the First Five Year plan for agriculture. Its filming was interrupted by the tenth anniversary commission of the film *October*, and resumed on June 10, 1929. Finally completed after additional interruption and critical reorientation from Stalin, the film was retitled *Old and New* in February 1929, just before Eisenstein's departure to Berlin and a three-year journey to points west. The purpose of that journey was, as we know, the investigation of the new sound recording techniques then being introduced in the American film industry. The famous manifesto on sound, issued as a warning against further theatricalisation on film form, written presumably by Eisenstein and signed by Pudovkin and Alexandrov had been published in July, 1928.[22] In the outline of a second score for *The General Line* dated 17 August, 1929, Eisenstein enumerated the possibilities to be developed within the manifesto's program.

We must see, then, the production of *The General Line* as pivotal in the Eisenteinian oeuvre. It is elaborated with a sense of the imminence of sound and generating the perspective of a polyphonic montage for the future sound cinema. Discussing what he characterizes as *The Fourth Dimension in Cinema* (1929), Eisenstein claims *The Genral Line* as a work that is heterodox in its editing, and he distinguishes this from past work in that it is constructed "not only of individual dominants, but of the sum of all stimuli." That which he terms "an aristocracy of ambiguous dominants" has been replaced by "the method of democratically equal rights for all stimulants, viewed together as a complex."[23]

The political metaphor, subsequently expropriated by

[22] Sergei Eisenstein, Vsevolod Pudovkin and Grigori Alexandrov, "Statement," in *Film Form: Essays in Film Theory*, pp. 257–259.

[23] Sergei Eisenstein, "The Filmic Fourth Dimension," in *Film Form: Essays in Film Theory*, p. 66.

Bazin in his critique of Eisensteinian montage in the name of an hypostatisation of spectatorial position as existential choice grounded in the cinema of deep focus and of long shot/long take, is soon abandoned. Eisenstein moves quickly from the rhetoric of political theory to that of music, and it is within the latter framework that his constructs of "overtonal" montage and of the "interval" then emerge. They would seem to derive from a somewhat uncertain grasp of what he terms "contemporary music"—that of Scriabin and of Debussy (as opposed to that of his actual contemporaries, such as Stravinsky or the members of the Second Viennese School). It is now that a musical terminology and a musicalist rhetoric began to invade the Eisensteinian discourse on the *visual* parameter. This is stimulated, no doubt, by a sense of the imminence of sound film production. If the notion of the *gesamtkunstwerk* had, from the first, animated the Eisensteinian aesthetic, music now provides the model for both theory and practice. Eisenstein now elaborates a theory of "polyphonic" montage as "fusion," a principle that commands the construction of the several visual themes within any given sequence of *The General Line*. This polyphonic fusion and its intervallic structure are most explicitly instantiated by the celebrated procession sequence of the film.

It is now, too, that Eisenstein's incessant refining, extension, and radicalization of his major theoretical constructs produce the multiplicity of montage modes: metric, intellectual and overtonal. For as an increasing number of parameters are integrated into the totalising montage principle, the notions of interval and overtone come to represent an ultimate of montage. It is then that Eisenstein declares that he has detected "the sharply defined scope of this particular mode of montage in *The General Line* ..." As he examined the sequence of the procession on the editing table, he found himself confronting a novel and puzzling situation: compositional criteria derived from prior working experience seemed unable to determine the new patterns, and seen statically on the table,

> The criteria for their assembly and their intervallic determination appear to be outside formally normal cinematographic criteria.

And here we observed one further curious parallel between the visual and musical overtone; it cannot be traced in the static frame, just as it cannot be traced in the musical score. Both emerge as genuine values only in the dynamics of the musical or cinematographic process.[24]

The overtonal conflicts (*conflict* is a term preserved from his insistent attempt to define composition as a rehearsal of the dialectic) emerge only in projection. And "the visual overtone is proved to be an actual piece, an actual element of a fourth dimension!"

As I have elsewhere argued, this musicalist discourse, this metaphorical reading by Eisenstein of interval and overtone has its source in the musical aesthetic of Russian Symbolism as epitomized in the work of Scriabin and disseminated through the writings of Scriabin's principal exegete, Sabaneiev.[25] Close investigation of Eisenstein's theoretical work as it develops thenceforth reveals him as other than the unambiguously constructivist innovator whose profile dominates Eisensteinian scholarship; rather, one comes to understand Eisenstein as deeply implicated in the tradition of symbolist aesthetics as they had developed in the pre-revolutionary era.[26]

Eisenstein is, however, intent upon examining both function and range of this musically conceived notion of the interval. "There can," he says, "be cases where the distance of separation is so wide that it leads to a break—to a collapse of the homogeneous concept of art." For instance "the inaudibility of certain intervals."[27] It is this reticence with respect to the revision of interval classes achieved in contemporary atonal and serial composition which appears to have restricted Eisenstein's musical references and musicalist discourse within the framework of tonality. He then concludes: "For these intervals, for this new musical overtone... it is not strictly fitting to say: I hear. Nor for the visual overtone: I see. For both a new formula must enter our vocabulary: I feel."[28] It is in this opening of percept to affect that Eisenstein perceives the promise of what he calls—very loosely, indeed—a *Filmic Fourth Dimension*. It is in that opening as well that we may situate the origin of the epistemological break which structures his *oeuvre*, both in theory and in practice.

[24] Sergei Eisenstein, "The Filmic Fourth Dimension," p. 69.

[25] Annette Michelson, "Reading Eisenstein Reading 'Ulysses'," pp. 64–77.

[26] Ibid., pp. 69–72.

[27] Sergei Eisenstein, "A Dialectic Approach to Film Form," p. 47.

[28] Sergei Eisenstein, "The Fourth Dimension in Cinema," in *Eisenstein: Writings 1922–1934*, ed. and trans. by Richard Taylor (London: B.F.I. Publishing, 1988), p. 186. This quotation is derived from the alternate, more recent edition of writings by Eisenstein, which includes a translation of the text translated by Leyda as "The Filmic Fourth Dimension."

Investigation of the history of n-dimensional thought in Russia, as presented in Linda Henderson's careful study of the subject [29], reveals a distinct popular interest that pre-dates both the revolution and the introduction into popular consciousness of the theory of relativity.

In 1893, Alexander Vasiliev had organized at Kazan a centennial celebration of Lobachevsky's birth and published a volume of translations of earlier work on non-Euclidean geometry.[30] These publications stimulated articles in the popular press, eventually introducing into Russia the spatial relativism that had developed in Western Europe during the late nineteenth century. Among the artists of Eisenstein's generation, the poet Khlebnikov, trained as a mathematician, was probably the best informed as to the theoretical premises and implications of non-Euclidean geometry. However, a certain tradition of what has been termed "hyperspace philosophy" had found popular expression in 19th century science fiction, followed by a partial integration into theosophy and through the widely disseminated and influential work of Uspensky, whose *Tertium Organum* and *The Fourth Dimension* were published in the first decade of the 20th century. As the inheritors of a tradition of platonic idealism, the proponents of hyperspace philosophy joined their firm belief in the reality of a fourth dimension of space to an intransigent opposition to any form of positivism that required empirical proof of its existence. They are described as largely unconcerned, in Russia, with the innovations of non-Euclidean geometry; rather, they saw it as an answer to the evils of positivism and materialism. Salvation lay in the development of human powers of intuition, thus enabling the perception of the fourth dimension of the world and of a true reality.

If the theosophists saw n-dimensional thought as the gateway to a "higher" plane of being, Khlebnikov viewed the figure of Lobachevsky as a kindred spirit (and described himself in a poem dedicated to the Cossack Hero Stepan Razin as "a Razin with the banner of Lobachevsky.") He saw the varieties of non-Euclidean geometry in general as symbolic of freedom from the constraints and dictates of the past.

[29] Linda Dalrymple Henderson, *The Fourth Dimension and Non-Euclidean Geometry in Modern Art* (Princeton: Princeton University Press, 1983). See especially Chapter Five, "Transcending the Present: The Fourth Dimension in the Philosophy of Uspensky and in Russian Futurism and Suprematism," pp. 238–299 passim.

[30] Henderson, p. 242.

Vasiliev had seen non-Euclidean geometry as the root of the contemporary revolution in ideas about space and about the possible curvature or multidimensionality of space, but he associated Relativity Theory primarily with the issue of time. "However one reacts to the futuro-scientific theories of Eisenstein and Minkowsky," Vasiliev stated in his introduction to *New Ideas in Mathematics*, "it is clear that it is no longer possible to ignore it (The Theory of Relativity) in an examination of the question of time and to be satisfied with old modes of thought."[31] References to non-Euclidean geometry are far outnumbered by the uses of the term "the fourth dimension" in the period prior to the October Revolution. Eisenstein's allusion to the fourth dimension and his euphoric evocation of the prospect of a "fifth dimension" convey, in their characteristic expansiveness, something of the vagueness, the unconcern with both premises and empirical evidence that derive from the tradition of the hyperspace mythos and its central place in symbolist metaphysics.[32]

The case with respect to Vertov is quite other. We note, first of all, the resolutely anti-humanist context in which the interval appears in the very earliest of his important texts, *We: Variant of a Manifesto*, published in 1922. This text initiates Vertov's sustained celebration of the machine and its supra-human power and precision; its synthetic and analytic powers which, as he puts it, "inspire shame" at human error. "Electricity's unerring ways are far more exciting to us than the disorderly haste of active men and the corrupting inertia of passive ones. Saws dancing at a sawmill convey to us a joy more intimate and intelligible than that on human dance floors." Vertov then announces, with a characteristically provocative and categorical bravado, "We thus temporarily at least exclude man as a subject for film."[33] He proposes, instead, the "geometrical extract of movement through an exciting succession of images."[34]

Kinochestvo (cinematicity) is, then, "the art of organizing the necessary movements of objects in space as a rhythmical artistic whole, in harmony with the properties of the material and the internal rhythm of each object."[35]

Intervals, which Vertov specifies as "the transition from one movement to another," are the elements of the art of

[31] Henderson, p. 243.

[32] Sergei Eisenstein, "The Filmic Fourth Dimension," p. 70.

[33] Dziga Vertov, *Kino-Eye: The Writings of Dziga Vertov*, p. 7.

[34] Vertov, p. 8.

[35] Vertov, p. 8.

movement and—this is stressed—they are by no means the movements themselves.[36]

> It is they (the intervals) which draw the movement to a kinetic resolution. The organization of movement is the organization of the elements or its intervals into phrases... A composition is made of phrases, just as a phrase is made of intervals of movement.[37]

Cinema is, as well,

> the art of inventing of things in space in response to the demands of science; it embodies the inventor's dream—be he the scholar, artist engineer or carpenter; it is the realization by *kinochestvo* of that which cannot be realized in life.
>
> Drawings in motion, Blueprints in motion. PLANS for the future. *The theory of relativity on the screen.* (Italics mine.)
>
> We greet the ordered fantasy of movement.
>
> Our eyes, spinning like propellers, take off into the future on the wings of hypothesis.[38]

In addition to the anti-humanist tenor, we note that this text (unlike that of Eisenstein, which was written at the end of his production in the silent era) appears at the very beginning of Vertov's mature production, and that the interval is evoked as a response to the demands of scientific method. Vertov's program, despite significant differences, was conceived and proclaimed in a manner not wholly unrelated to Eisenstein's extension of the notion of montage. It involves, however, a *displacement* of the principle of montage, which now governs not only the editing of all the visual parameters of the film text, but becomes the operative compositional principle invoked at every level or stage of the labour process. Vertov, as constructivist, with his unqualified and militant promotion of a rationalized cinema, redefines montage as the conception of the theme, as empirical observation in preparation of the given theme, as the selection of observed phenomena, as the scouting for location shooting, as the shooting process itself, as the inspection of rushes, as the work at the editing table. All represent stages of montage. Montage is a process now expanded well beyond the work at the editing table, no longer restricted to the composition of the image (or later to the sound track), but now governing all stages and parameters of production. Vertov's theorization of montage is, like that

[36] Vertov, p. 9.

[37] Vertov, p. 9.

[38] Vertov, p. 9.

of Eisenstein, aimed toward the construction of a totalitizing structural principle. Or we may say that taken together, their projects represent the point of intersection of the most radically conceived montage project of the medium within the given historical period.

We can see, however, in Vertov's insistent rationalization of every stage of production, in his focusing upon the organization of the gaps between movements and between frames, a line very different from that of Eisenstein. We discern, in fact, in his reference to the "interval" a possible model other than that of musical composition. It would appear, rather, to derive in large part from mathematics and physics.

In the analysis of movement and of rates of change, the notion of the interval is applied to the ever divisible gap between two points along a defined continuum. For the practical significance of calculus lay in its use in the determination of motion through all moments of time. Its methods were applicable to all problems involving rates of change: to the motion of vibrating string, to that of the earth, to the flow of fluids and of electric currents, and to the behavior of particles in the subatomic world.

Vertov's scientism in general and the proclamation, in particular, of his theory of intervallic montage appear as a direct response to the challenge and imaginative stimulus of contemporary scientific thought; they would seem to derive from the force exerted within a particular historical moment, that of the early 1920's, of a post-Newtonian paradigm. Therefore, the Vertovian frame of reference with respect to a Fourth Dimension should be carefully distinguished from the idealist cast of hyperspatial and n-dimensional speculation current among the pre-revolutionary symbolists and allied Russian intellectuals.

Popularization of Einsteinian theory was well underway in the pre-revolutionary period. Khvolson's description of Einstein's work in the Russian journal *Priroda (Nature)* was published in 1912. N.A. Umov's December, 1911 address before the Mendeleevskian convention dealt with Minkowski's reinterpretation of space and time according to the Special Theory of Relativity. Umov's address served, in fact, as Ouspensky's source for his account of the subject in the

[39] Henderson, p. 243.

[40] Henderson, p. 244.

[41] Velimir Khlebnnikov, *Letters and Theoretical Writings*, ed. by Charlotte Douglas, trans. by Paul Schmidt (Cambridge, MA: Harvard University Press, 1987), p. 231.

[42] For a detailed account of Fock's dialectical materialist position on relativity physics, see Loren R. Graham, *Science and Philosophy in the Soviet Union*, (New York: 1966), pp. 127–138.

1916 second edition of *Tertium Organum*. Umov also published mathematical papers on the four-dimensional universe of Minkowski in 1910 and 1912.[39] Although these publications afforded access to the Special Theory of Relativity, it was not until 1919 and the empirical confirmation of the General Theory of Relativity that their impact was fully manifest. And that impact, among both artists and the general public was universal, powerful, spectacular.

It was not until the 1920's that Malevich began to reinterpret his basically spatial fourth dimension as time and it was then, as well, that he began to incorporate references to "relativity" in his writings. Thus, while Khlebnikov undoubtedly shared his awareness of Special Relativity with his artistic friends, their painterly preoccupation with space made them less likely to respond to a theory that Vasiliev himself had identified as most important for interpretations of time.[40]

In 1916, Khlebnikov had, however, proclaimed in a text, *The Trumpet of the Martians*: "The human brain until now has been hopping around on three legs (the three axes of location!)." He now proposed a fourth: "the axis of TIME…"

> People from the past were no smarter than us; they thought the sails of government could be constructed only for the axes of space.
>
> But now we appear, wrapped in a cloak of nothing but victories, and begin to build a union of youth with its sail tied to the axis of TIME and we warn you that we work on a scale bigger than Cheops, and our task is bold, majestic and uncompromising.[41]

The complex and interesting reception of The Special Theory of Relativity within the Soviet Union has been exhaustively analyzed by Loren Graham.[42] Also, Vladimir Fock, the distinguished physicist who was to pursue over the ensuing decades a powerful critical commentary on the theory of Special Relativity, had published an exposition of it in *Pravda*.

It is in the light of the foregoing that we can begin to understand the privileged status of the Theory of the Interval within Vertov's production. Careful consideration will require, however, some scrutiny of the iconography which is developed to serve its function within his film texts. One is led to reflect, in particular, on the recurrent image of the

railway train in motion, of which the metaphoric and met-
onymic propensities have so frequently animated both the
narrative and the documentary film, that it can serve as an
axis along which we may plot a certain history of the cinema.

The lineage of this image, less than a century old by
Vertov's time, was nevertheless extremely rich; "the train of
history" figures within a broad spectrum of Marxist literary
tropes and visual iconography, and in those of Soviet film
production in particular. *Arsenal* (Dovjenko, 1928), *Turksib*
(Victor Turin, 1930), and *Blue Express* (Ilya Trauberg, 1928)
are three prime examples (among many others) of its major
modes within cinematic form: the train in motion as site or
decor of narrative, the train as theme of the documentary
form, and the train as the allegorical representation of the
revolutionary project. Trauberg's film stands as the hyper-
bolic instance of the latter, since its diagesis is wholly gov-
erned by the metaphorical potential of Eisensteinian
montage, relentlessly applied to every component of the
train's structure in a narrative of anti-imperialist insurgency.[43]
To these modes and instances, Vertov was to add another
of his own, that of the train in motion as heuristic device.

He was not, of course, the very first to do so, for it was
precisely this figure that Einstein had employed a decade
earlier in his efforts to disseminate to a general audience
his theoretical formulations; and it has since served almost
every subsequent popularizer of the theory of relativity. It
most tellingly conveys those terms by which distance, mass,
and time, or temporal intervals are understood as relations.
The figure of a train in motion along an embankment serves
to illustrate the disparity effected by different positionings
with respect to the reception of signals from disparate sources,
such reception being either simultaneous or successive. More
than that, it clearly and effectively demonstrates the difficulty
of positing simultaneity of reception of a given signal at
two different points in space. Thus, in *Relativity: The Spe-
cial and General Theory*, first published in 1916, Einstein
introduces the exposition of *Space and Time in Classical
Mechanics* by stating that "the purpose of mechanics is to
describe how bodies change their position in space with
time."[44] He then proceeds to introduce doubt.

It is not clear what is to be understood here by "position"

[43] For a discussion of the role of the train in
its metaphoric and metonymic modes, see
Annette Michelson, "Track Records, Trains
of Events," in *Junction and Journey*, ed. by
Larry Kardish (New York: Museum of Mod-
ern Art, 1991).

[44] Albert Einstein, *Relativity: The Special and
the General Theory*, trans. by Robert Lawson
(New York: Crown Publishers, 1961), p. 9.

Photographer unknown
Camera men of the Soviet Film Train,
established by the People's Commissariat of
Transportation 1931
Modern print from archival negative
Private Collection

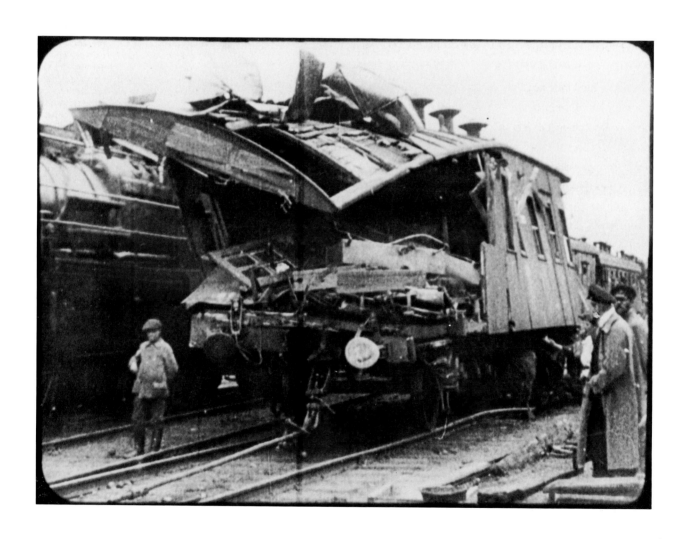

and "space."

> I stand at the window of a railway carriage which is travelling uniformly and drop a stone on the embankment, without throwing it. Then, disregarding the influence of the air resistance, I see the stone descend in a straight line. A pedestrian who observes the misdeed from the footpath notices that the stone falls to earth in a parabolic curve. I now ask: Do the "positions" traversed by the stone lie "in reality" on a straight line or on a parabola? Moreover, what is meant here by "motion in space?"[45]

The figure of the railway carriage is maintained for heuristic purposes in chapters V, VI, VII, VIII, IX, and X. It is in Chapters VIII and IX, entitled *"On the Idea of Time in Physics"* and *"The Relativity of Simultaneity"* [46] that he extends the use of this figure to the question of simultaneity. The figure of the train, soon to be adopted by Bertand Russell,[47] among many other exegetes, becomes integral to the literature of popular exposition.

Vertov's train makes its appearance in his documentary chronicling of the Civil War (1922). In his films from 1925 onwards it functions not only as an emblem of industrial progress, but as an important agent for the reclamation of the panoply of so-called cinematic "anomalies." Thus, "Kino-Eye" makes use of every possible kind of shooting technique: acceleration, microscopy, reverse action, animation, camera movement, the most unexpected foreshortenings—all these we consider to be not trick effects but normal methods to be fully used."[48] And the purpose of this deployment is multiple. First, "the conquest of time (the visual linkage of phenomena separated in time). Kino Eye is the possibility of seeing life processes in any temporal order or at any speed inaccessible to the human eye."[49] In the text entitled *Kinopravda and Radiopravda*, Vertov offers his program for the establishment of bonds between workers in different sectors of industry, between workers and peasants, between nations. He envisions a cinema that might establish unifying, indissoluble bonds, erasing the distances, dichotomies, and hierarchies between manual and intellectual labor, between factory and farm. In 1931 the People's Commissariat of Transportation promoted a strikingly practical move in this direction: a travelling film-train designed to mobilize the working masses around the

[45] Ibid.

[46] Einstein, pp. 21–27. Chapter VIII, "On the Idea of Time in Physics," opens as folows: "Lighting has struck the rails on our embankment at two places, A and B, far distant from each other. I make the additional assertion thast these two lightning flashes occurred simultaneously. If I ask you whether there is any sense in this statement you will answer my question with a decided 'Yes.' But if I now approach you with the request to explain to me the sense of the statement more precisely, you find after some consideration that the answer to the question is not so easy as it appears at first sight.

[47] See Bertrand Russell, *The ABC of Relativity*, Thrid revised edition, ed. by Felix Pirani (New York: New American Library, 1959). In Chapter VI, "The Special Theory of Relativity," Russell follows his exposition of Einstein's interpretation of the Lorenz transformation by proposing an example of a moving train. Still another, among many more, is that of Guy Murchie in *Music of the Spheres: The Material Universe from Atom to Quasar, Simply Explained*, vol. II, *The Microcosm* (New York: Dover Publications, 1961), pp. 535–538.

[48] Vertov, "Kino-Eye to Radio-Eye," in *Kino-Eye: The Writings of Dziga Vertov*, p. 88.

[49] Ibid.

Line drawing from Guy Murchie, *Music of the Spheres*, vol. 2 with illustrations by the author, (New York, 1961) p. 536
Private Collection

Dziga Vertov
Film still from *The History of the Civil War*
1922
Private Collection

tasks of socialist construction and the renovation of rail transport. This fully equipped mobile film studio, produced, under the directorship of Alexander Medvedkin, critical films on local conditions (bureaucracy, inefficiency, nepotism, etc.) that were shown on the site of production to local audiences. This unit generated a large body of work over a two-year period of travel to major construction sites, to collective farms in the Ukraine and the railways of the Don Basin. Certain films were selected for national distribution.

It is in the film *Kino-Eye*, as well, that Vertov introduces, through reverse movement, the cinematic form of the trope, *hysteron-proteron*. "If time could run backward...," declares an inter-title that signals the first of the sequences in which motion is reversed through the "magic" that astounds and delights the spectators, positioned like children, mesmerized by the power of the cinema.[50]

This trope is first applied to human locomotion, but the reversal of movement is then systematically deployed so as to illuminate the inter-relations of labor processes throughout the social formation and its economy. The imagery of the railway plays a central role; the distribution of meat and grain, transported by train, is traced back in reverse motion to the site of their production on the soviet *kolkhoz*. The ludic freedom of the Kino-Eye at the editing table, suspending or reversing temporal order and causal relations is the instrument of analytic revelation of material process.

Vertov's program, announced in *The Birth of Kino-Eye*, proposed an expansion of the Kino-Eye such that it would offer "the theory of intervals," the theory of relativity on the screen. Seeing that which the eye cannot see, it would function, as the "microscope and telescope," as "the negative of time." It is in this passage that Vertov first asserted the "truth value" of cinema in its converting of the visible into the visible, in its rendering of the hidden manifest, in its revelation of disguise, and in its conversion of falsehood into truth. It is, then, in the name of epistemological certitude that Vertov at the start of his career reclaims the power of the "anamalous" optical processes. And he does so through the implementation of the cinema's most radical resource, its most empowering parameter, that of freedom from the constraints of temporality which, until the

50 The centrality of this trope in Vertov's work is discussed in Annette Michelson, "The Man with the Movie Camera: From Magician to Epistemologist," in *Artforum*, March, 1972, pp. 60–72.

early years of this century had appeared absolute and unalterable. Both the interest and hostility generated by Vertov's project (a hostility from which, as we know, Eisenstein was not exempt) evoke the other side of euphoria's coin: the malaise induced by the destabilising effect produced by the modification of the Newtonian paradigm of spatio-temporality as articulated in film. Vertov's train, careening back and forth between city and countryside, enabled through its problematizing of causality, his project of the "decoding of Communist reality."

Annnette Michelson is Professor of Cinema Studies at New York University and a founding editor of *October*, a journal devoted to the theory and criticism of artistic practice. Among her publications on the history and theory of the avant-garde in cinema is *Kino-Eye*, a critical edition of the writings of Dziga Vertov, published by the University of California Press.

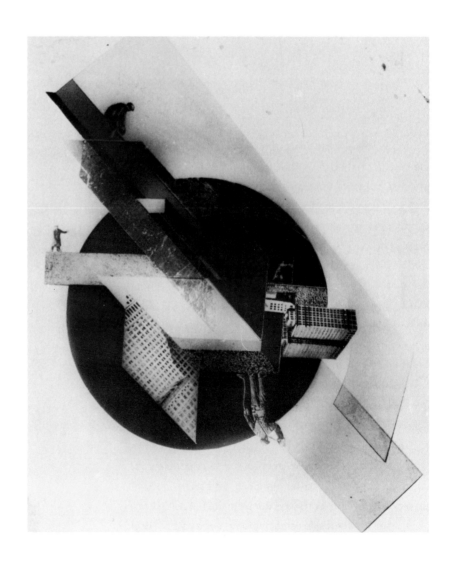

From the Politics of Montage to the Montage of Politics

SOVIET PRACTICE 1919 THROUGH 1937

Margarita Tupitsyn

Writing in 1930 Gustav Klutsis claimed photomontage as the newest method in art, noting that it was first applied in the Soviet Union in his work called *Dynamic City* in 1919. Although Aleksandr Rodchenko and El Lissitzky were also practitioners of this medium, Klutsis declared that "their production often slipped into the methods of Western advertising—formalist montage which had no influence on the formation of political montage."[1] With this statement Klutsis aimed to separate his intentions in this medium from those of Rodchenko and Lissitzky, thus implying a complex and controversial history of Soviet photomontage. Indeed, when Klutsis produced *Dynamic City*, his first photomontage composition, Rodchenko was still applying collage made from random newspaper and magazine cutouts in the familiar fashion of Cubist works, and Lissitzky, after meeting Kazimir Malevich in Vitebsk, had shifted to non-objective art. In *Dynamic City*, Klutsis demonstrated his departure from abstraction; and in a poster maquette called *The Electrification of the Entire Country* produced in the following year, he revealed his interest in using photomontage as a political weapon rather than as a new formal method.[2] Photomon-

[1] Gustav Klutsis, "Photomontage as a New Kind of Agitational Art," in *Izofront*. "Klassovaya borba na fronte prostranstvennykh iskusstv," (Class Struggle on the Front of Visual Arts) 1931, p. 126. Although written in 1930 in connection with the first exhibition of the October group, this article was not published until 1931.

[2] The first version of *Dynamic City* (1919) was non-representational and was produced at roughly the same time as Lissitzky's first Proun paintings in Vitebsk. The dates of Klutsis's first photomontages are supported by a number of scholars including Christina Lodder and Larisa Oginskaya. The latter art historian claims that Klutsis first used photomontage in 1918, in his design for a panneau for the Fifth Congress of Soviets in Moscow; the panneau is now at the Museum of Latvian and Russian Art in Riga. See Larisa Oginskaia, *Gustav Klutsis*, Sovetsky Khudozhnik, Moscow, 1981. Also, in the existing list of all Klutsis's works prepared by the artist, he indicates the same dates for these montages.

Gustav Klutsis
Dynamic City 1919
vintage gelatin silver print
11 x 9"
Private collection

[3] Klutsis, op. cit.

[4] Yve-Alain Bois, "El Lissitzky: Radical Reversibility," *Art in America*, April, 1988.

[5] Ibid. p. 174.

[6] Quoted in Victor Erlich, *Russian Formalism: History Doctrine*, Mouton and Co., The Hague, 1965, p. 127.

Gustav Klutsis
Electrification of the Entire Country 1920
poster design 6 3/4 x 4 1/2"
Collection of Merrill C. Berman

tage," he later wrote, recalling his breakthrough work of 1919/1920, "appeared on the 'left' front of art at the time when non-objectivity lost its meaning. For agit-art one needed realistic representation."[3]

Klutsis's embrace of photomontage began with the grafting of photographic elements onto basic collage practice—an introduction of representational content to formalist device. In *Dynamic City*, Klutsis arranged four small figures of construction workers around central geometric shapes, adding an element of "reality" to an otherwise abstract composition. Here, he sought to abolish the usual sense of gravity by both placing photographic images of construction workers in various relations with skyscraper fragments, and by adding the inscription, "To look at from all sides." Although this collage stands apart from the non-objectivity of his first version of *Dynamic City* or his Axonometric compositions of 1920, it preserves his interest in the spatial instability that Yve-Alain Bois, writing of Lissitzky's Prouns, described as a "radical reversibility"—a space and composition that aims to overthrow the spectator's certainty and customary viewing position.[4] Within a year, however, in the *Electrification of the Entire Country*, Klutsis departed dramatically from the essentially formal concerns that were grounded in Lissitzky's interest in "a structure round which we must circle, looking at it from all sides, peering down from above, investigating from below."[5] By 1920 Klutsis began to regard this kind of formal emancipation as secondary to the need to convey a clear political message. Adopting the expression of his contemporary literary critic Boris Eichenbaum, one can say that for Klutsis "The question 'how to write?' was soon overshadowed by another query: 'how to be a writer.'" Accordingly, in *The Electrification*, Klutsis started to discard the more extreme forms of spatial reversibility and "overall confusion in the visual field" in order to introduce a more readable "ideological content."[6] Here, into a composition centrally dominated by a geometric circle, strides a giant figure of Lenin, carrying with him metal scaffolding and architectural sections—symbols of the technological modernization promised by the Bolshevik government. Lenin and the other figures planted into the composition are grounded in the pictorial field, suggesting

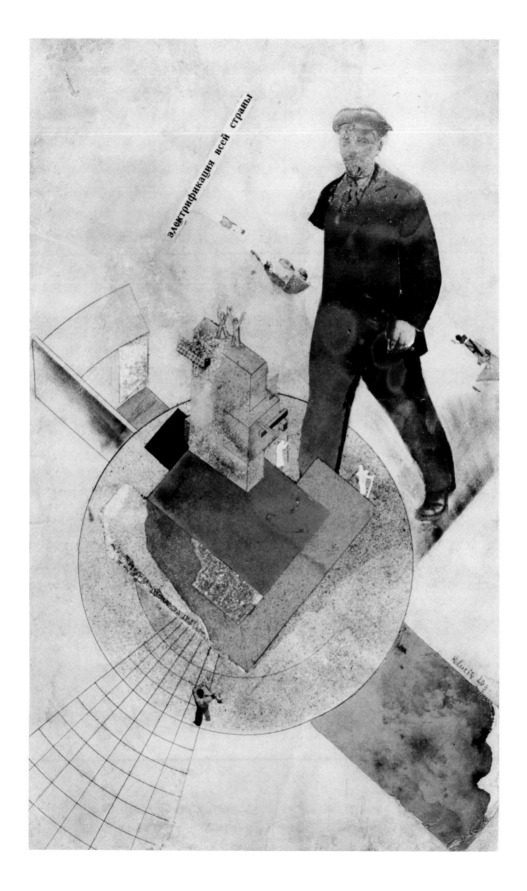

электрификация всей страны

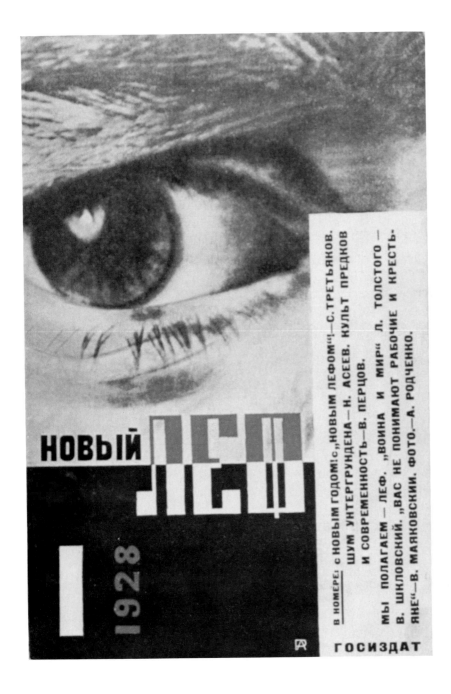

НОВЫЙ ЛЕФ

1928

В НОМЕРЕ: с НОВЫМ ГОДОМ: с „НОВЫМ ЛЕФОМ“!—С. ТРЕТЬЯКОВ. ШУМ УНТЕРГРУНДЕНА—Н. АСЕЕВ. КУЛЬТ ПРЕДКОВ И СОВРЕМЕННОСТЬ—В. ПЕРЦОВ.

МЫ ПОЛАГАЕМ — ЛЕФ. „ВОИНА И МИР“ Л. ТОЛСТОГО — В. ШКЛОВСКИЙ. „ВАС НЕ ПОНИМАЮТ РАБОЧИЕ И КРЕСТЬ-ЯНЕ“—В. МАЯКОВСКИЙ. ФОТО.—А. РОДЧЕНКО.

ГОСИЗДАТ

86

the viewer make a direct and easy identification with that space.

In this article I would like to trace the history of a political photomontage in the Soviet Union that was inspired by the paradigmatic change from the artist as formalist to the artist as activist message-maker. In this history I place Klutsis as the primary practioner of montage.[7] Klutsis's interest in the notion of author as producer most likely was nurtured by his association with the circle of artists who, in 1923, inspired Vladimir Mayakovskii to found *LEF* magazine. Among its contributors were the major literary critics Osip Brik, Sergei Tretyakov, and Viktor Shklovskii, and the film maker Dziga Vertov. The group was bound by the urge to move from a prevalent emphasis on "constructive devices" toward the agitational qualities of the work of art. They stressed the "primacy of content" through themes taken from surrounding reality. Dziga Vertov's production of *Kino-Pravda* in 1922 and specifically his manifesto "We," (written at the time of the founding of the *kinoki* [cinema-eye men] group in 1919, the year of Klutsis's first photomontage) demonstrate certain similarities in terminology and iconography with those utilized by Klutsis in his first montages.[8] Vertov, using expressions similar to Klutsis's, such as "dynamic geometry" and "dynamic sketch," writes:

> Our path is from a dawdling citizen via the poetry of a machine to a perfect electric man. A new man, freed from weight and clumsiness, with the exact and light movements of a machine, will become a useful object of filming.[9]

In the first issue of *LEF* in 1923, Osip Brik expressed his related concern with the education of "young proletarian writers," by asserting that "poets do not invent themes but take them from surrounding reality" and that "a great poet does not reveal himself but only executes the social commission."[10] Later, in *Novyi LEF*, Brik argued directly against "generalizations and abstractions" and for "details and descriptions of the concrete realia of Soviet life."[11] His colleague Tretyakov insisted on "the primacy of the material over the writer's interpretation of it," saying that "the fabricated story and created novel are hateful [to us]. The once esteemed title of 'creator' sounds insulting in our age. The true man of letters in our age is the cautious 'discoverer'

[7] Although Rodchenko and Lissitzky also turned to political montages (primarily beginning with the late 1920s) their conviction in this direction was not as consistent as that of Klutsis. In their work it became predominant only when political conditions more and more defined the nature of an art work.

[8] This manifesto was only published in 1922.

[9] Dziga Vertov, *Kino-fot*, No. 1, 1922, p. 11.

[10] Osip Brik, *LEF*, No.1, 1923.

[11] Osip Brik, "Blizhe k faktu," *Novyi LEF*, no. 2, 1927, p. 34.

Aleksandr Rodchenko
Novyi LEF, 1928
magazine cover
Collection of Merrill C. Berman

of new material, its non-distorting molder."[12] The writers' tendency to "reach beyond 'pure' Formalism toward a position more inclusive and more congruent with the 'social demands' of the time"[13] precisely mirrors Klutsis's shift from abstract compositions to works that incorporated factographic elements.[14] Calling this tendency "utilitarian aesthetics" or "extra-aesthetic" production, the *LEF* theorists "hailed 'factography' as a perfect example of the integration of art with life."[15] Mirroring some degree of and adopting this documentary orientation, the socio-formalist artists and writers undermined the myth of original production, and raised the importance of mechanically executed art forms such as photography and photomontage.

Surprisingly, in his article "Into Production" written in 1923 for the first issue of *LEF*, Brik chose Rodchenko rather than Klutsis as an exemplary artist who "knows that you won't do anything by sitting in your own studio, that you must go into real work. . . "[16] At this distance, however, it is evident from Rodchenko's first photomontages—such as *Psychology* (1922) and *Detective* (1922), which were printed in *Kinofot* to accompany Lev Kuleshov's text on montage, or the subsequent illustrations for both Vladimir Mayakovskii's poem *Pro Eto* (1923) and Jim Dollar's *Mess Mend* (1924)—that Rodchenko, unlike Klutsis, was not so much interested in representing political "realia of Soviet life" as in creating a complex, multilayered world of poetic imagination and private references. In these early series of photomontages, Rodchenko's iconographic arsenal functions within the framework of unexpected juxtapositions and absurd contexts. It comes much closer to the application of photomontage by such Berlin Dada artists as Hannah Höch and George Grosz than to the "agitational-political" orientations of Klutsis and the *LEF* theorists. Although in his photographs of the late 1920s and early 1930s he would deal with documentary material, Rodchenko later would specifically criticize Brik's obsession with reportage as the "fetishism of a fact." In the context of this development in the history of photomontage, it is possible that the long disputed authorship of the anonymous text on "Photomontage" printed in *LEF* in 1924 was Klutsis's and that he was reacting to Brik's failure to recognize him as the pioneer of viewing

[12] Quoted in Natasha Kolchevska, "Toward a 'Hybrid' Literature: Theory and Praxis of the Faktoviki," SEEJ, Vol. 27, No. 4, 1983.

[13] Victor Erlich, op. cit., p. 120.

[14] Factography is associated with iconic documentary information.

[15] Victor Erlich, op. cit. pp. 120–121.

[16] *The Tradition of Constructivism*, ed. Stephen Bann, Viking Press, 1974, p. 84.

Aleksandr Rodchenko
page from Vladimir Mayakovskii, *Pro Eto*,
(Moscow: Gos. Izd-Vo, 1923)
12 1/2 x 9"
Collection of the International Museum
of Photography at George Eastman House,
Rochester, New York

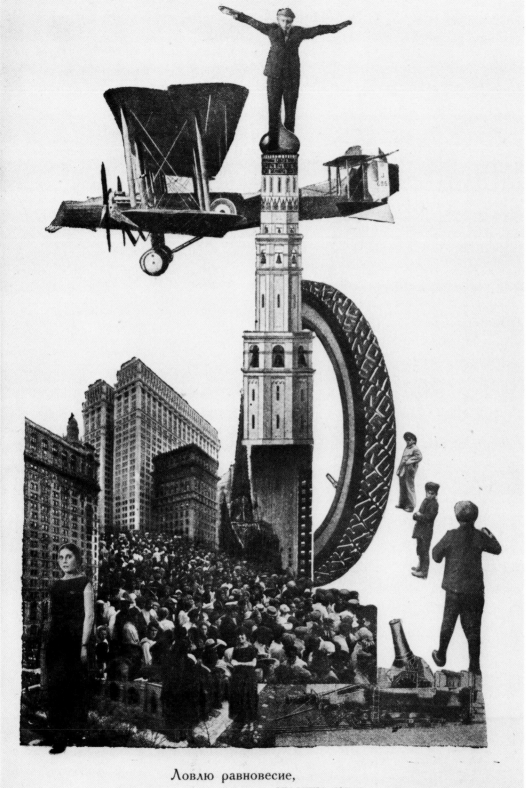

Ловлю равновесие,
страшно машу.

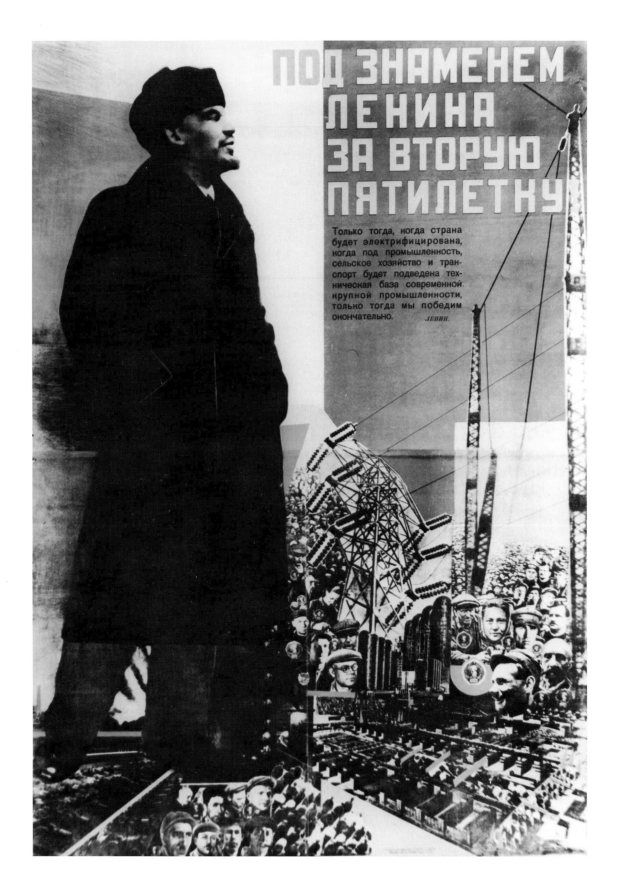

ПОД ЗНАМЕНЕМ ЛЕНИНА ЗА ВТОРУЮ ПЯТИЛЕТКУ

Только тогда, когда страна будет электрифицирована, когда под промышленность, сельское хозяйство и транспорт будет подведена техническая база современной крупной промышленности, только тогда мы победим окончательно. *ЛЕНИН.*

photomontage as a weapon for social changes.[17] In its emphasis on documentary and agitational aims, the text suggests many of Klutsis's biases.

In its first phase, before the inauguration of the First Five Year Plan in 1928, photomontage as a method was applied primarily to design magazines, especially those dealing with films, and to illustrating literary works such as Mayakovskii's *Pro Eto*. For example, in 1922, Rodchenko contributed photomontages to the magazine *Kino-Fot*, in which the editors were primarily involved in theorizing about compositional aspects of film and photography (rather than using that media to propagandize facts of Soviet life). In that magazine Rodchenko's view of photomontage was presented in the context of his constructivist agenda, which dealt primarily with the issues of line and composition. In contrast Klutsis illustrated such magazines as *Kino-Front*, *Vestnik Truda* (Herald of Labor) and *Molodaya Gvardiya* (Young Guard), the very titles of which suggested their association with the radical frontier of Soviet life. For example, *Kino-Front*'s covers were factographic and simple in design and consisted of representations of a working class. In *Molodaya Gvardiya* produced in 1924, the year of Lenin's death, Klutsis and his close colleague Sergei Senkin executed a series of photomontages dedicated to Lenin.[18] This continued Klutsis's preoccupation with the image of the leader which had begun with *Electrification*. For *Vestnik Truda* Klutsis, again in collaboration with Senkin, made montages to illustrate the VI Meeting of the Unions. Here, as well as in *Molodaya Gvardiya*, Klutsis completely transformed the nature of photomontage practice. It stopped being a formalist technique and became an "extra-aesthetic" tool solely serving propagandistic goals. As a result the artists like Klutsis and Senkin separated themselves from a conventional idea of a creator, and instead took a position similar to that of anonymous political book designers who had practiced montage soon after the Revolution.

In 1928, with the inauguration of the First Five Year Plan as a major program of Socialist reconstruction, photographic images in general, and photomontage in particular, became effective weapons in the fast and rapid dissemination of the agenda of industrialization. The Plan

[17] *LEF*, No. 4, 1924.

[18] In the year of Lenin's death, Rodchenko also produced several magazine and book covers with the leader's image. However, the fact that in the same year he left montage for apolitical portrait photography of his friends and relatives indicates that his interest in propagandistic imagery was limited and short.

Sergei Senkin
Under the Banner of Lenin—To the Second Five Year Plan 1931
poster 55 1/8 x 39 2/5"
Courtesy of Russia State Library, Moscow

[19] From this point on Rodchenko was involved in the debates on photography. Together with other photographers, like Boris Ignatovich and Eleazar Langman, Rodchenko contributed photographs to various popular magazines including *Daesh* (Let's Go!) and *30 Dnei* (30 Days). He produced virtually no Five Year Plan posters and, in general, returned to photomontage techniques only in his designs for *USSR in Construction* and other mass produced magazines in the early 1930s. That was after he was expelled from October's photography section in 1932 for formalist inclinations.

[20] F. Konnov and Y. Tsirelson, "Vystavka Oktyabrya," *Iskusstvo v Massy*, No. 7 (15), July, Moskva, 1930, p. 10.

rejuvenated and greatly expanded the debates on the meaning and uses of photography and photomontage, and led various radical groups of critics to establish (or as in the case of the magazine *Novyi LEF* to re-establish) their forums. The October Association, which was to play a paramount role in the development of photomontage and photography, also came into existence in March of 1928, and in the same year the Fine Arts Department of the State Publishing House (IZOGIZ) began to hire artists for the regular production of Five Year Plan posters—many of which were executed with the photomontage technique. With the inauguration of the First Five Year Plan, the second phase in the history of Soviet photomontage unfolds. Montage is not only greatly supported and, to a degree, controlled by the government (through IZOGIZ editors) but also is specifically preoccupied with the representation of productive forces carried on almost always by anonymous male and female workers. It is at this point that Klutsis's political radicality and his devotion to connect art with politics help him to ascend to one of the most prominent positions in this medium.

The October group's first "exhibition-demonstration" in Gorky Park, which took place at the end of May, 1930, included photomontages only by Klutsis and Senkin. Lissitzky and Solomon Telingater contributed graphic designs, and Rodchenko exhibited single-frame still photography, which at that point became his main preoccupation.[19] Lissitzky and Telingater were criticized for their attempts to hide the more political bent of their designs behind the novelty of the form. Klutsis's and Senkin's posters were praised in Feodor Konnov and Yakov Tsirelson's review of the exhibition as examples "which convince the viewer of the great potential of photomontage."[20] Photomontage was recognized as a technique that could be placed in service as "a good weapon of propaganda and agitation." Konnov and Tsirelson's review separated the photomontage practitioners into two camps, one more formalist and the other more concerned with the factographic aspects of photomontage, and initiated official controversial debates, which until 1932 would be openly discussed in the press. Although Klutsis joined the October group to produce a general declaration that be-

El Lissitzky
Pelican Drawing Ink 1925
advertising poster 17 1/2 x12 3/4"
Collection of Merrill C. Berman

El Lissitzky
Runner in the City c. 1926
collage gelatin silver print 5 3/16 x 5 1/16"
Courtesy of The Metropolitan Museum of
Art, Ford Motor Company Collection,
Gift of Ford Motor Company and John C.
Waddell, 1987

El Lissitzky
Pressa Catalogue 1928
exhibition catalogue cover 11 1/4 x 8 3/4"
Courtesy of the Fotografische Sammlung,
Museum Folkwang, Essen, Germany

Nikolai Prusakov
detail from *Second Five Year Plan* 1932
poster 40 1/8 x 86 3/4"
Courtesy of Russia State Library, Moscow

Vasili Ermilov
Design for Pressa Exhibition c. 1928
photomontage on cardboard
15 3/4 x 11 3/4"
Courtesy of Natan Fedorowskij, Avantgarde
Galerie, Berlin

came part of these debates, he separately wrote a text entitled "Photomontage as a New Kind of Agitational Art." In this article Klutsis declared the medium as a new mode of representation and its practitioners as "artists of totally new nature—activists, specialists in mass political and cultural work, constructors who possess the tool of photography and structure their compositions by totally new laws of representation, never used before."[21] In this text Klutsis allied his own production with that of Vasili Elkin, Valentina Kulagina (Klutsis's wife), Nikolai Spirov, Chutnov, Faik Tagirov, Natalia Pinus, Senkin, and "thousands of anonymous artists-workers and collective farmers at the production places. . . "[22], and in doing so, Klutsis set out his opposition to the formalist work of Rodchenko, Lissitzky, Lavinskii, Prusakov, and the Stenberg brothers.

By the time of the October exhibition and the peak of IZOGIZ poster production, Rodchenko had essentially removed himself from debates on photomontage. Thus, perhaps the most important and uncertain issue associated with photomontage of the late 1920s and early 1930s is the clarification of Lissitzky's position. The relationship between Lissitzky and Klutsis is especially significant in the context of the International Press Exhibition (Pressa) in Cologne, which gave the Soviet artists an opportunity to demonstrate to Western viewers the quintessence of their achievements in photomontage. In 1928, Lissitzky was offered the opportunity to head the Pressa project. Soviet officials such as Anatolii Lunacharskii, head of Narkompros (People's Commissariat for Enlightenment), knew that Lissitzky had important connections in Germany and that his association with Soviet propaganda material would be much more favorably received than anyone else's. Klutsis was associated with Pressa only in the context of his being a member of the large preparatory group that was put together to produce preliminary Pressa designs in Moscow. To execute this ambitious commission Lissitzky was provided with a large group of assistants, which included Klutsis and Senkin.[23] Klutsis's letter to Kulagina reveals how he viewed his role in Pressa project:

> Recently I received from Sereozha [Senkin] two catalogues of
> Cologne exhibition [Pressa]. . . There are some illustrations in

the catalogue of Cologne exhibition: a much discussed freize with an inscription "von Lissitzky und S. Senkin." Also there are works of Prusakov, Borisov, Plaksin, Naumov; several photographs of installation views. By the way, compositional devices are all mine, only they are better in my execution. Scums! As one should expect, neither yours or mine works are there. I have not written to him [Senkin] and do not intend to do so.[24]

Lissitzky had apparently only modest interest in the directions of political photomontage. By the time he took over the Pressa project in 1928, he had written but one text for a catalogue for the Russian Typographic Exhibition of 1927, in which he expressed his concern with propaganda issues. One finds no example of propagandistic factographic images in his work before 1928 and his major designs of exhibitions executed right before Pressa, including the room of non-objective art at Internationale Kunstausstellung in Dresden (1926) and the design for Raum der Abstrakten in Hanover (1927) were based entirely on the principles of non-objective art.[25] Moreover, although in the Russian Typographic Exhibition text he emphasized photomontage as the most socially effective art form, one of the installation views from this exhibition shows that in it he chose to represent himself not as a political photomontagist but as a creator of abstract designs. In this view his famous suprematist poster *Beat the Whites with the Red Wedge* hangs next to Klutsis's and Senkin's collaborative factographic book cover design entitled *To the Memory of the Lost Leaders*.[26] Together, these two examples of Soviet political typography, one abstract and the other based on documentary material (a photograph of Lenin's mausoleum penetrated by the long line of the proletariat and the hands of a worker carrying the red flag), demonstrate the gap between Lissitzky on the one hand and Klutsis and Senkin on the other. The Pressa designs begun by Lissitzky shortly after the Russian Typographic Exhibition significantly differ from most of his concurrent production. One may suggest that Lissitzky *responded* to political photomontage as it was developed by Klutsis in collaboration with Senkin and others in the late 1920s. Their concern with political, agitational, and documentary imagery influenced the Pressa's contents, which are full of reportage material. And yet, while

[21] Klutsis, op. cit. pp.120–121.

[22] Ibid. p. 126.

[23] Knowing Klutsis's independence, it is hard to imagine that he would easily accept such a subordinate position, and this may explain why it was Senkin (who already functioned as Klutsis's adherent) who agreed to follow Lissitzky to Cologne for the actual installation of the Pressa.

[24] A letter from June 11, 1928. Klutsis Family Archive, Moscow.

[25] The exception is Lenin's figure added by him in 1924 to the design for Lenin Tribune, the original design of which was done in 1920.

[26] This installation photograph was made by Klutsis on a glass negative.

27 Quoted in Kolchevska, op. cit. p. 453.

28 Quoted in Benjamin H.D. Buchloh, "From Faktura to Factography," *October*, Fall 1984, p. 109.

29 The term used by constructivists to describe formal investigation which in future could be used for utilitarian task.

shifting towards the methods of his colleagues, Lissitzky even in Pressa continued to be concerned with abstract graphic designs and with constructivist architecture. He influenced the formal organization of the whole collection of propagandistic material prepared in advance in Moscow. In a very real sense, the Pressa designs were not Lissitzky's project alone, but rather a collective production which resulted in the creation of a hybrid between agitational-political photomontage (content) and constructivist design (form).

This state of hybridity between formalist aspirations and those inclined to propaganda was paradigmatic of much critical writing produced at the time. For Sklovskii, for example, the writer's goal lay in "the development of 'hybrid' prose forms which combined journalism's respect for material with narrative or compositional techniques which could most expressively *organize* [my emphasis] that material."[27] Unable to refuse such an ambitious project as the Pressa, Lissitzky, who was aware of the requirements of the State, was prepared to work with highly politicized imagery, which, judging from his work before 1928, was not particularly close to his own beliefs. He thus functioned as someone who could "expressively 'organize' [propagandistic] material." In his letters referring to the results of the Pressa he emphasized such concepts as "aesthetics" and "form" when he wrote:

> . . . but aesthetically there is something of a poisoned satisfaction. The extreme hurry and the shortage of time violated my intentions and the necessary completion of the *form* [my emphasis]—so it ended up being basically a theater decoration.[28]

From these statements, it is apparent that Lissitzky gave little emphasis to propagandistic aspects of the exhibition and that he was still strongly inclined toward the laboratory phase of constructivism.[29] What he discovered, however, and could not deny was that upon his return to the Soviet Union he had little chance of being a viable force in the cultural arena if he continued to create objects whose very self-reference made them inaccessible to the masses he was addressing.

Unlike Lissitzky and his rationalized submission to the call of a political agenda, Klutsis never doubted that art should have a direct connection to political goals. He was an ac-

tivist: he participated in the events of the Revolution, specifically as a member of the Latvian Rifles Regimen, and he was later assigned to guard Lenin in the Kremlin.[30] Thus, unlike Lissitzky who in the late 1920s was gradually equating his experimental tools with propagandistic ones, Klutsis, almost from the outset of his career, saw aesthetics as inseparable from politics. In other words, Klutsis gave up "bourgeois experiment for the sake of experiment," in order to grasp "political contentness (meaningness)" and to achieve dissemination of the Bolshevik agenda.[31]

Klutsis's posters exhibited in the October exhibition of 1930 demonstrate his desperate search at that time for the paradigmatic representation of the collective voice, which he realized most effectively in his well-known poster photomontage *Let Us Fulfill the Plan of the Great Projects* and in its second version called *Male and Female Workers All to the Election of the Soviets*, executed for the XIII Anniversary of the October Revolution. A number of existing preparatory photomontages for this poster demonstrate the artist's step-by-step development of this image. He began by photographing his own palm to function as the primary sign of voting power, and in the following maquettes used his hand in repetition across the whole composition. In these first designs, the space is densely filled with the figures of voting workers and includes two larger heads, one anonymous and the other Lenin's. In the subsequent photomontages, Klutsis reduced the number of hands to one and placed it in a strictly diagonal fashion. He continued, however, to include the crowd of workers, all with raised hands, some merging into the surface of the artist's palm. In these preliminary designs, Klutsis clearly attempted to present the masses in an easily readable fashion. The final version shows a drastic reduction of the workers and a dominant presence of Klutsis's hand repeated many times but strictly controlled within a strong design sensibility. It is important that, in the final poster, Klutsis kept only his own hand, for it can be said that he submits his authorial hand to that of the proletariat (who thus acquired the power of an ultimate author) and so redefined the role of an artist/creator in a socialist society. He proposed a new authorial paradigm by using an artist's hand as a metaphor for pro-

[30] Klutsis even made sketches of Lenin while watching him take walks.

[31] I. Vaisfeld and A. Mikhailov, *Plakatno-Kartinnaya Agitatsiya na Putyakh Perestroiki*, (Poster-Pictorial Agitation on the Road Towards Perestroika), OGIZ-IZOGIZ, Moskva-Leningrad, 1932, p. 40.

page 100
Gustav Klutsis
Let Us Fulfill the Plan of the Great Projects
1930
vintage gelatin silver print 5 x 3"
Courtesy of Walker, Ursitti, McGinniss,
New York

page 101
Gustav Klutsis
Let Us Fulfill the Plan of the Great Projects
1930
original photomontage 5 1/4 x 3 3/4"
Courtesy of Walker, Ursitti, McGinniss,
New York

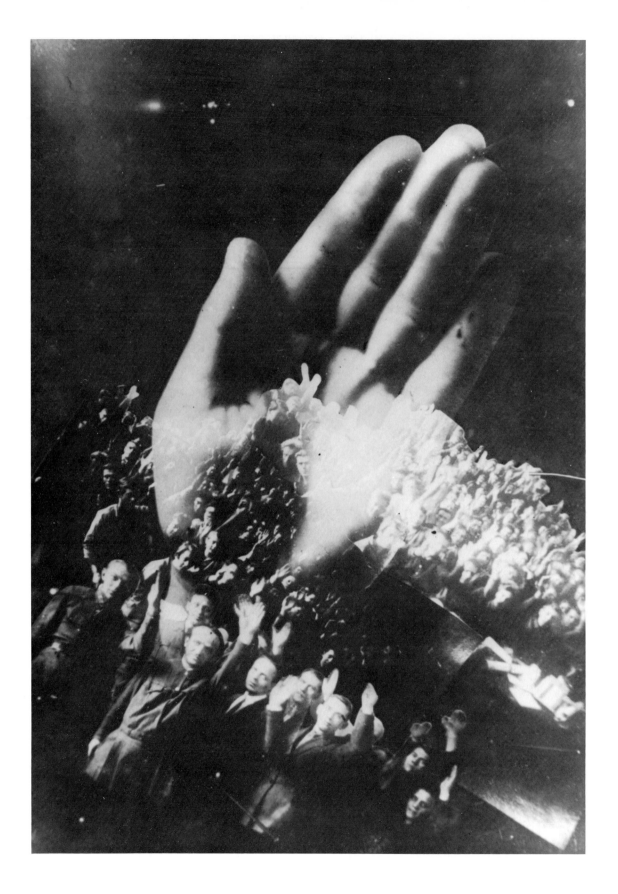

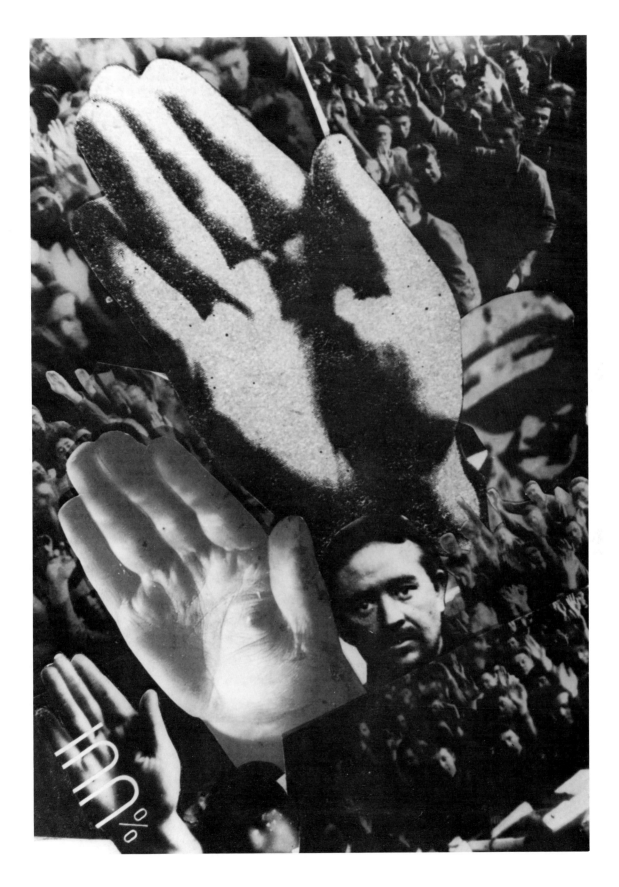

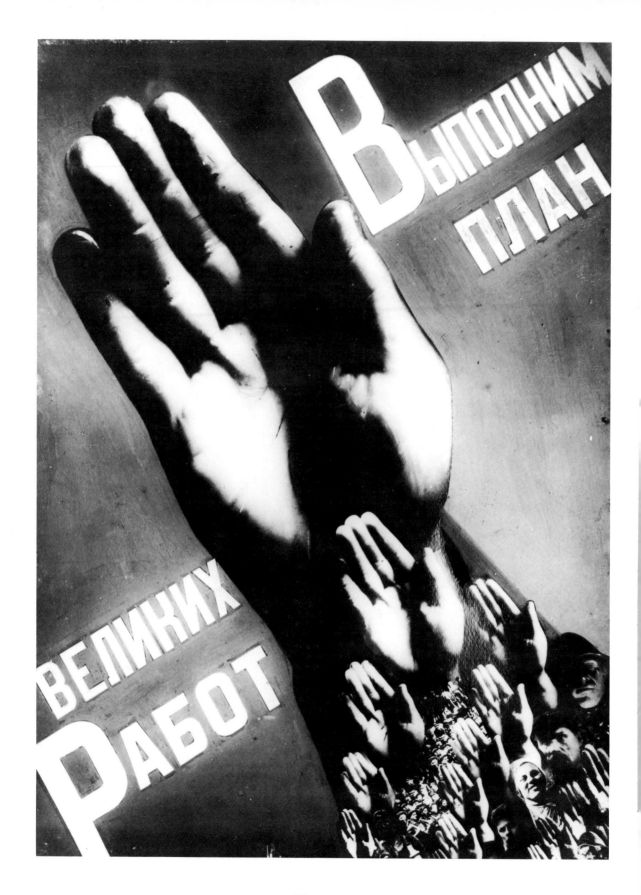

duction rather than for creation.

In the context of this new authorial paradigm, two examples of Lissitzky's utilization of his hand are notable by contrast. In *The Constructor* of 1924, Lissitzky photographed his hand holding a compass. In doing so, he merged the two models of an artist: the creator (hand) with the constructor (compass). In his appropriation of his own hand, Lissitzky maintained the importance of the individual creator. A later example of Lissitzky's treatment of a hand image executed for the cover of the periodical *Artists' Brigade* in 1931 demonstrates a striking change in his perception of the artist's position in society. Lissitzky's cover shows two hands in a fervent clasp which, because of the magazine's title, suggests that one of the two hands stands for the artist/producer and the other one for the proletariat.[32] At this point, Lissitzky like Klutsis, was concerned with the de-individualized hand of the producer (rather than the creator) who had made his decision "to side with the proletariat."[33] In a manner that suggests the influence of Klutsis's ideas and those of the writers around him, Lissitzky's work of 1930–31 demonstrates that at that point "the conventional distinction between author and public, which is upheld by the bourgeois press, begins. . . to disappear."[34] According to Tretyakov, who traveled to rural areas at this time to convince independent peasants to enter the *kolkhoz* (collective farm), this process can be identified as a change from "the informing writer to the operating one." The latter's role "is not to report but to struggle; not to play the spectator but to intervene actively."[35] To keep in close touch with the proletariat, many artists were also touring the sites of the Five Year Plan constructions. Klutsis described one such trip in a letter to Valentina Kulagina:

> Last night at 10 o'clock [Sergei] Senkin and I descended into a
> coalmine together with a shift of workers. . . Only now do I
> understand all the seriousness and hardship of the coalminer's
> labor. . . We received special coalminers' outfits and lanterns.
> Despite the fact that we did not work but only walked, we got
> dirty like real coalminers.[36]

In June, 1931, a debate over the political effectiveness of posters in general and of photomontage posters in particular took place at the Institute of Literature, Art, and

[32] Lissitzky's design for the *Artists' Brigade* is strikingly similar to Klutsis's one for the magazine *Vestnik Truda* (Herald of Labor) from 1925, in which he shows two clasping hands and arms filled with industrial and agricultural imagery. Printed in Oginskaya's book *Gustav Klutsis*, p. 73, and in *Gustav Klutsis: Retrospektive*, Museum Fridericianum, Kassel, 1991, ill. pp. 180–181.

[33] Walter Benjamin, "The Author as Producer," in *Reflections*, ed. Peter Demetz, Harcourt Brace Jovanovich, New York, p. 220.

[34] Benjamin, op. cit. p. 225.

[35] Ibid. p. 223. Significantly, together with Telingater, Tretyakov prepared a book about Heartfield, which suggested his interest in the method of photomontage.

[36] A letter from September 7, 1931. Klutsis Family Archive, Moscow. Most likely it was during this trip that Klutsis made a photograph of himself in a coalminer outfit, later used for the poster *The Struggle for Heat and Metal.*

Gustav Klutsis
*Let Us Fulfill the Plan of the Great Projects
(Fulfilled Plan, Great Work)* 1930
gravure 46 3/4 x 33 1/4"
Courtesy of The Museum of Modern Art,
New York. Purchase fund, Jan Tschichold
Collection.

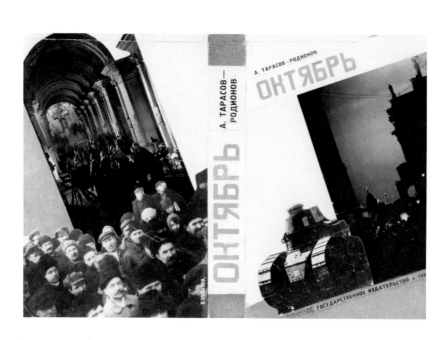

Language. This debate was organized in response to a criticism that the Central Committee of the Communist Party had publicly expressed in relation to the activities of many artistic organizations including IZOGIZ, which was primarily responsible for the commissions of photomontage posters. Klutsis, Senkin, and Elkin actively participated in the discussions. Klutsis gave a lecture entitled "Photomontage as a Tool for Agitation and Propaganda," which was an extended version of his earlier article "Photomontage as a New Kind of Agitational Art," written for the October group publication. In this second paper on photomontage, Klutsis repeated some of his major ideas about the medium, including his insistence on a distinction between advertising tendencies and political ones, and his disillusion with non-objective art, here expressed in a much harsher and politicized manner. Klutsis argued that by distinction, "photomontage was offered by the goals of the proletariat's struggle as a counter-attack against non-objective art."[37] Klutsis's position against any manual production of art and his praise of mechanical reproduction is mentioned to underline a major achievement of photomontage. In general, the artist's anti-aesthetic statements take on a much more prominent place in the second article. He asserts that "photomontage is not a form but a method" and thus negates the idea of it as one more step in the development of modernist forms.

A number of photomontage practitioners, including Senkin and Elkin, responded to Klutsis's lecture, but a more controversial discussion of Klutsis's contemporary posters came from lesser known participants in the debate. The critic N. Bekker, for example, criticized Klutsis for "a deindividualization of a worker," claiming that a poster artist must differentiate between various types of workers. Specifically, he attacked Klutsis's poster *Male and Female Workers All to the Election of the Soviets* for showing only the process of voting and complained that "it looks as if we only vote but do not work."[38] Bekker's accusations are significant because they relate to a much broader argument of the period, an argument about narrative photographs and photomontages in opposition to those based on fragmentation and allegory. His critique of Klutsis's non-real-

[37] This lecture was published in the volume *Za Bolshevitsky Plakat* (For a Bolshevik Poster), Moscow-Leningrad, OGIZ-IZOGIZ, 1932, p. 86.

[38] Ibid. p. 112.

Designer unknown
Woman Workers for Literacy, Quality, and the New Life c. 1920
41 3/4 x 28 3/8"
Courtesy of Russia State Library, Moscow

Valentina Kulagina
cover design for A. Tarasov-Radionov,
October 1930
photomontage 8 x 12 3/8"
Courtesy of Natan Fedorowskij, Avantgarde Galerie, Berlin

[39] Peter Burger, *Theory of the Avant-Garde*, University of Minnesota Press, Minneapolis, 1984, p. 70. A similar debate on the question of fragmented versus organic art work was going on in the camp of straight photographers, including Rodchenko and Boris Ignatovich on the one hand and the ROPF (Revolutionary Society of Proletarian Photographers) group on the other. For further discussion of this issue see my article "Fragmentation Versus Totality: Politics of de(Framing)," in *Russian and Soviet Avant-Garde: 1915–32*, The Schirn Kunsthalle, Frankfurt, March, 1992 and the Solomon Guggenheim Museum, New York, October 1992.

[40] Vladimir Voloshinov, *Marxism and the Philosophy of Language*, Harvard University Press, Cambridge, 1973, p. 12.

[41] Ibid. p. 15.

El Lissitzky
Russian Exhibition 1929
exhibition poster 49 x 35 1/4
Courtesy of Barry Friedman, Ltd.

Gustav Klutsis
We Will Build Our Own World 1930
vintage gelatin silver print 6 1/2 x 4 3/4"
Private collection

istic representation of the voting process anticipates Peter Burger's discussion of the distinction between the avant-gardist work of art which "joins fragments with the intent of positing meaning," and the organic (realistic) work of art, which "treats [its] material as something living."[39] But it is even more appropriate to relate Klutsis's practice of "deindividualization of a worker," pinpointed by Bekker in connection with *Male and Female Workers All to the Election of the Soviets*, to contemporary writing on language and ideologies published at the time by Mikhail Bakhtin and Vladimir Voloshinov. The latter in his study *Marxism and the Philosophy of Language* pointed out that

> signs can arise only on interindividual territory. It is territory that cannot be called "natural" in the direct sense of the word: signs do not arise between any two members of the species *Homo sapiens*. It is essential that the two individuals be organized socially, that they compose a collective (a social unit); only then can the medium of signs take shape between them. The individual consciousness not only cannot be used to explain anything, but, on the contrary, is itself in need of explanation from the vantage point of the social, ideological medium.[40]

Voloshinov also argued for the function of the word "as an essential ingredient accompanying all ideological creativity whatsoever,"[41] which designated posters' verbal messages as the prime element in the Marxist function of language. Published in 1929, Voloshinov's *Marxism and the Philosophy of Language* most likely had an impact on the practitioners of "ideological medium" like political photomontage. In his major posters of 1929–31, Klutsis constructs what Voloshinov calls "interindividual territory" by grouping workers and other individuals in close connection with each other and by fragmenting "natural" aspects of each composition, including bodies and other descriptive elements. The most striking example of the creation of an "interindividual territory" or "a social unit" is Klutsis's design for the poster *We Will Build Our Own New World* produced in 1931 for the XVIth Party Congress. Here, two faces, one male and one female, gaze out at the viewer with smiles of contentment, looming over a smoky industrial landscape. Significantly, the woman's face is placed

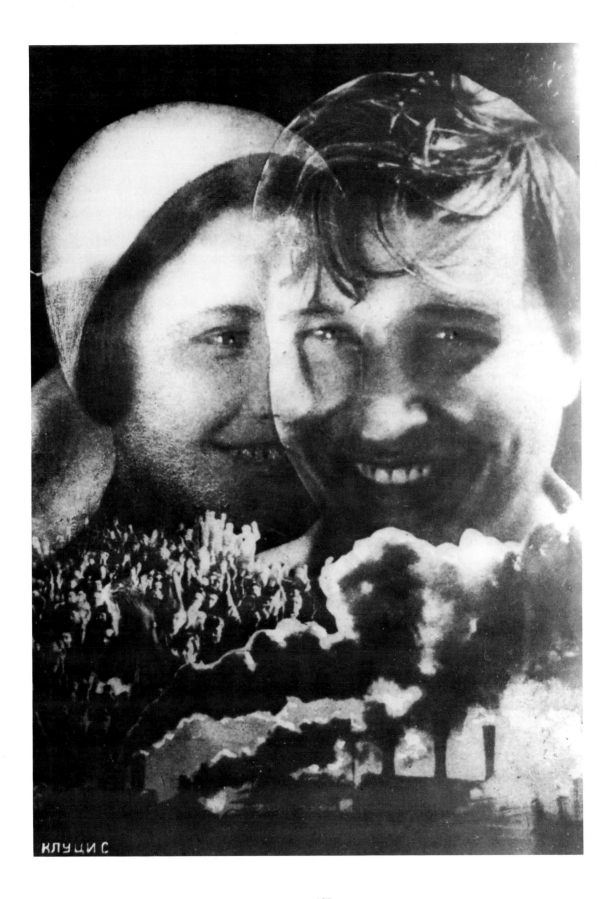

КЛУЦИС

[42] A similar composition was developed by Lissitzky in the same year in his design for the poster for the Exhibition of Soviet Art, Zurich, 1929. What is important here, however, in terms of my point about Lissitzky's ongoing interest in constructive elements, is a different treatment of the foreground. Klutsis created a factographic representation of the industrial landscape, whereas Lissitzky depicted a wall of constructivist stands. Lissitzky left them empty conveying his ambiguity about full commitment to factographic representation.

[43] Klutsis's initial slogan for the earlier discussed photomontage We Will Build Our Own World was also substituted by a more common phrase "Let Us Accelerate the Tempo of Industrialization." Klutsis specifically criticized the growing IZOGIZ bureaucracy when he wrote that "the underqualified editors made the decisions in all departments [of IZOGIZ] through which the work had to pass before it would finally be accepted or rejected." See "Schet khudozhnika, za tvorchesky kontakt khudozhnika i redaktora," (Artist's Account: For a Creative Contact Between Artist and Editor), Brigada Khudozhnikov (Artists' Brigade), N. 2, 1932, p. 13.

[44] Vaisfeld and Mikhailov, op.cit. p. 40.

Gustav Klutsis
In the Storm of the Third Year of The Five Year Plan 1930
photomontage 9 1/4 x 8 3/4"
Private collection

Gustav Klutsis
In the Storm of the Third Year of The Five Year Plan 1930
poster 34 1/2 x 24 1/3"
Private collection

behind the man's and partially merges into it, giving the impression of an androgynous or "interindividual" image and transgressing a natural appearance to create what Voloshinov calls a sign.[42] Also for the XVIth Party Congress, Klutsis worked out a similar model of "interindividuality" based, in this case, not on the anonymous images of men and women but on the known images of Lenin and Stalin. It was this last design that was eventually used for a poster in which the original slogan, "The Plan for Socialist Attack" (most likely chosen by the artist himself), was replaced by "Under the Banner of Lenin for Socialist Construction," a change most likely imposed by the censoring department of IZOGIZ. Such a change indicates the increasing governmental control over language in general and the verbal messages in posters in particular.[43] The nature of this change was based on a departure from daring revolutionary slogans to pre-determined and repetitive bureaucratic postulates.

In two other posters of the same period entitled *We Shall Repay the Coal Debt to Our Country* and *In the Storm of the Third Year of the Five Year Plan*, Klutsis merged three images of coalminers, eliminates any narrative background, and turns these workers into the signs of a productive process, rather than representing them as real producers. In 1931, however, in partial response to contemporary criticism, (like N. Bekker's criticism of Klutsis for "deindividualization of a worker"), Klutsis began to construct a more readable picture of the coalminers' function in the process of the advancement of the Five Year Plan. This initiates a new shift in Klutsis's representational politics, which may be associated with the moment when "the absence of a man or his abstract, formalist treatment is replaced by concreteness."[44] In posters such as *We Will Give Millions of Qualified Workers* (1931) or *The Struggle for Heat and Metal* (1932), Klutsis depicts coalminers as concrete, powerful giants of the earth descending into the mines. For Klutsis, coalminers presented the most radical force in society. His position paralleled the enormous propagandistic campaign that glorified the coalminers as achievers of unsurpassable productivity. When Klutsis had to differentiate between various types of workers he always gave preference to coalminers.

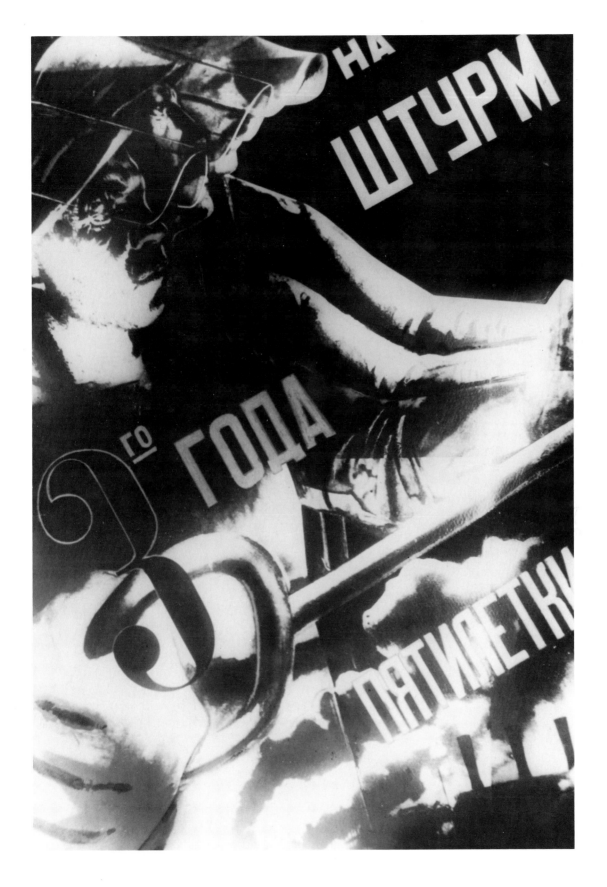

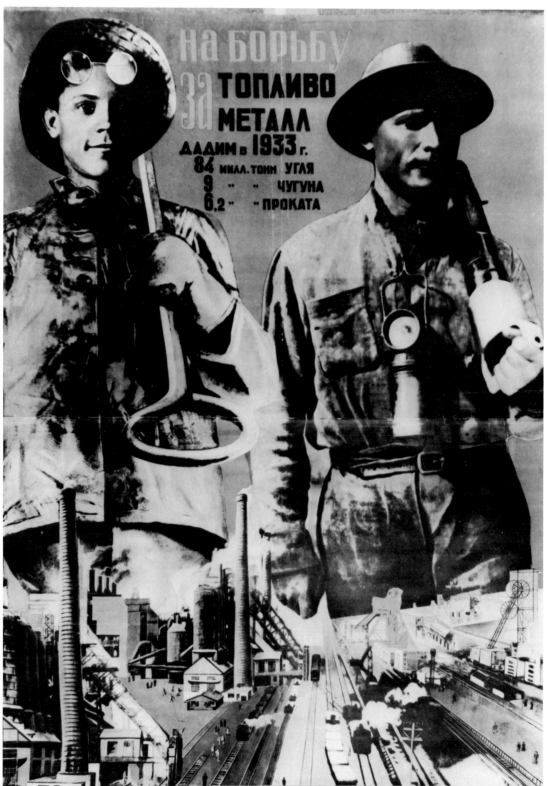

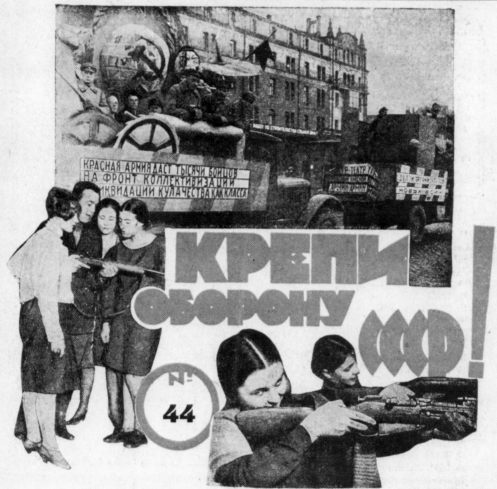

page 110
Gustav Klutsis
Struggle for Heat and Metal 1933
poster 56 7/10 x 40"
Courtesy of the Russia State Library,
Moscow

page 111
Artist unknown
Rabis: Strengthen the Defense of the USSR,
no. 44, 20 November 1930
brochure cover 9 15/16 x 7 3/32"
Collection of Sergei Bugaev

Varvara Stepanova
Untitled
endpapers for *Threatening Laughter*
(Moscow/Leningrad, 1932)
Collection of Sergei Bugaev

page 113
Valentina Kulagina
International Day of the Women Workers—
The Fighting Day of the Proletariat 1931
poster 41 x 29"
Courtesy of Russia State Library, Moscow

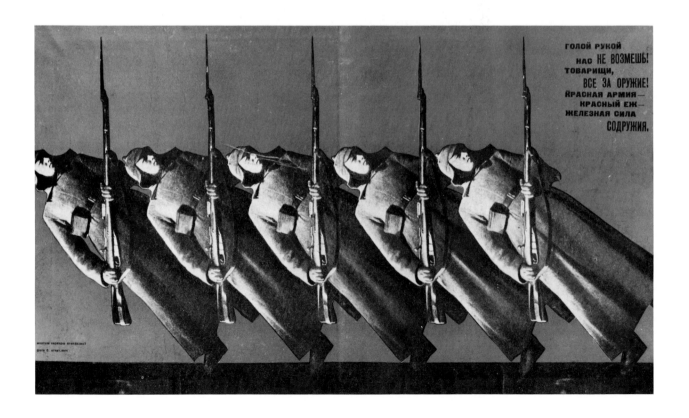

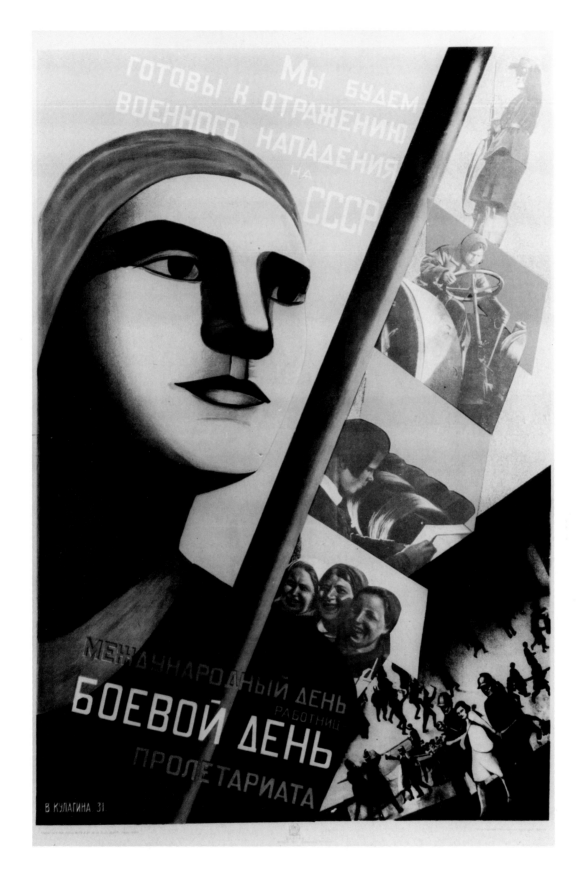

Coalminers were formed, literally, in his own image; in *The Struggle for Heat and Metal*, the artist chose to include his self-portrait in a coalminer's uniform. As in the case of the appropriation of his hand, for this poster Klutsis made preliminary photographs of himself alone or next to another coalminer which he then combined with an intricate industrial landscape stretching out at the coalminers' feet. Recalling the bond between the authorial hand and the power of the proletariat—first articulated in *Let Us Fulfill the Plan of the Great Projects*—Klutsis created a new paradigm of an artist, authenticating the producer above the individual creator. This allowed him to bridge the gap between author and public and, in Tretyakov's words, to shift from "the informing writer to the operating one." In *The Struggle for Heat and Metal* Klutsis replaced his hand, which functioned more as an authorial sign than as an autobiographical element, with his self-portrait, which finally allowed him to literally "side with the proletariat."[45]

In 1932 the Tretyakov Gallery held a large exhibition of posters which was entitled "Posters at the Service of the Five Year Plan." The exhibition summarized the achievements of this "ideological medium" over the last four years; the accompanying catalogue stated that the show was organized in response to a resolution of the Central Committee of the Communist Party Regarding Poster Production, to demonstrate "a hard path from a passive illustrative poster or the bourgeois advertising one to an expressive one which is clear and intelligible to the masses. This bolshevik poster must convey a proletarian idea."[46] Nikolai Dolgorukov, Elkin, Klutsis, Senkin, and two women, Pinus and Kulagina, participated in the show, each presenting from two to seventeen posters—the largest number being contributed by Klutsis, the fewest by the women. The exhibition was organized thematically, with only one section dedicated to advertising posters which were made for export. Regarding posters made for domestic usage, the catalogue's author P.S. Kaufman noted that our poster's main and new quality is that in addition to carrying its usual service of notification and information, it attempts to combine this function with politically instructive mass work. Thus a mere informative poster turns into a tool of

[45] For a further discussion of this poster see my "Szenarien der Autorenschaft," in *Gustav Klucis: Retrospektive*, Museum Fridericianum, Kassel, 1991, pp. 261–277, and the English version of this article in *The Print Collector's Newsletter*, Vol. XXII, No. 5, November–December, 1991.

[46] *Plakat Na Sluzhbe Pyatiletki*, catalogue, Tretyakov Gallery, ORRP-IZOGIZ, Moscow-Leningrad, 1932, p. 7.

S. Rossopovsky and S. Prussov
Glory to October which Liberated Wome
1927
poster 27 1/8 x 39 3/8"
Courtesy of Russia State Library, Moscow

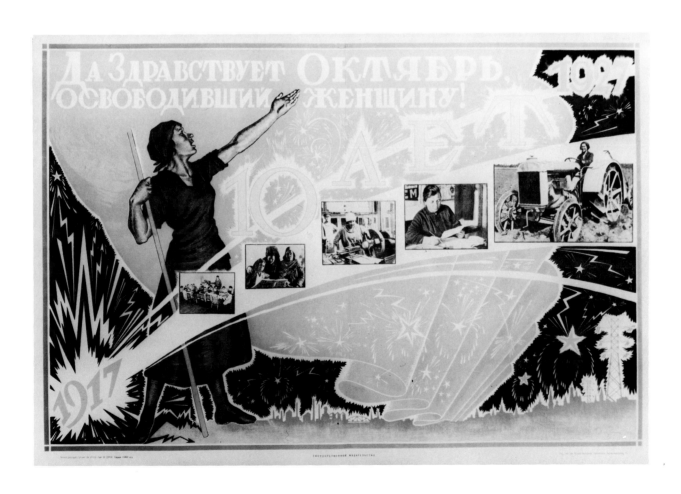

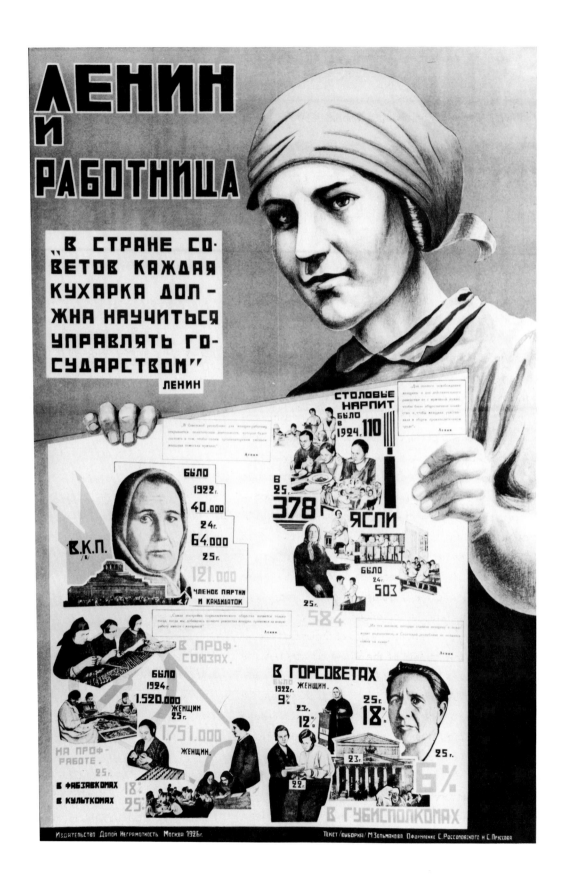

political agitation.[47]

In this context, Kaufman emphasized Klutsis's poster produced in 1931 for the "Anti-Imperialist Exhibition" as a successful example of a poster "combining an announcement about an exhibition with a graphic call to the vigilance of the proletariat. . . "[48] Unlike this example of propaganda, another section of the exhibition was called "discussional" and included posters in which according to the catalogue, "the alien influences, formalist tricks, advertising approaches, inability to choose the right images, and political illiteracy are clearly expressed."[49] Although Klutsis, Elkin, Senkin, and Dolgorukov primarily dealt with industrial themes, both Kulagina and Pinus specifically sought to encourage women's involvement in factories and on collective farms, and thus women's direct participation in the events of the Five Year Plan. In these posters, and in many anonymously authored posters dedicated to women's issues, photomontage played a paramount role in the dissemination of ideas related to women's rights and in the activation of women in the events of industrialization. In this second phase of photomontage women were represented as anonymous powerful heroines responsible for ongoing social changes. In many examples the image of one female character dominates the representation— the primary activists—while other women are shown in supportive photographic fragments attesting to various opportunities for and improvements of women's lives. In the mid-1930s this line of representation changed. Both poster slogans and the structural layout of imagery in photomontages were put to various ideological controls. Layout was centered around images of Stalin and the industrialization and control of the whole country became the primary narrative content. At that point although images of women still advertised them as equals of men, the images began to serve the condition outlined by Hèléne Cixous who wrote, "When a woman is asked to take part in . . . representation she is, of course, asked to represent man's desire." [50] Natalia Pinus / Gustav Klutsis's poster *Women on Collective Farms Are a Substantial Power* (1933) illustrates this process of the subordination of women's desires, which are invested in labor, to Stalin's authority. The

[47] Ibid. p. 8.

[48] Ibid.

[49] Ibid., p.9.

[50] Quoted in Craig Owens, "The Discourse of Others: Feminists and Postmodernism," *The Anti-Aesthetic: Essays on Postmodern Culture*, ed. by Hal Foster, Bay Press, Port Townsend, 1983, p. 75.

Designer unknown
Lenin and Woman Worker 1926
poster 37 x 24 2/5"
Courtesy of Russia State Library, Moscow

El Lissitzky
Workers and Smokestacks c. 1930
vintage gelatin silver print 5 7/8 x 7 5/8"
Courtesy Houk Friedman, New York

Gustav Klutsis
*The Feasability of Our Program is Real
People, It's You and Me* 1932
watercolor and collage 9 1/2 x 6 1/2"
Collection of Merrill C. Berman

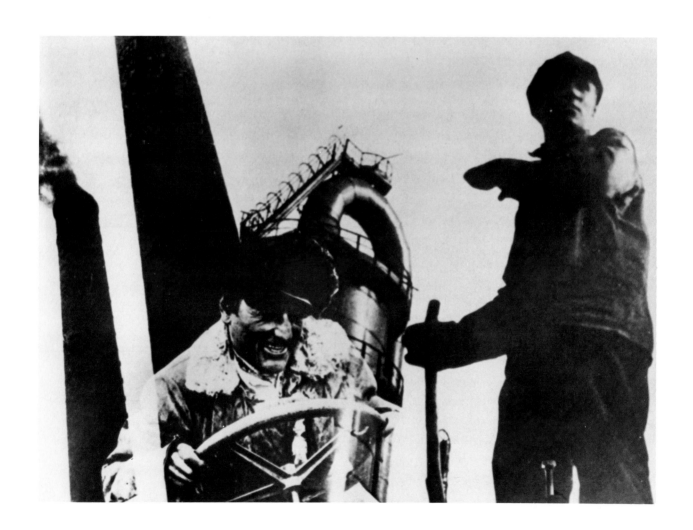

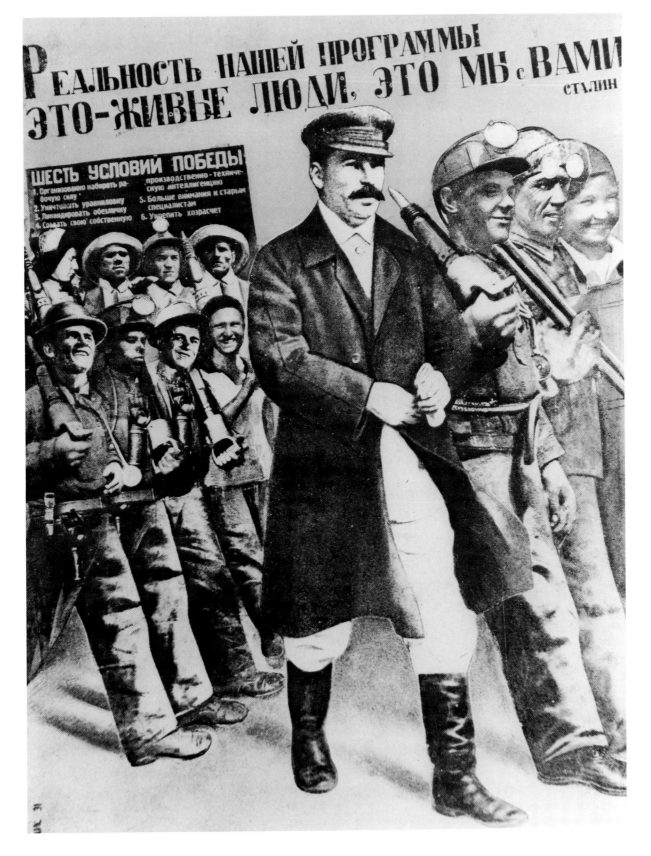

poster shows two female collective farmers, one on a tractor and another mowing, under the patriarchal gaze of Stalin. There is no ambivalence here: Stalin is offered as the ultimate referent for their effort and accomplishment.

The Pinus/Klutsis poster, as well as two of Klutsis's posters included in the "Posters at the Service of the Five Year Plan" exhibition, are of particular importance to our understanding of the function of the final phase of photomontage in the Soviet Union. In contrast to earlier representations of anonymous male and female workers, in these late examples, the power of the proletariat is subsumed in the power of the bureaucratic machine. In *The Reality of Our Program in Real People: You and Me*, by means of montage Stalin is suddenly made to appear in the ranks of the marching coalminers. Here, structurally at least the image remains "democratic," since no distinction in scale is made between leader and workers. Stalin is aligned with the workers as one of them, in an effort toward solidarity and support for progress, which by then was causing widespread hardship. [51]

In *The Victory of Socialism Is Guaranteed in Our Country* (1932), Stalin's image grew to enormous proportions, dominating both workers and other Communist Party members.[52] Stalin and his party apparatchiks appear in many of Klutsis's and Lissitzky's posters and magazine designs of the mid-1930s, which was photomontage compositions structured similarly by the two artists. Most serve as symbolic representations of Soviet industrial and military strength; in them, the metaphor of scale becomes equated with the hierarchy of power, with the masses increasingly playing a subordinate, supplementary role vis-a-vis the gigantic leader. Unlike the earlier posters, with their emphasis on social facts and reference to topics of the moment, this later work used photomontage to mythologize post-revolutionary Soviet reality in general and the figure of Stalin in particular. The factual information that had been an important part of the earlier posters was replaced by Stalin's tedious slogans: "The Soviet Working class surely and firmly advances the technical arming of its ally, the working peasantry." Some of these late photomontages document the ongoing repressions sanctioned by Stalin.

[51] At about the same time, a similar change took place in the photomontages of Lissitzky, produced for the magazine *USSR in Construction*. In the illustration "The Current Is Switched On" (1932), for example, the switching hand is akin to that represented on the cover for the magazine *Artists' Brigade*, but if the earlier photomontage conveyed a revolutionary message by the representation of a working class hand, here Stalin's image holds a dominant place, suggesting that his role in the victories of the Plan is equal to that of the working class, if not more important. It is interesting to note that the photograph of "The Current Is Switched On" was kept by Klutsis in his archive.

[52] Significantly, it was also in 1931 that Stalin appointed Andrei Vyshinsky as the chief prosecutor at the Moscow show trials. This fact indicates that Stalin gained full power in that year.

Gustav Klutsis
Workers' meeting in the streets of Moscow, posters by Gustav Klutsis. c. 1932
vintage gelatin silver print
Private collection

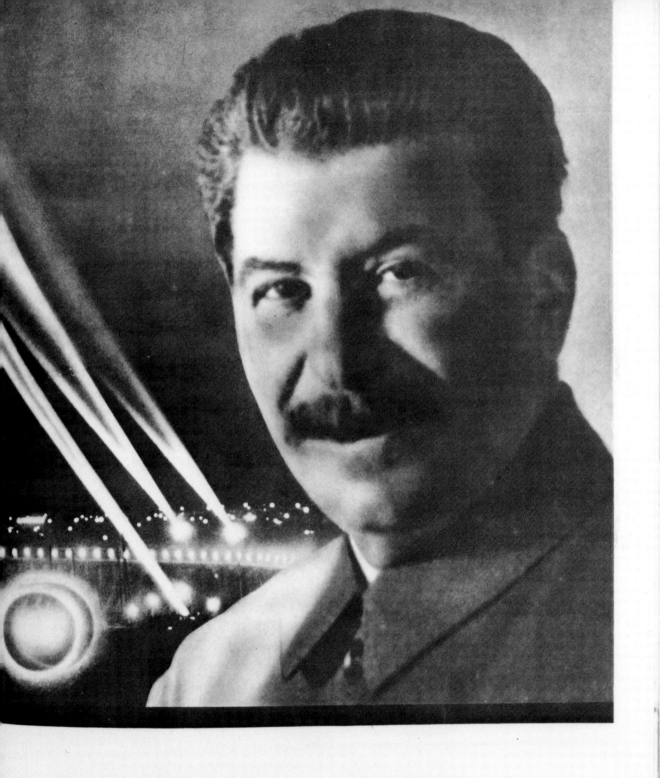

THE CURRENT IS SWITCHED ON

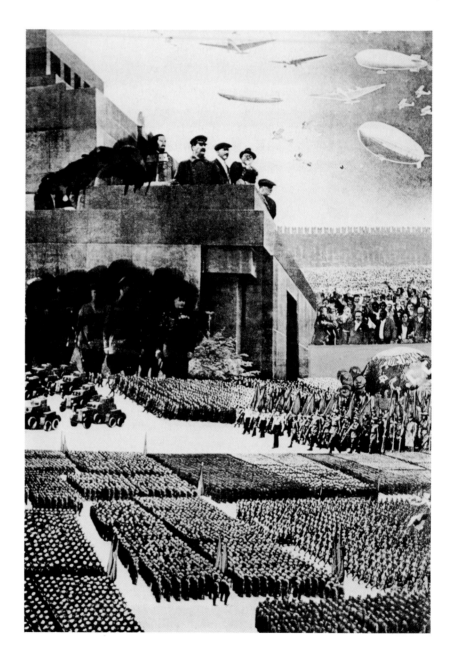

Vasili Elkin
Glory to the Red Army c. 1933
poster with effaced images 13 1/2 x 9 1/2"
Courtesy of Walker, Ursitti, McGinniss,
New York

Pages 122–123
El Lissitzky
The Current is Switched On c. 1932
vinatge gelatin silverprint 2 1/2 x 4"
Private Collection

This process may be noted in Klutsis's effacing of some of the Politburo members' faces from his posters and photographs. In the early 1920s, it could be said that photomontage replaced painting as the dominant media of "messages." It was seen as "modern" media, able to keep pace with social events. And yet, by the end of the decade, photomontage had fallen victim to its own omnivorousness, its formal flexibility, its ability to respond immediately to current events, its use of up-to-date photographic documentary material, and its goal to politicize art. One might argue that by the mid-1930s, photography and photomontage, even more effectively than Socialist realist painting, served to displace the strains of Soviet reality behind a "simulative" vision of a benign Stalinist utopia.

Although the reasons for Rodchenko, Lissitzky, and Klutsis's contribution to the glorification of Stalin's image cannot be explained easily, certain answers can be drawn from the side effects of industrialization and collectivization. The process of collectivization led to the peasants' migration on a significant scale to urban areas and industrial sites. This phenomenon engendered a housing problem of enormous proportions, turning the cities into a conglomerate of overcrowded apartments where different families were forced to cleave together in a single communal body. Stalin's course was to exploit the situation in the advancement of his project to de-individualize the consciousness and daily life of the Soviet people.

As a consequence of this mass communalization the proletariat had been lost in the communal swamp, desolved in "urban" peasantry or to use Leopold Sacher-Masoch's term, in "the low of the commune."[53] Under these circumstances, for an artist to continue to submit his/her "authorial hand to that of the proletariat," became as painful (if not suicidal) as being swallowed by the "Same."[54] An identification crisis was the result of this eco-ideological change. For artists like Lissitzky, Klutsis, and Rodchenko, the alternative was to seek identification with the superego, modeled on an inflated conception of the father's role, assumed by Stalin. The late posters of Klutsis show that, in his case, the artist's ego turned into an accomplice of Sadistic Superego (Stalin) establishing what French phi-

[53] "The low of the commune" is Leopold von Sacher-Masoch's term. It is identified by Gilles Deleuze with the so-called "oral mother," the Dionysian element of "agrarian communism." See Gilles Deleuze, *Coldness and Cruelty*, Zone Books, New York, 1991, p. 95.

[54] "The Same" is Michel Foucault's term used by him in *The Order of Things*. As Foucault argues, it is the identity of the return of the same. . . which causes the erasure of man "like a face drawn in sand at the edge of the sea." p. 387.

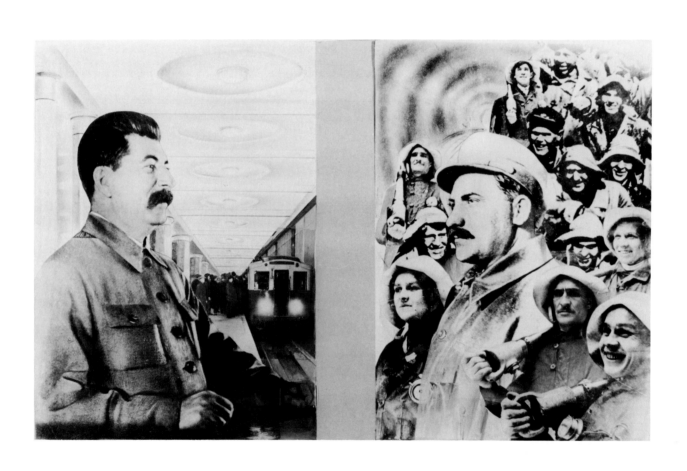

losopher Gilles Deleuze has called "institutional partnership" with the "father," the ultimate "spectator and residing genius to whom all activities are dedicated."[55]

Lissitzky and Rodchenko chose a different model to resolve their identification crises. Their position as artists was based on a "contractual partnership" between the ego and other "agencies," such as "the low of the commune," the failed revolution (the libertine), or fetishistic representations of "torturing and perversive idols" of the ideological. All this is rather typical for a masochist, and that is perhaps why Lissitzky's ego had always been institutionally uncommitted, constantly changing vantage point in order to contemplate its images in various projections of the "ideal ego." This condition was manifested in all his production beginning with the architecture of the commune (prouns and architectons) and ending with photomontages incorporating Stalin's representation.[56] We also easily recognize "who is who" in terms of the sadomasochistic vocabulary when Deleuze writes, "There is an aestheticism in masochism,"[57] (e.g., Lissitzky and Rodchenko, who never refused aesthetics), while in sadism "the imperative and descriptive function of language transcends itself toward a pure demonstrative, instituting function," (e.g., Klutsis).[58] Finally, the whole set-up of reiterating Five Year Plans, which could be attributed to "the cold purity of thought in superego" is a typically sadistic enterprise. This also explains an obsession with numbers (often written on posters) characterizing the years of industrialization. As Deleuze once again points out, "sadism operates by means of quantitative reiteration."[59] Contrary to that, in the case of victimized laborers, their masochism rests on a "suspension," that is, on a painful waiting for the culmination, the fulfilment of the given plan and the beginning of the next one.

[55] Deleuze, op. cit. p. 59.

[56] Rodchenko's famous photographs of his mother (1924) come to mind as Deleuze argues that "the masochistic contract. . . displaces onto the mother the task of exercising and applying the paternal law." p. 93. One may also refer to Masoch's "Venus in Furs" in connection with Lili Brik's image, which was utilized in Rodchenko's photomontages for Vladimir Mayakovskii's *Pro Eto*. In these illustrations, as well as in Rodchenko's famous montage called *Advertising Poster for Books* (1925), Brik is offered as the true libertine of her time. Lissitzky's *Self Portrait with Wrapped Head and Compass* promotes the notion of an artist as a victom which is typical of socio-masochism.

[57] Deleuze, op. cit. p. 134.

[58] Ibid. p. 23.

[59] Ibid. p. 134.

Gustav Klutsis
Metro 1935
photomontage 23 1/2 x 34"
Private collection

Margarita Tupitsyn, born in the Soviet Union, is an art historian and independent curator. She is the author of *Margins of Soviet Art: Socialist Realism to the Present* and has organized a number of important exhibitions on contemporary Soviet art. She is currently working on a book *The Function of Photographic Image: Soviet Practice 1924–1936*.

"Good fences make good neighbors"

AMERICAN RESISTANCE TO PHOTOMONTAGE BETWEEN THE WARS

Sally Stein

Something there is that doesn't love a wall,
That sends the frozen ground-swell under it
And spills the upper boulders in the sun,
And makes gaps even two can pass abreast.

I let my neighbor know beyond the hill;
And on a day we meet to walk the line
And set the wall between us once again.

—Robert Frost, *Mending Wall* [1]

Frost's poem "Mending Wall" came to mind when I tried to account for the relatively spare use of photomontage in the United States between the two World Wars. Previously I had studied examples of early twentieth-century American graphic design that deliberately joined, or at least juxtaposed, disparate imagery to produce new effects and meanings, often in the spirit of efficiency.[2] However, working in the context of a comparative cultural study, I was forced to ask why in the most rationalized industrial society was there not more, and more obvious, semiotic engineering?

[1] From Robert Frost's "Mending Wall" (1914), in Edward Connery Latham, ed., *The Poetry of Robert Frost* (Barre, MA, 1971), pp. 33–34.

[2] See my essays, "The Composite Photographic Image and the Composition of Consumer Ideology," *Art Journal* (Spring, 1981), pp. 39–45, and "The Graphic Ordering of Desire: Modernization of a Middle-Class Women's Magazine, 1914–1939," in Richard Bolton, ed., *The Contest of Meaning* (Cambridge, MA, 1989), pp. 145–161.

fig. 1
Paul Strand
The White Fence, Port Kent, New York, 1916
photograph
©1971, Aperture Foundation, Inc.,
Paul Strand Archive

Something about American culture put a brake on the kind of aggressive montage practice that characterized European visual culture between the wars.

"Mending Wall" seemed an appropriate place to begin to comprehend the American desire to maintain traditionally-bounded social and pictorial space. The poem was first published in Frost's 1914 collection, *North of Boston*, a collection titled to indicate the poet's deliberate distance from the modern urban scene. Quaint yet accessible, the poem turns on the vernacular aphorism "good fences make good neighbors" to demonstrate the literary force of staunch figures of speech and the social force of equally staunch markers of possessive individualism.

Already in the 1930s, "Mending Wall" had attained canonical status; it was one of a few twentieth-century poems printed as a broadside for display in public schools and libraries.[3] By the 1960s, Frost's poetry had become a staple in high school English classes: mannered and allegorical enough to require a bit of interpretive work, yet reassuringly familiar in its narrativity and its mythically timeless New England landscape. Of course, in schoolroom discussions of "Mending Wall," no one commented on, if any noticed at all, the homoerotics in the scene of two men groping with rocks—"some are loaves and some so nearly balls"—while resisting the impulse to jump the fence and come in closer contact. The wall seemed natural and inevitable, even if Frost wrote a poem grappling with its rationale.

Numerous critics have emphasized the spirit of open inquiry that serves as the poem's central motive.[4] Yet the title, "Mending Wall," safely indicates the outcome, for the challenge mounted against arbitrary restrictions is at best half-hearted. Although the poem opens by wrestling with the "something there is that doesn't love a wall," the wrestling is quickly curtailed. The speaker toys only briefly with possibilities of rebellion and then resigns himself to convention, closing with the neighbor's recitation of his father's saying, "Good fences make good neighbors." Such an ending expresses the poet's own conservatism, for the dogma distilled so epigrammatically betrays the solace as well as sadness Frost found in this spatial arrangement.[5]

The way I recall we read the poem in the mid 1960s,

[3] Joseph Blumenthal, *Robert Frost and His Printers* (Austin, Texas, 1985), p. 11.

[4] See, for example, Frank Lentricchia, *Robert Frost: Modern Poetics and the Landscape of Self* (Durham, 1975), pp. 103–107, and Richard Poirier, *Robert Frost: The Work of Knowing* (New York, 1977), pp. 104–106.

[5] On the eve of World War II, Frost expressly authorized conservative political readings of this poem, while discounting the tone of lament that the work successfully sustained. Invited to speak at a 1941 conference at Bread Loaf, the poet "observed ironically that some readers were known to have found political implications in 'Mending Wall'. He had no objections to that. He noted that good walls are necessary to keep things properly in and properly out. Good walls define good geography, which is necessary for a sound national life." Peter J. Stanlis, "Acceptable in Heaven's Sight: Robert Frost at Bread Loaf, 1939–1941," in Jac Thorpe, ed., *Frost Centennial Essays* (Jackson, MI, 1978), p. 305.

the law of the father had the rhythmic appeal of doggerel, and the images of rural boundaries being perennially shored up imbued the landscape of suburban lots with an unimpeachable tradition. The poem's traditionalism, combined with a form of rough-hewn modernism, was no less appealing in 1914; its invocation of native isolationism at a local level was especially reassuring on the eve of World War I, and *North of Boston* not only enjoyed glowing reviews by both traditional and modernist critics but also became an immediate best-seller.[6]

It is likely (though not certain) that Paul Strand, perhaps the most innovative modernist photographer of the teens, had read the poem by 1916 when he took his large camera out of the city and produced *The White Fence*, in which the demarcating line of property utterly dominates and alters the traditional rural landscape (fig. 1). The fence bisects and flattens the image, and its repetitive serrated pattern appears to be utterly definitive of both space and viewpoint. The fence, in other words, gives sense to the arbitrary quality of the framing; it proclaims even the act of framing, of fencing in, to be the photographer's proprietary right, indeed, his reason for being.

A year after he made this picture, Strand published his manifesto of modernist photography, a manifesto that made no less a point of the necessity for self-imposed boundaries. In this 1917 essay titled categorically "Photography," Strand rejected outright the hybrid practices of pictorial photography, a turn-of-the-century movement he considered utterly compromised by its tendency to resort to retouching, soft-focus, surface brushwork, and other artful dodges of the fundamentally mechanical process. Only by clearing the decks of all painterly influences, Strand argued, could photography realize its unique potential for "absolute unqualified objectivity. . . . The full potential power of every medium is dependent upon the purity of its use, and . . . all attempts at mixture end in . . . dead things. . . . The fullest realization . . . is accomplished without tricks of process or manipulation, through the use of straight photographic methods. . . . The existence of a medium, after all, is its absolute justification. . . ."[7] On the surface, Strand's advocacy of "straight photographic methods" was not based

[6] A broad selection of reviews of the volume by Ezra Pound, Harold Munro, Amy Lowell, and Louis Untermeyer, as well as by William Dean Howells and John Gould Fletcher, are reprinted in Linda W. Wagner, ed., *Robert Frost:The Critical Reception* (Burt Franklin, 1977), pp. 11–41. Lawrance Thompson notes the phenomenal popular success of the book, which in its first year was reprinted four times; Lawrance Thompson, *Robert Frost: The Years of Triumph, 1915–1938* (New York, 1970), p. 56.

[7] Paul Strand, "Photography," first published in the August, 1917, issue of *Seven Arts*; reprinted in Nathan Lyons, ed., *Photographers on Photography* (Englewood Cliffs, NJ, 1966), pp. 136–137.

on any literal sense of territoriality in relation to the land; his passion for purity, his proscriptive view of "all attempts at mixture," prefigure a quest for something whole and organic, as an end as well as a means.

It is true that in the rest of the series in which this image first appeared—the issue of *Camera Work* in which Strand announced his coming of age as a modern artist and Stieglitz bowed to a new generation—Strand's other examples of the new photography were all made in metropolitan New York or else were of small objects seen close up as abstract forms; although in one of these closeups, the geometric form of a railing is no less present and definitive for the shadow it casts.[8] It is also true that for the next few years, Strand continued to make the city his home, and its mechanical symbols inspired him to push the principle of photographic economy and relentless objectivity ever further, sharpening his conception and technique of straight photography. Yet as early as 1922, Strand voiced doubts about the "new god," the machine, implying that the culture of the machine required a more critical stance.[9] Rather than rethinking his advocacy of "straight photographic methods," however, Strand renounced, by and large, the city. After distilling in the urban environment a photographic style that seemed appropriately modern, he took it to the countryside. Straight photography served him very well, formulaically even, in representing the enduring power of folk traditions; and the rural pull evident in Strand's career is fairly representative of American art photography of this period.

What I want to explore, then, is the correspondence between the American cult of the straight photograph and a rather nostalgic, agrarian view of private property and bourgeois individualism. The American attachment to straight photography cannot be explained simply by invoking its unembellished, machine-like modernity, since the straight photograph represents only one strain of photographic modernity, as critics at the time often noted. For along with the rise in the late teens of a straight photographic aesthetic, there emerged another modern practice with photographs: photomontage—a mode of graphic assemblage in which significance derived from the disruption of

[8] See the series of eleven plates by Strand published in the final issue of *Camera Work*, June, 1917; the suite is reproduced in Marianne Fulton Margolis, ed., *Camera Work: A Pictorial Guide* (New York, 1978), pp. 138–140.

[9] Strand, "Photography and the New God," originally published in *Broom* 3:4 (1922); reprinted in Lyons, *op. cit.*, pp. 138–144.

the normative space of naturalistic photography and the normal appearance of things. The principle of active mediation underlying photomontage cast doubt on the adequacy of the autonomous photograph by suggesting that meaning required more than the selection of subject matter in the viewfinder but could be produced only through a combination of discontinuous visual and/or textual elements.

A cross-cultural examination of photography between the wars presents us with a paradox. In Europe and the Soviet Union, photomontage figured as a supremely modern graphic form, valued for its dynamic capacity to connote urbanism, industrial acceleration, and the explosive potential for change—as well as reaction—in social and sexual relationships. Europeans tended to view many of these features of contemporary life as consummately "American," or "Fordist," in their repudiation of tradition. To express that rupture with tradition, they often used montage to depict the disjunct, unrefined, heterogeneous character of modernity.[10] In the United States, however, the same processes of social transformation were far less often depicted, either affirmatively or critically, by means of photomontage.

European and American writings about photography in the interwar period underscore the divergent cultural responses to montage. In Europe, on the one hand, critics readily acknowledged the work of John Heartfield, the leading practitioner of left-wing photomontage. So apparent was Heartfield's influence that a number of European critics expressed concern that the growing fashion for cutting and pasting threatened to devolve in less purposeful hands into mindless play, devolve, in other words, into its anarchic roots in Berlin Dada.[11] In the United States, on the other hand, photomontage was discussed with some frequency in print, but always as if for the first time—as if it were an alien genre requiring elaborate explanation, definition, and endorsement, or peremptory dismissal.

In 1932, one American writer, surveying new European trends in photography, recommended photomontage as an especially apt pictorial vehicle for complex ideas and satire. "Probably no other form of modernism," he concluded, "has so many different variations and potentiali-

[10] See in general the recent catalog by Beeke Sell Tower, *Envisioning America: Prints, Drawings, and Photographs by George Grosz and his Contemporaries, 1915–1933* (Cambridge, MA, 1990), and in particular the photomontage designed by John Heartfield for endpapers in J. Dorfman, *Im Lande der Rekordzahlen* [In the Land of Record Profits], Vienna/Berlin, 1927, reproduced on pp. 52–53.

[11] See, for example, Franz Hollering, "Photomontage" (1928), and two essays by Durus [Alfred Kemeny], "Photomontage, Photogram" (1931) and "Photomontage as a Weapon in Class Struggle," (1932), in Christopher Phillips, ed., *Photography in the Modern Era* (New York, 1989), pp. 128–131, 182–185, 204–206. In a less dogmatic but still prescriptive vein, see in the same collection of European writings on photography the essays on photomontage by Raoul Hausmann and César Domela Nieuwenhuis, both of which were published in 1931 on the occasion of an international exhibition of photomontage that the latter had organized.

ties."[12] Other writers, however, tended to view this same variability as a form of pollution. In his 1934 study, *Technics and Civilization*, Lewis Mumford referred briefly to photomontage only to classify it as a deviation from photography proper. "The photographer," Mumford admonished, "cannot rearrange his material on his own terms." After extolling the reality principle in photography, he went on to decree: "As for the various kinds of *montage* photography, they are in reality not photography at all but a kind of painting, in which the photograph is used—as patches of textiles are used in a crazy quilt—to form a mosaic. Whatever value the montage may have derives from the painting rather than the camera."[13] While echoing the gist of Strand's earlier pronouncements, Mumford drew a new boundary around pure photography, extending the stigma of painting to the genre of photomontage.

Throughout the 1930s, most American photographers seemed to share Mumford's aversion. Barbara Morgan, who more than any American experimented avidly with photomontage, acknowledged this climate of resistance in a 1943 essay. "Photomontage," Morgan proclaimed in the encyclopedia *The Complete Photographer*, "stands before us [as] a great undeveloped potential." Yet offsetting this enthusiastic endorsement was a lingering tone of defensiveness about her atypical position. "The 'purists' call photomontage a bastard medium," she began, and then countered rather weakly, "I call it a challenging medium of expressing things that can be expressed in no other way." Morgan herself allowed that the bastard form needed careful introduction if it was to gain acceptance in America. Instead of beginning her discussion with the most emphatic types of graphic intervention, she took a less direct route, starting with illustrations of "natural photomontage," followed by a legitimating discourse on "modern life as a photomontage." In effect, she reduced photomontage to a realist paradigm. Only after these extended preliminaries did she arrive at her most significant examples of contemporary photomontage practice, works by John Heartfield and Herbert Bayer.[14] Addressing American photographers, Morgan obviously felt her audience had to be "prepped" before facing so momentous a form of surgical intervention in the body

[12] Edwin Buxbaum, "Modernism in Photography," *American Photography*, Nov. 1932, p. 620. To arrive at these conclusions, Buxbaum may have spent time in Europe, but he could have developed these views based on various European periodicals and publications that were available in the U.S.; or perhaps this essay constituted an indirect review of the New York exhibit, "Foreign Advertising Photography," held in 1931. For a brief discussion of this exhibit and its reception in the U.S., see Robert Sobieszek, *The Art of Persuasion: A History of Advertising Photography* (New York, 1988), pp. 36–37.

[13] Lewis Mumford, *Technics and Civilization* (New York, 1934), pp. 338–339.

[14] Barbara Morgan, "Photomontage," in Willard D. Morgan, ed., *The Complete Photographer: An Encyclopedia of Photography*, Vol. 8 (1943), pp. 2853–2866.

of the photograph.

Photomontage in the U.S. may have suffered from its association with European modernism, and even worse, Bolshevism, at a time when American contact with Soviet society was limited, and U.S. artists who had not emigrated to Europe were feverishly attempting to turn their backs on the continent and find native inspiration for their work.[15] However, it would be a mistake to infer from Morgan's essay that photomontage in the early 1940s was an idiom unknown to American photographers. As she herself acknowledged, the technique of cutting and pasting photographs was sufficiently common in America that it already had been rejected by photographic purists as a "bastard" form.

As in Europe, some of the more innovative efforts at montage in this country were produced by those who did not conceive of themselves primarily as photographers. A few are quite effective, such as the photomontage of New York bridges produced by Leigh Irwin for an early 1930s photobook, *This is New York* (fig. 2); in this instance, the collaborative character of authorship is underscored in a credit line that acknowledges the contributions of both individual photographers and bridge engineers. Compared with Irwin's deft graphic joining of various bridge spans into a labyrinthine, Luna Park-like structure, most American photomontages seem far more tentative. In the case of Hugo Gellert's "What's It All About," which appeared in the July, 1928, issue of the radical journal *New Masses* (fig. 3), the effort at political satire seems forced, an obvious first experiment in which the American ingredients are overpowered by a foreign recipe. More significant than the failure of the first effort was that it spawned no subsequent ones: the full-page montage has no other counterpart in Gellert's archive, nor did any other artists supplying illustrations to the *New Masses* publicly pursue this direction any further.

Photographers associated with the left-leaning Photo League seemed similarly disinclined to adopt this strategy, even though the League, which had begun as a cultural front of the Communist International, officially promoted the communist photomontages of John Heartfield. Though one

[15] On the nativist strain in American art photography between the wars, see Terence Pitts, *Photography in the American Grain* (Tucson, 1988).

fig. 2 (pages 136–137)
Leigh Irwin
"Skyways to New York," in Gilbert Seldes, and Leigh Irwin, photographic ed., *This Is New York* (New York, 1934), pp. 32–33.

Designers: Ammann, Lindenthal, Roebling, Hornbostel
Photos: Ewing Galloway, Lincoln, Levick, Bourke-White, Evans

SKYWAYS TO NEW YORK

Traversed a hundred million times, these magnificent struc-
tures, monuments of the useful, are among the greatest
works of art in Manhattan.

Composition by Hugo Gellert

WHAT'S IT ALL ABOUT?

They call it a Presidential Election, but it's all a bloody farce. Pickets still go to jail, smaller nations are still oppressed, Labor is hungry, there's a new world war coming, chorus girls get Rolls-Royces, whoever succeeds Clammy Cal.

published photomontage bearing the title "Workers of the World Unite!" is credited to the Film and Photo League, this appears to have been an isolated piece of work that had little lasting influence on the style of its members.[16] The short account of Barbara Morgan's 1940 lecture on photomontage that appeared in the League's journal, *Photo Notes*, reports that the evening concluded with Morgan serving as judge in the League's monthly salon-style competition of individual prints.[17]

Radical politics notwithstanding, most U.S. photographers on the left did not take issue with the prevailing belief that the claims of authorship were best pursued on a straight and narrow photographic path. If anything, photomontage in the U.S. seems to have leapfrogged the left and captured the imagination of conventional amateurs. By 1937, Fred Korth, a professional photographer who had emigrated from Europe, would declare in the leading amateur magazine, *American Photography*, that photomontages "are rarely pieces of art," but are worth considering for those situations requiring special illustration by more than one image. The same magazine continued to feature reports of amateurs adapting montage techniques to convert their hobby photography into functional forms of interior decor (fig. 4).[18] Added to the stigma of being an alien mode of practice, photomontage's domestication into Babbitt gadgetry must have further inhibited the interest of more serious American photographers.

Nevertheless, various forms of non-straight, combination photographic imagery can be found in the archives of many major photographers of this period—such as Berenice Abbott, Anton Bruehl, Imogen Cunningham, Walker Evans, Charles Sheeler, Edward Steichen, and even Paul Strand— though when considered as part of an artist's *oeuvre*, they appear as freak, marginal occurrences. When viewed as a group, however, the exceptional experiments tend to cluster around a few specific types of demand or else distinct historical moments of extreme political and cultural crisis. These experiments occurred most frequently in the following contexts: advertising; commissioned and independent depictions of theater, dance, and the movies; mural commissions; early responses to the economic crisis of the

[16] "Workers of the World Unite!," photomontage credited to the Film and Photo League, which was first published in the magazine *New Theatre* and was reproduced again in M. Lincoln Schuster, *Eyes on the World* (New York, 1935), pp. 24–25.

[17] "Barbara Morgan Speaks on Photomontage," *Photo Notes*, Feb. 1940, p. 2.

[18] Fred G. Korth, "Making Photomontages in the Enlarger," *American Photography*, Jan. 1937, pp. 22–26; Robert Mishell, "I Made a Mural," *American Photography*, Oct. 1939, pp. 721–728; C. F. Henken, "I Made a Travelog Lampshade," *American Photography*, Oct. 1940, pp. 712–718.

fig. 3
Hugo Gellert
"What's It All About?" in *New Masses*,
July, 1928, p. 16.
Courtesy of Widener Library, Harvard
College Libraries.

Illustrating exposures on both outside and reverse side of shade.

tion? Should the enlargement be made of the entire or of only a part of the negative? To what shape would it best conform and at what angle should the diagonal lines be made to frame the picture which would eliminate non-essentials and bring out its composition to best advantage? How would its size and shape look in relation to pictures surrounding it and to the whole pattern? Above all, how in heaven's name could I get all these pictures in without the appearance of cramming, keep them all in fairly good size, and the general design in good balance? All this I had to visualize from small prints of uniform size, taking up the pictures one at a time and tentatively sketching them in their allotted spaces.

The layout as finally completed did not quite satisfy me. Although I had given two pictures at widely spaced intervals the entire depth of the shade, there was the tendency elsewhere to too obvious a center horizontal dividing line in the pattern. I found, however, that by working in two or three very small pictures I could effectively overcome this

Outline pattern of shade, showing shapes and relative dimensions of pictures used.

714

and at the same time, enhance the effect of the entire pattern. I found also that I had to give up the idea of working in my entire original collection of pictures, and had to be content with a mere twenty-seven of them.

The negatives of these twenty-seven pictures I now arranged in order for a real test of the layout. In my enlarger I projected each of these negatives to its allotted space in the layout, manipulating in each case for the particular section of the negative and size of the enlargement I was to use; then from the projected image I penciled a sketch of the picture itself in fairly complete detail. By this means I was able to make alterations and improvements in the pattern at several points, and even a few substitutions of negatives as I went along, although on the whole there were few radical departures from the basic layout as tentatively drawn up.

With this phase completed, I had a fairly comprehensive idea of what the finished shade would look like, at least as to its all-over design. At this point, also, I ventured to show the layout to some of my camera-club friends. "It's too ambitious" was about the mildest of the comments made, all combined tending to throw a very cold, wet blanket over the project.

Undaunted, I next tackled the problem as to the proper exposure each of these negatives was to receive. I was unfamiliar with Duolux and could not afford to rely on guesswork, or even my experience with other enlarging emulsions. Moreover, to secure a sharp image clear through to the reverse side, Duolux requires the use of a yellow filter over the enlarger lens and a dull black surface beneath the Duolux to prevent reflecting light on the reverse side. I secured a package of a dozen small sheets of this material and cut them into test strips of different sizes to accommodate the various sized enlargements. For economy, I made a filter from a square of Wratten gelatin, mounted in a lantern slide and affixed with adhesive tape to the enlarger lens — crude but workable, the only drawback being the difficulty of critical focusing with the unaccustomed yellow light, since it was impracticable to remove the filter for each focusing operation.

Again with my negatives in order and the layout in place on the easel, with a square of black cardboard and the Duolux test strips accessible, with 55-D developer, shortstop and hypo all ready — everything to simulate actual conditions of the real job to follow — I was ready for the exposure tests. Each negative was carefully focused to the size of its

Entire lamp, showing transparent shade illuminated by both transmitted and reflected light.

715

140

Depression and the emergence of New Deal social policy; and then again at the start of a new period of crisis a decade later, as propaganda for wartime mobilization. In this essay, I offer only suggestive remarks about advertising and mural photomontages in order to concentrate on the use of photomontage to depict political and economic conditions at moments of extreme uncertainty. These latter works are especially revealing for the way they constitute the meeting ground of rhetorical and social instability.

Advertising represents a special case. For advertisers, the semantic instability of photomontage appealed and threatened simultaneously, with the result that they used montages quite cautiously. Interwar American advertising, of course, thrived on sharp comparisons—between the old and the new, the common and the uncommon—while also always imposing limits on the nature of discontent and the drift of desire. Disruption had to be followed by restabilization. Print ads typically incorporated diverse text and graphic elements, but they also tended to keep them strictly segregated. When brought into close contact, the resulting configurations were most often fairly simple and easily readable. For example, one ad for linoleum from the late 1930s stacks two "before and after" views of a dining room on top of each other. The addition of cutouts of a husband and wife—he's painting, she's sewing—actually makes the ad more conventional, for the figures are remarkably similar in scale and position to *putti* aeronautically conferring blessings on the hallowed scene of domestic renovation (fig. 5).

It is rare to find ads from this period in which photographs are combined in radically new configurations, producing a symbolic disruption of familiar icons, as in the Young & Rubicam agency ad with its striking picture of a businessman's head superimposed with a padlocked trap door, intended to figure here as a negative model of a closed mind (fig. 6). A bit more customary and more positive is the ad for an office typewriter in which the secretary appears on a distinctly urban pedestal (fig. 7), and part of the appeal of this reconfiguration is that the figure of the secretary, though elevated, remains intact. As a rule, in American

fig. 4
Designer unknown
Illustration from C. F. Henken, "I Made a Travelog Lampshade" in *American Photography*, October 1940, p. 714.

fig. 5
Designer unknown
"Mary–they won't know this room when we're all finished with it!" advertisement for Armstrong linoleum in *Ladies' Home Journal*, vol. 56, no. 10, October 1939, p. 5.

fig. 6 (page 142)
Designer unknown
"Wrong place for a padlock," Young & Rubicam, Inc. agency advertisement in *Fortune*, April 1940, p. 93.

fig. 7 (page 143)
Designer unknown
"A New Freedom for Secretaries!," advertisement for L. C. Smith typewriters in *Fortune*, vol. 21, no. 2, February 1940, p. 157.

Wrong place for a padlock

It has been said that, as an advertising agency grows, it veers toward self-satisfaction and smugness. It tends to rest content with the way things have been done, to be reluctant to dig out ways that are new and fresh, to put a padlock on that part of the brain from which the daring and the different spring.

Through nearly 17 years of growth, Young & Rubicam has made it a point to maintain an open mind, a willingness to learn, a healthful dissatisfaction with the usual and the hackneyed.

And so we consider it the most flattering kind of compliment when a client tells us (as one did recently): "I've never yet met a fellow from your place who pretends to know all the answers."

Young & Rubicam, Inc. ADVERTISING
NEW YORK · CHICAGO · DETROIT · SAN FRANCISCO · HOLLYWOOD · MONTREAL · TORONTO

A new Freedom for Secretaries !

WELCOME NEWS TO EXECUTIVES...and more welcome news to those hard-working girls who carry the burden of office work! A new freedom...from end-of-day fatigue. Long jobs made shorter, hard jobs made easier, by the easy action and speed of this new L C SMITH. New typing aids, too:

> New Automatic Margin Set (actually operative with one hand!) which sets right and left margins with one lever. New Concealed Touch Selector with *seven* positive adjustments. New Card Holder...New Linespace Mechanism...Improved Tabulator... plus all the time-tested L C SMITH features.

New in appearance...modern, smart...and a step ahead in typing aids, this is truly the finest typewriter ever to bear the famous L C SMITH name. We want to prove to you, in your own office, that it will save time, money, and energy for you...and for your operators. Any L C Smith branch or dealer will gladly demonstrate it, without obligation.

L C SMITH & CORONA TYPEWRITERS INC • SYRACUSE, NEW YORK

THE NEW *Super-Speed*
L C SMITH
...the finest typewriter in our history

Our CORONA PORTABLE TYPE-WRITERS also give top values in each price class. Five models, from $29.75 up; only $1.00 a week, plus small down payment. Dealers everywhere; booklet on request.

★ ★ ★

ALSO CARBON RIBBON TYPEWRITERS
CORONA ADDING MACHINES
VIVID DUPLICATORS
TYPEBAR BRAND RIBBONS & CARBONS

SECRETARIES: Send coupon for this new edition of "Tips to Typists"... a useful little booklet of time-saving ideas on typing. Free on request.

L C Smith & Corona Typewriters Inc
Desk 2, 113 Almond Street, Syracuse, N. Y

Maybe some of your *"Tips to Typists"* would be new to me. Please send free copy.

Name_____

Office Address_____

City_____ State_____

[19] See in particular the fairly subtle alteration of scale in the advertisement for Arrow shirts in Color Sells (New York, 1935), n.p. Archival research has uncovered a considerable number of less naturalistic montages produced for advertising in the 1930s, notable examples being works by Gordon Coster and Will Connell, however many of these efforts do not seem to have been used or at least do not appear in any of the major magazines of the period.

[20] Albert Poffenberger, *Psychology in Advertising* (New York, 1925), p. 573.

fig. 8
Designer unknown
"Let's see what happens on this fellow's chin," detail of an advertisement for Schick razors in *Life*, vol. 4, no. 5, January 31, 1938, p. 8.

photomontage of this period, the human body was not tampered with, the way it was in works by Herbert Bayer and Hannah Höch. One only can speculate that the relation between photographic image and reality was felt to be so immediate and organic that any pictorial alteration of the human figure risked being taken literally for anatomical mutilation.

Occasional ads depend for their effect on a certain degree of perverse estrangement, but in most cases shock effects were limited to alterations in conventional scale relations; as in an ad for Schick razors from 1937 (fig. 8), or an ad for refrigeration by ice from 1941 (fig. 9). Such Lilliputian scenarios were especially useful to advertisers when it was necessary to arrest the reader's attention, compelling the viewer to study a fairly complicated or quasi-technical sales pitch (for example, the swan song for older, more labor-intensive ice boxes desperately seeking the right "woman's angle"). However, advertisers considered this strategy a last, if sometimes necessary, resort. When the scale relations between consumer and commodity were altered to place more emphasis on the goods, the alteration tended to be less dramatic and more seamlessly produced, with skillful stripping in of component parts. This strategy was noted repeatedly in Conde-Nast's deluxe sales brochure *Color Sells* (1935), which promoted the skill of its engravers as well as its in-house photographers.[19]

In general, 1930s American advertising placed a premium on naturalistic illusion. "The suggestion should be indirect," Albert Poffenberger insisted in his mid-twenties text on advertising psychology, and he briefly elaborated that the market, like the democratic political process, should appear as unmanipulative as possible: "No one wants to feel that he is under the control of another; everyone clings to the notion that he is a free being."[20] What developed was an institutional myth of sincerity. Commercial photographers became masters of stagecraft in order to compress into a single naturalistic scene all the elements stipulated by an art director; this was true even for Lejaren à Hiller, who already in the teens had produced skillful photomontages for N. W. Ayer, the leading advertising agency before World War I, but who then in the twenties adopted more conven-

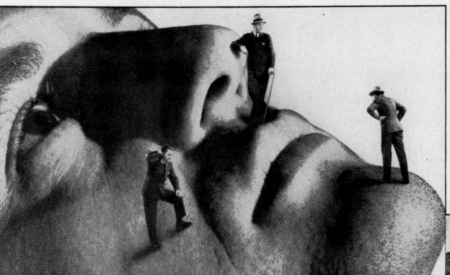

"Let's see what happens on this fellow's chin"

Scientific Fact: Whiskers grow in "pits," like this. Every man's skin is a series of tiny humps and hollows, thus making a close and comfortable shave difficult.

Here's what _must_ happen if he is to get a close and comfort-

able shave . . . To get a clean but comfort-able shave, the uneven skin surface (shown above) must be *stretched*, *smoothed* and *flattened*, so that the blade can cut the whisker evenly at the skin line without slicing the tops from the skin "bumps." A 5-year study of shaving problems made by one of America's great Industrial Research Institutes, proved absolutely that a *flat*, *solid* blade guard was the scientific way to accomplish this. The Schick Injector Razor incorporates this scientifically endorsed *solid* Guide Bar, which functions as *more* than a mere

Schick Blades are protected in a bath of oil in this metal blade-injector cartridge. Blade edges are suspended in space; no paper cov-ering which might rub and dull them.

Schick Blades are double-thick . . . are *able* to take a sharper edge and *hold* it. Each blade individually honed, stropped, in-spected. Result . . . more shaves per blade.

★ WOMEN AND CARROTS

have one enemy in common

That enemy is *dryness*. Dryness robs a woman's skin of its youthful beauty. *Dry cold* steals from vegetables and fruits their garden freshness, robs meats of their rich nutritive juices. Guard your foods against rapid drying out *and* the exchanging of flavors. Give them the protection of *proper moisture* and *clean-washed, vitalized air* available *only* in the air-conditioned *ice* refrigerator. Economical—costs a third to a half as much as other types... a servicing of ice lasts three to five days or longer. Plenty of pure, crystal-clear, taste-free ice cubes. Ask your local Ice Company *today* for a *free trial*.

TESTED AND APPROVED
NATIONAL ASSOCIATION
OF ICE INDUSTRIES

LOOK FOR THIS SEAL ... for your protection it is placed *only* on genuine air-conditioned ice refrigerators which conform to rigid standards of construction and performance established by the National Association of Ice Industries —refrigerators built to give you complete food protection and a lifetime of trouble-free, economical service.

NATIONAL ASSOCIATION OF ICE INDUSTRIES
228 N. La Salle Street, Chicago, Ill.
In Canada: 137 Wellington Street W., Toronto

FOR PERFECT REFRIGERATION
Cold alone is not enough... USE ICE!

WE CHALLENGE YOU TO LOOK AT ALL 3!

Before you buy any refrigerator get the facts about all 3 types—then choose. We challenge you to match the 1941 air-conditioned ICE refrigerator in sheer *food-keeping ability*—in its provision of both *proper moisture* and *clean-washed air*, in addition to constant cold. We challenge you to match its *economy*—its freedom from breakdowns, from defrosting and from noise.

The ice refrigerator illustrated is a large family size McKEE priced at **$62.50** f.o.b. factory. Genuine air-conditioned ice refrigerators recommended by the National Association of Ice Industries are manufactured under the following trade names: COOLERATOR, McKEE ICEDAIRE, OLYMPIC, PROGRESS and VITALAIRE. There is a wide variety of styles and sizes available on *easy terms* at prices ranging from $29.50 to $94.50.

fig. 9
Designer unknown
"Women and Carrots," advertisement for
National Association of Ice Industries in
McCall's, vol. 68, no. 10, July 1941, inside
front cover.

fig. 10
"Impact," Young & Rubicam, Inc. agency
advertisement (Vaughn Flannery, art
director; Martin and Anton Bruehl,
photographers) in *Fortune*, July 1930, p. 81.

tional methods of theatrical enactment in the studio.[21] According to one European photographic historian, this type of elaborate stagecraft was practically unknown in European commercial photography of the period.[22] It also has obvious parallels to the priority given to *mise en scène* in American narrative film of this period.

Photographers like Steichen, Keppler, Bruehl, Muray, and Hiller welcomed the opportunity to control the terms of production and rose to the challenge of orchestrating life-like scenarios. The best ads, it was widely thought, should seem plain and forthright, though many apparently simple ads were far from simple to produce. To take one example, the knockout shot used to illustrate the idea of "Impact" (fig. 10) actually involved many trial enactments until black models were substituted for the original white combatants, providing the white viewer with a comfortable margin of distance from the spectacle of assault. This Young & Rubicam agency ad can hardly be counted as typical, since it initially was aimed at a select audience of *Fortune* readers. Still, this ersatz type of hard-hitting photojournalism won a number of awards, was rerun throughout the 1930s, and within advertising circles was regarded as a supremely effective model of communication.[23]

The revival of interest in the mural as an art form also gave rise to a limited amount of photomontage work. Impressed with the vitality of the mural art of the Mexican revolution, the Museum of Modern Art attempted to reinvigorate what traditionally was a conservative form of public art in the U.S. In 1932, MoMA invited more than sixty U.S. artists to produce murals on the general theme of the postwar world. Most of the painters had little experience with large-scale works, but the photographers were even less prepared for this project, since most modern photographs that were made with an eye for detail and precision tend to fall apart when greatly enlarged. As a result, the 1932 show at MoMA exhibited a surprising number of photomontages composed of smaller images. A few photographers, like Berenice Abbott and George Platt Lynes, took the opportunity to depart radically from their established working methods (fig. 11). While Abbott pursued this direction no further, Lynes would

[21] Although Lejaren à Hiller was a very successful commercial photographer during the first four decades of this century, his career awaits serious study. One photomontage he produced for Goetz silk in 1916 is reproduced in Ralph M. Hower, *The History of an Advertising Agency* (Cambridge, MA, 1949). A large quantity of photomontages in the form of quite brittle newspaper tearsheets relating to the same World War I era advertising campaign are preserved in the Archives Center of the National Museum of American History, Smithsonian Institution, Washington, D.C. The largest collection of Hiller's work from the interwar period is found in the Visual Studies Workshop, Rochester, N. Y. The Visual Studies Workshop printed a brochure to accompany its traveling exhibit of Hiller's work that was curated in the late 1970s; a slightly longer account of Hiller's career is found in Robert W. Marks, "Portrait of Hiller," *Coronet*, March, 1939, pp. 147–157.

[22] Notes from a conversation with Ute Eskildsen, New York City, September, 1989.

[23] According to Raymond Rubicam, the ad not only appeared in one of the first issues of *Fortune* (July, 1930, p. 85), but it also ran in the first issue of *Life* and was still being used by the agency in 1946; the ad and a brief account of its genesis are included in John Lewis Watkins, *The 100 Greatest Advertisements* (New York, 1959), pp. 96–97.

fig. 11
Berenice Abbott
New York 1932
modern print from archival negative
Courtesy of Commerce Graphics Ltd., Inc.

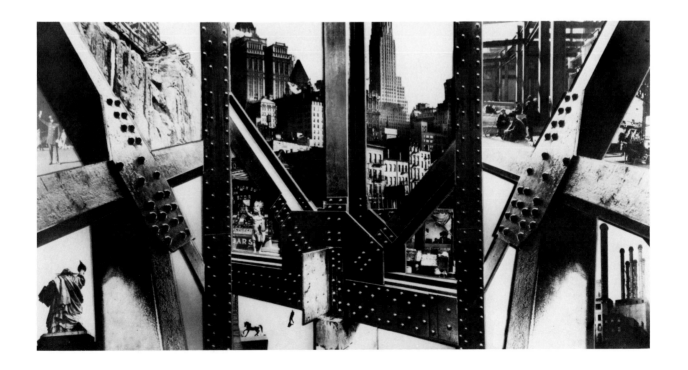

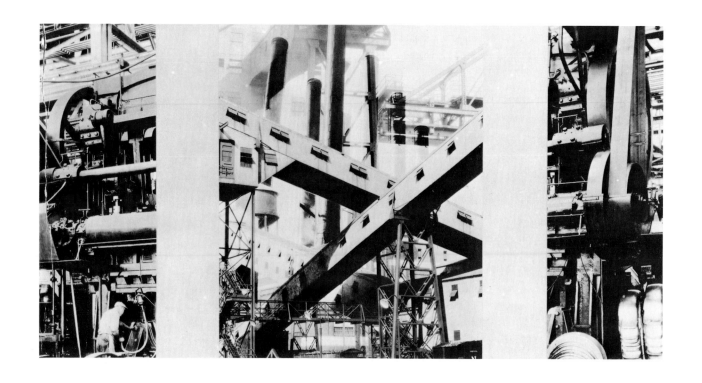

continue to experiment with composites of classical male nudes in modern settings. Most of the participating photographers, however, took fewer chances, tending to resolve the problem of scale by dividing the space into three, or five, smaller compartments, which resulted in fairly conventional triptych formats. To compensate for lack of detail in these still considerable enlargements, Charles Sheeler supplied additional texture by means of fairly soft, unconfusing double exposures (fig. 12). The most radical instance of disorienting multiple printing was produced by Thurman Rotan (fig. 13), and even here the result conforms to the bilaterally symmetrical triptych, although Rotan at least created more movement across the plane by dispensing with internal borders.

The short catalog essay by Julien Levy, guest curator of the photographic section of the exhibit, noted the adoption of montage as one practical strategy for photographers working on large-scale projects, while also sounding a note of caution regarding the use of montage: "there is always the chance that the result will appear disjointed and arbitrary," implying quite clearly that these were effects photographers would want to avoid at all costs.[24]

Steichen, though represented in this MoMA exhibit by a single worm's eye view of the George Washington Bridge, in the next year would employ more complicated techniques executing two mural commissions: one for the New York State Building at the Chicago World's Fair, another for the men's smoking lounge in the new Roxy Theatre at Rockefeller Center (fig. 14). The Roxy mural on the topic of aviation met with considerable public approval, yet the most enthusiastic response in print emphasized the quality of "unbroken sequence," and the few surviving illustrations of the mural suggest that Steichen kept his component parts sufficiently few and large to achieve a lyrical spacious movement around the room, thus avoiding any disjointed effect.[25]

Much closer in spirit to European montage practice was the complex collection of urban fragments assembled by Alexander Alland on the theme of Old and New Newark for the Newark Public Library, a project sponsored by the WPA (fig. 15). However, the photographic literature

[24] Julien Levy, "Photo-Murals," in *Murals by American Painters and Photographers* (New York, 1932), p. 12.

[25] Edward Alden Jewell's review in the *New York Times*, as quoted in Nicholas Haz, "Steichen's Photo-Murals at New York's Radio City," *American Photography*, July, 1933, p. 406.

fig. 12
Charles Sheeler
Industry (mural maquette) 1932
modern print from archival negative

fig. 13
Thurman Rotan
Skyscrapers c. 1932
gelatin silver print, toned brown
4 1/2 x 8 3/4"
Courtesy of The Art Institute of Chicago, The Julien Levy Collection, Gift of Jean and Julien Levy

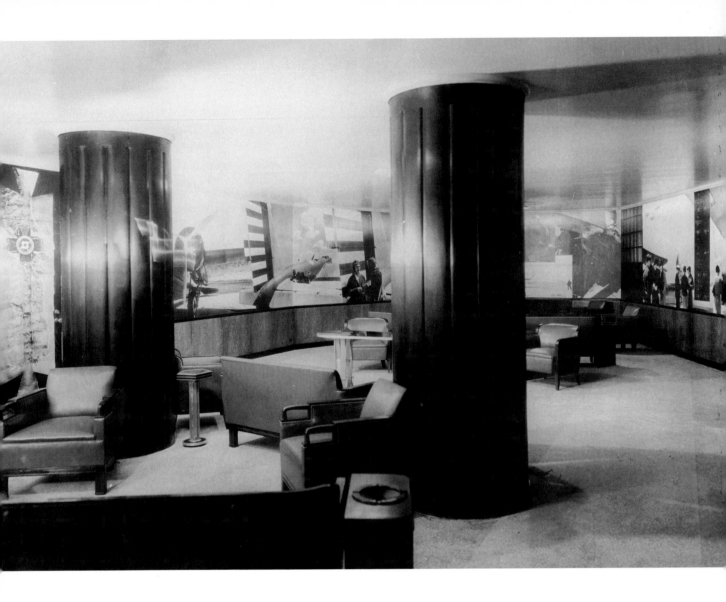

contains no discussion of this impressive work, and even the New Jersey library where it was installed has no record of either the mural or of public reaction to it.

From maquettes of proposed murals in the WPA archives, it is clear that photomontage was consistently thought appropriate for certain modern themes like contemporary sports, aviation, and the city.[26] Yet these were neither the dominant themes, nor was the mural a common form for American photography in the interwar period. In form, thirties photography proved better suited to the smaller scale of magazines, books, and conventional exhibitions. And in all of these contexts, the most prevalent topic for photographs other than advertising was the depiction of economic and social life, usually in terms of individual social adaptation, usually situated outside of urban centers.

The style that ultimately prevailed in American social photography of the thirties is that of documentary—though it would not be hailed publicly as such until 1938.[27] In addition, the most widely circulated documentary images were portraits of isolated individuals or of individual families. Roy Stryker, chief of the Farm Security Administration photography unit that exemplified the style, dubbed it "the individual case method," thereby invoking the rhetoric of traditional welfare work, applied on an individuated "case-by-case" basis.[28] Yet this "case method" strategy of social photography emerged only over the course of the Depression, superseding earlier modes of photographic representation that were closer to montage. Indeed, during the first half of the Great Depression, some of the most socially-oriented, photographically illustrated publications were governed by quite different presentational modes. These social photography books from the early 1930s tended to treat the single photograph as an insufficient unit of communication; in an attempt to render the extent of the crisis and in some cases to depict its structural causes, they experimented with more complex graphic constructions—layouts that registered uncertainty about the existing social order. Only after reforms were institutionalized and a sense of order was restored did the single image assume a more prominent position in a stable grid of graphic com-

[26] In addition to Alland's "Old and New Newark," see the maquettes by Leo Lances, Byron Browne, Alexander Alland, Wyatt Davis, and Dmitri Kessel that are reproduced in Merry A. Foresta, "Art and Document," Pete Daniel, Merry A. Foresta, Maren Stange, and Sally Stein, *Official Images* (Washington, D.C., 1987), pp. 175–179.

[27] Beaumont Newhall offers a preliminary discussion of documentary photography in his essay, "Documentary Approach to Photography," *Parnassus* 10 (March, 1938), pp. 3–6.

[28] Roy Stryker to Russell Lee, Feb. 13, 1937, pp. 1–2; Stryker Personal file, University of Louisville Photographic Collection, Louisville, KY.

fig. 14
Photographer unknown
Installation photograph of Edward Steichen's mural on the theme of aviation at the RKO-Roxy Theater c. 1935
Courtesy of Rockefeller Center,
© Rockefeller Group, Inc.

fig. 15
Photographer unknown
Installation photograph of Alexander Alland's mural, *Old and New Newark*, Newark, N. J. 1938
Courtesy of National Archives, Washington, D.C.

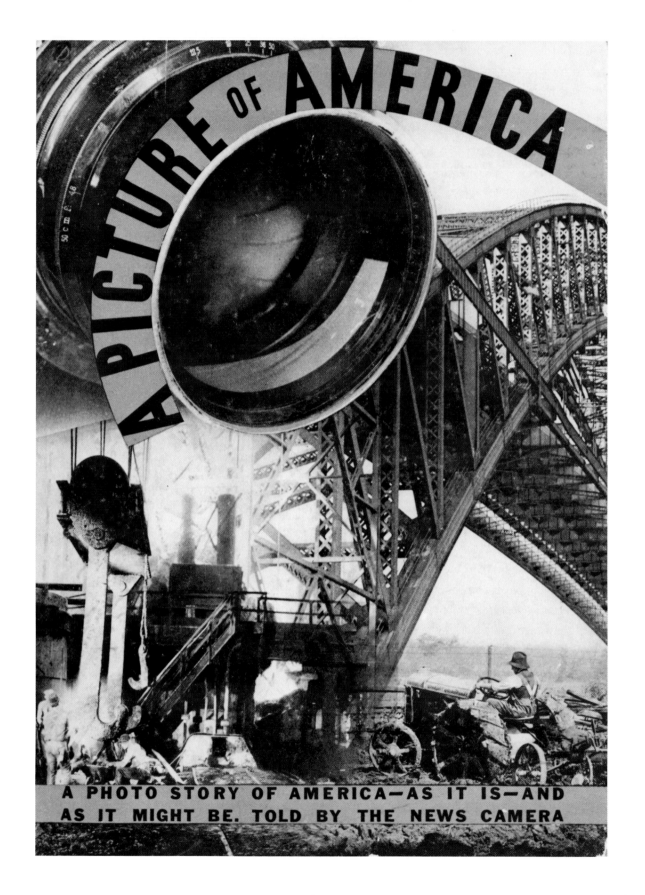

A PICTURE OF AMERICA

A PHOTO STORY OF AMERICA—AS IT IS—AND AS IT MIGHT BE. TOLD BY THE NEWS CAMERA

munication. The earlier publications warrant close consideration in order to appreciate the normalizing rhetoric of these later, more familiar, and seemingly less polemical forms of New Deal photography.

The first of these books illustrating the social crisis, Charles Cross's *A Picture of America*, was published in 1932, the last year of the Republican Hoover administration. In the montage appearing on the book's cover (fig. 16), the camera occupies the most prominent position, but nearly as important is the image of a bridge, a symbol of movement rather than stasis. Inside, the book combined short bits of economic analysis with small photographic reproductions that had been strictly organized into diverse illustrative configurations. This format downplayed the individual photograph; the graphic evidence was not left to "speak for itself" but was problematized in larger structural relations. While the book made a point of the human misery caused by capitalist crisis, it dwelt more on the *causes*, particularly the impact of mechanization, and the consequent need for national planning and reduction of the working day (fig. 17). Politically, the author championed "democratic socialism" as the most reasonable response to capitalism's failure, especially when compared with the alternatives, communism and fascism, and it is worth noting that the peaceful road to socialism was represented by a straight photograph of an individual poised on the threshold of a voting booth—in contrast to the montage representations of communism and fascism (fig. 18). Yet montage was used more prominently to convey a supremely positive image in the next double-page spread that depicted the benefits of socialism (fig. 19). Inserted at the center of this utopic representation was the recurrent motif of the scale, symbol of the planned economy. Significantly, however, the various subordinate elements that revolved around the scale were not closely clustered but were broadly arranged in an open constellation; in other words, the use of soft vignetting around each of these images guarded against the possibility of collision and conflict, suggesting a very loose, non-restrictive confederation of individuals.

Two years later, a number of books published in 1934 provided early assessments of the New Deal. One of these,

fig. 16
Designer unknown
cover of Charles Cross, ed., *A Picture of America* (New York: Simon & Schuster, 1932)
Courtesy of University of California, Los Angeles, Arts, Architecture and Urban Planning Library, Los Angeles, California

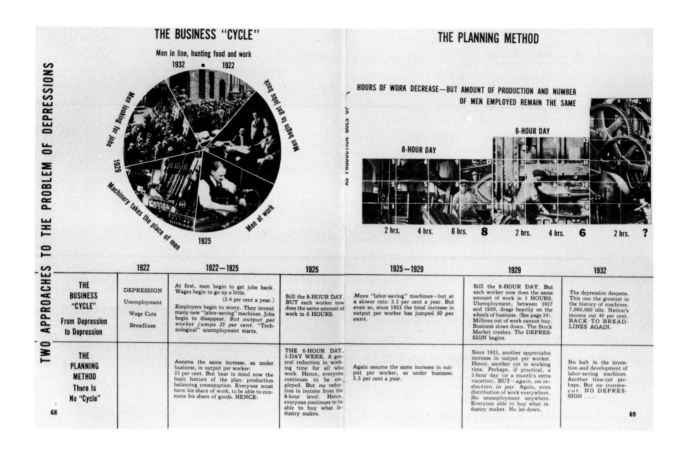

THE BUSINESS "CYCLE"

Men in line, hunting food and work

1932 1922

Men looking for jobs

Men begin to get jobs back

Seek jobs back

1929

Machinery takes the place of men

Men at work

1925

THE PLANNING METHOD

HOURS OF WORK DECREASE—BUT AMOUNT OF PRODUCTION AND NUMBER OF MEN EMPLOYED REMAIN THE SAME

8-HOUR DAY 6-HOUR DAY

2 hrs. 4 hrs. 6 hrs. **8** 2 hrs. 4 hrs. **6** 2 hrs. **?**

	1922	1922—1925	1925	1925—1929	1929	1932
THE BUSINESS "CYCLE" From Depression to Depression	DEPRESSION Unemployment Wage Cuts Breadlines	At first, men begin to get jobs back. Wages begin to go up a little. (2.4 per cent a year.) Employers begin to worry. They invent many new "labor-saving" machines. Jobs begin to disappear. *But output per worker jumps 35 per cent.* "Technological" unemployment starts.	Still the 8-HOUR DAY. BUT each worker now does the same amount of work in 6 HOURS.	*More* "labor-saving" machines—but at a slower rate: 3.5 per cent a year. But even so, since 1922 the total increase in output per worker has jumped *50 per cent.*	Still the 8-HOUR DAY. But each worker now does the same amount of work in 5 HOURS. Unemployment, between 1927 and 1929, drags heavily on the wheels of business. (See page 34.) Millions out of work cannot buy. Business slows down. The Stock Market crashes. The DEPRESSION begins.	The depression deepens. This one the greatest in the history of machines. 7,000,000 idle. Nation's income cut 40 per cent. BACK TO BREAD-LINES AGAIN.
THE PLANNING METHOD There Is No "Cycle"		Assume the same increase, as under business, in output per worker: 35 per cent. But bear in mind now the basic feature of the plan: production balancing consumption. Everyone must have his share of work, to be able to consume his share of goods. HENCE:	THE 6-HOUR DAY, 5-DAY WEEK. A general reduction in working time for all who work. Hence, everyone continues to be employed. But *no reduction* in income from the 8-hour level. Hence, everyone continues to be able to buy what industry makes.	Again assume the same increase in output per worker, as under business: 3.5 per cent a year.	Since 1925, another appreciable increase in output per worker. Hence, another cut in working time. Perhaps, if practical, a 5-hour day (or a month's extra vacation). BUT—*again, no reduction in pay.* Again, even distribution of work everywhere. No unemployment anywhere. Everyone able to buy what industry makes. No let-down.	No halt in the invention and development of labor-saving machines. Another time-cut perhaps. But *no income-cut.* NO DEPRESSION . . .

68 69

FASCISM

Since the war, we have a name for **the saving of capitalism by a dictator,** by a "strong man." Look now at the classic example: Italy! Mussolini! The "strong man" rises! Straight from the working class he rises. Then he, the traitor, will understand how best to placate the dumber of his former fellows and how best to silence the wiser of those he has betrayed. He will stop at nothing. He will imprison. He will exile. He will torture. He will assassinate . . . He will cut wages. He will threaten and frown at bankers and industrialists. (But note: he will not dislodge the bankers and industrialists). He will make a crazy explosive mixture of socialism-in-capitalism . . .

In America, Fascism may take a different form. We would probably keep the cloak of democracy. Our industrial leaders would begin to "plan." Already, they talk of doing so. But for whom would they plan? It is well to know. For whom would bankers plan? How would railroad presidents plan, to help competing oil pipe lines, gas lines, barge lines, motor bus lines? Who would plan for the interests of over 20 million

COMMUNISM

When Fascism fails, all has failed. Private gain, profit, individualism, individual initiative—all have had their final fling. They have lost. The last recourse of a desperate people is left. The end of Fascism is Communism. Barricades in the streets. Revolution. The armed and bloody **dictatorship of the people.** Who is not for the people, is against them . . .

How else can Communism conquer? How else can it rule? It is the child of violence, brought into being by the brutal, selfish violence of Fascism or of capitalism—of brutal Cossacks or police, in old St. Petersburg, or in New York, or in the mine fields of Kentucky . . . Years pass. The sound of

SOCIALISM

Are violent roads the necessary roads from capitalism to socialism? Must we travel them, each in turn? *The Socialists think not.*＊ They say that there can be no true socialism until the majority of the people understands and wants socialism. Then **socialism** will come without armed dictatorship, **without violent revolution.** Today, socialism, as a political party, has more members than any other political party in the world. But, in no one country has it yet had the power of the majority to put true socialism into effect. But in cities where it has gained power it has already begun to build toward the future. In poverty-stricken Vienna, in the heart of a hostile nation, Socialists have built the finest workers' apartments in the world.

The New Dealers, though otherwise unillustrated, opened to endpapers filled with a photomontage of the cast of bureaucrats and braintrusters appointed by Roosevelt in his first year to shape New Deal policy and reform programs. However, this type of compressed arrangement of images was avoided in another pictorial report on the New Deal that appeared in 1934, Pare Lorentz's *The Roosevelt Year*; with a jacket cover featuring a large portrait of FDR, the book broadcast its narrower focus on a single personality. Consistent with its glorification of the new president, Lorentz's book paid more attention to individual pictures, and the configuration of pictures resembled the fairly static layout of pictorial roto sections in contemporary newspapers. In his capacity as picture editor, Lorentz at times tinkered with the photographic frame, but even when the individual rectangles were radically disrupted—as with the overlap of pictures of Roosevelt in Miami and the unemployed man who attempted to assassinate the president-elect during his visit there—a prominent white margin created a buffer zone, which effectively signaled the ultimate outcome of stability and order (fig. 20). Moreover, the final double-page photographic spread strictly segregated full-page images of capital and labor, and the accompanying caption argued that the National Recovery Act, the first major piece of New Deal social legislation, did not wholly satisfy either labor or capital, but functioned for both as a productive, working compromise (fig. 21). Although the image of the president was absent in this coda to the book, the dual use here of straight photographs and deliberate borders had begun to serve symbolically as the graphic rhetoric of power in place and social conflict being kept at bay.

Lorentz's book probably was instrumental in gaining him a government publicity job; by 1935, he had begun producing some of the more famous New Deal documentary films, the first being *The Plow That Broke the Plains*.[29] Still, the picture books on the Depression that immediately followed his did not adopt the simple design format of *The Roosevelt Year*. Rather, in their quest for dynamic layouts, the topical publications of the mid 1930s often settled for a choppy (or, to use a period idiom, jittery) mode of book design. To take one example, M. Lincoln Schuster's *Eyes on*

[29] See Robert L. Snyder, *Pare Lorentz and the Documentary Film* (Norman, OK, 1968).

fig. 17
Designer unknown
"Two Approaches to the Problem of Depressions," from Charles Cross, ed., *A Picture of America* (New York: Simon & Schuster, 1932), pp. 68–69.
Courtesy of Stephen White Collection II

fig. 18
Designer unknown
detail of layout, "The choice of roads," from Charles Cross, ed., *A Picture of America* (New York: Simon & Schuster, 1932), p. 73.
Courtesy of Stephen White Collection II

fig. 19 (pages 158–159)
Designer unknown
"Where science and industry plan and balance...," from Charles Cross, ed., *A Picture of America* (New York: Simon & Schuster, 1932), pp. 76–77.
Courtesy of Stephen White Collection II

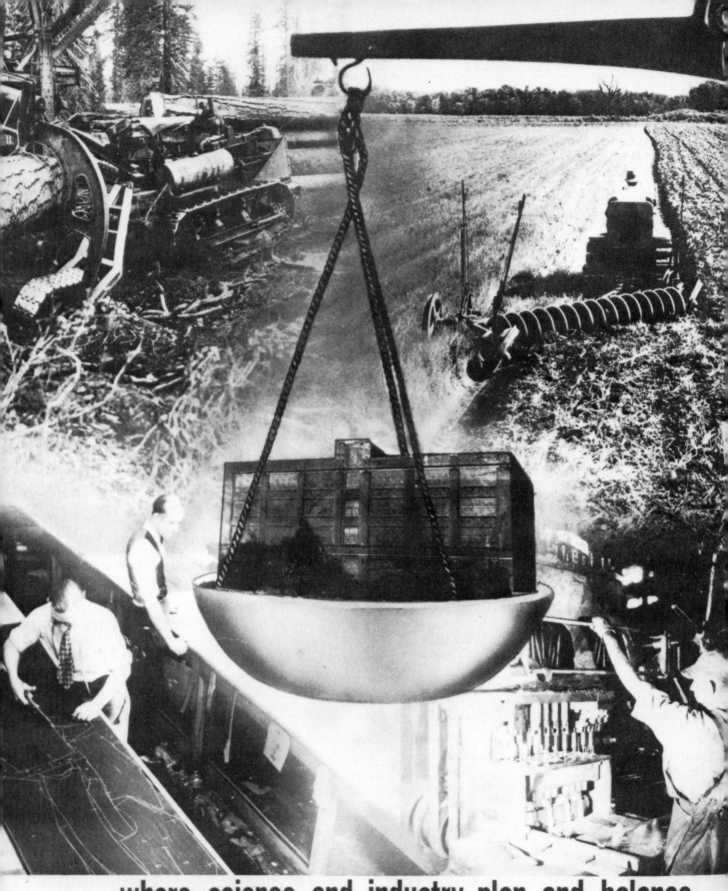

..... where science and industry plan and balance

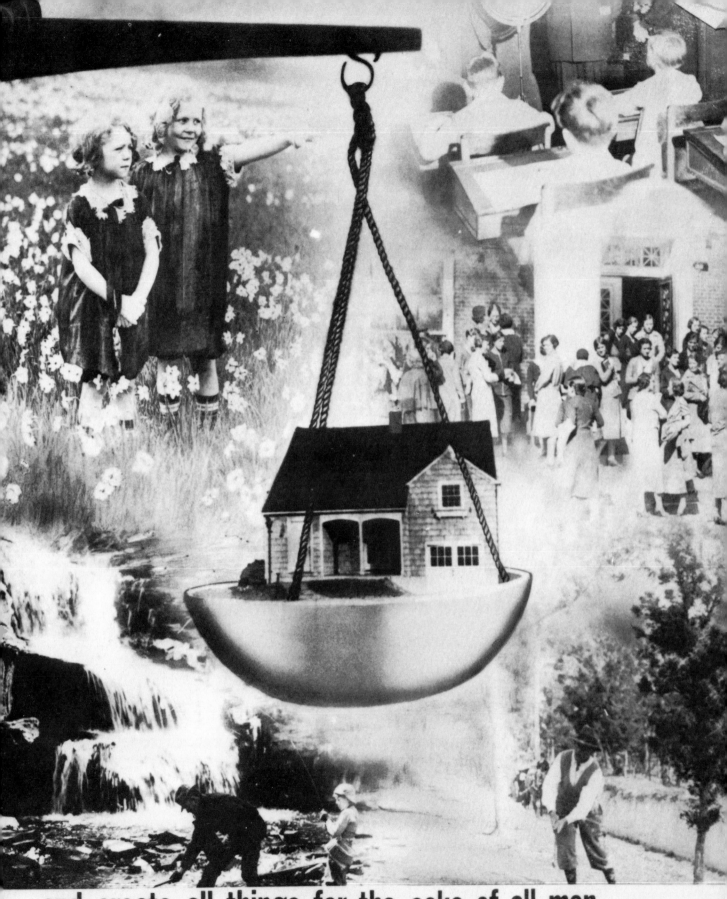

and create all things for the sake of all men

Returning from a twelve-day fishing trip on Vincent Astor's yacht, President-elect Roosevelt stopped at Miami to speak informally at Bay Front Park. After he finished, Mayor Cermak of Chicago and other friends crowded around him. Suddenly, from thirty yards away, Giuseppe Zangara began firing at him, a Mrs. W. Cross screaming and tugging at his arm meanwhile. Cermak dropped first, and then Margaret Kruis, Mrs. Gill, Mr. Sinnott and Russell Caldwell.

CERMAK STEPPED TO THE
RUNNING BOARD

Zangara, an unemployed laborer from Hackensack, the victim of an incurable stomach ailment, was speedily brought to trial by a shocked State Government. He was sentenced to eighty years in prison as he shouted defiantly at the judge. Several weeks later Cermak died, and Zangara was killed.

THE ULCERS DON'T
HURT NOW

fig. 20
Designer unknown
"Suddenly in Miami ...," from Pare Lorentz,
The Roosevelt Year (New York:
Funk & Wagnalls, 1934), pp. 12–13.

fig. 21
Designer unknown
"The Second Year Lay Between Them,"
closing spread from Pare Lorentz,
The Roosevelt Year (New York: Funk &
Wagnalls, 1934), pp. 196–197.

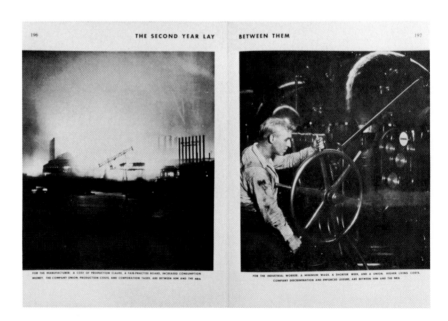

196 THE SECOND YEAR LAY BETWEEN THEM 197

FOR THE MANUFACTURER: A COST OF PRODUCTION CLAUSE, A FAIR-PRACTISE BOARD, INCREASED CONSUMPTION MONEY. THE COMPANY UNION, PRODUCTION COSTS, AND CORPORATION TAXES, ARE BETWEEN HIM AND THE NRA.

FOR THE INDUSTRIAL WORKER: A MINIMUM WAGE, A SHORTER WEEK, AND A UNION. HIGHER LIVING COSTS, COMPANY DISCRIMINATION AND ENFORCED LEISURE, ARE BETWEEN HIM AND THE NRA.

fig. 23 (pages 162–163)
"Who Has 128 Million Mouths to Feed . . .
and Could Feed 200 Million," from
S. A. Spencer, with art direction by Leslie
Beaton, *The Greatest Show on Earth* (New
York: Garden City: Doubleday, Doran,
1938), pp 28–29.

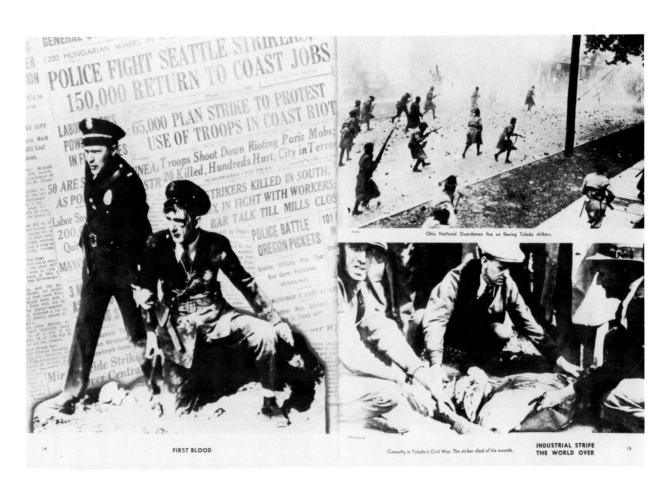

fig. 22
Designer unknown
"First Blood. . . Industrial Strife the World
Over," from M. Lincoln Schuster, ed.,
Eyes on the World (New York: Simon and
Schuster, 1935), pp. 14–15.

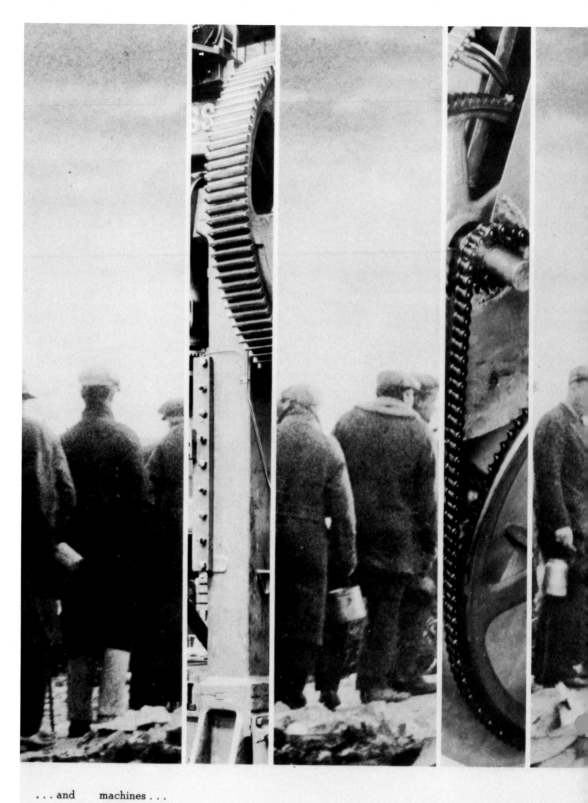

. . . and machines . . .

 . . . the simultaneous movements that create consumers and eliminate producers . . . the race between mor

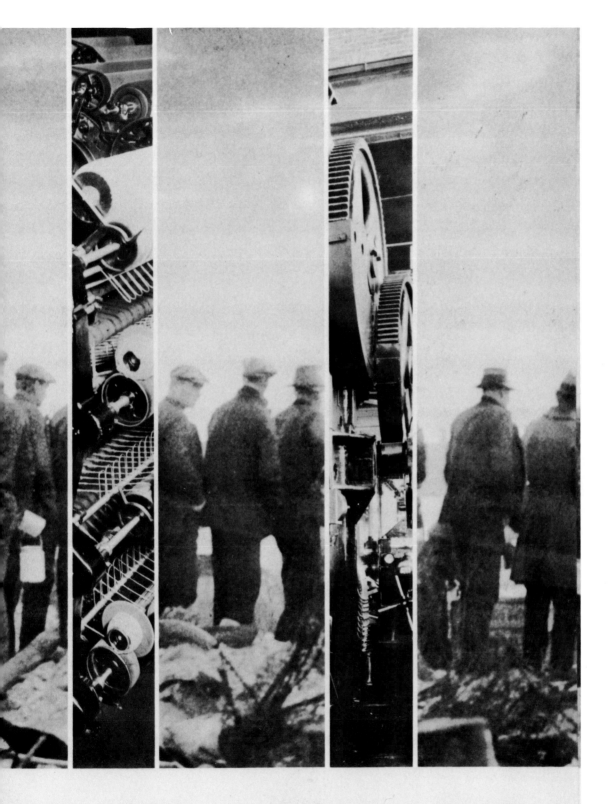

employment and more unemployment . . . the increasing standard of living . . . the increasing ingenuity
of the tools of industry and the increasing length of the lines

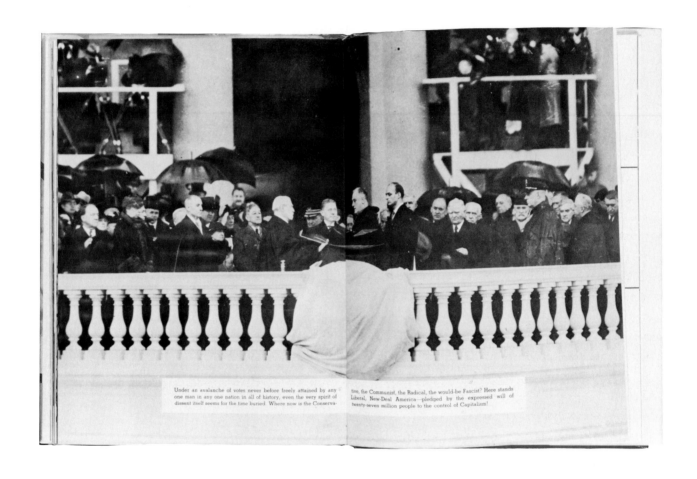

Under an avalanche of votes never before freely attained by any one man in any one nation in all of history, even the very spirit of dissent itself seems for the time buried. Where now is the Conserva-tive, the Communist, the Radical, the would-be Fascist? Here stands Liberal, New-Deal America—pledged by the expressed will of twenty-seven million people to the control of Capitalism!

fig. 25
closing spread from S. A. Spencer, with art direction by Leslie Beaton, *The Greatest Show on Earth* (New York: Garden City: Doubleday, Doran, 1938), pp 166–167.

fig. 24 (pages 164–165)
"…The increasing ingenuity of the tools of industry and increasing length of the lines," from S. A. Spencer, with art direction by Leslie Beaton, *The Greatest Show on Earth* (New York: Garden City: Doubleday, Doran, 1938), pp 108–109.

the World (1935) strove to address the full panoply of current events by means of a kaleidoscopic style of juxtaposition. In both iconography and format, the book also paid tribute to (and perhaps hoped to compete with) the staccato form of the newsreel, particularly the fast-tempo style of *The March of Time*, which commanded wide interest as soon as it was released in early 1935 (fig. 22).

As late as 1938, another compilation book, *The Greatest Show on Earth* (edited by S. A. Spencer, with art direction by Leslie Beaton), relied on striking photo-juxtaposition combined with captions presented in terse teletype format to make its points. Like the earlier *Picture of America*, this book stressed the gap between current levels of industrial productivity and the country's technological capacity to satisfy human needs in such areas as food, clothing, and housing (fig. 23). However, compared with Charles Cross's 1932 book, *The Greatest Show on Earth* supplied less analysis, provided no discussion of such concrete issues as reduction of the working day, and presented a more ordered and formulaic visual depiction of contrasts in the quite elegant, repetitive splicing of rectangular fragments (fig. 24). Moreover, on the book's closing pages, even this mannered form of juxtaposition shifted to a double-page shot of FDR's second inauguration in 1937 (fig. 25), a spread reminiscent of Lorentz's *Roosevelt Year*. The cult of benevolent paternalism had displaced a vision of more sweeping changes, and with this substitution was affirmed the propriety of the single image with its unified naturalistic space.

Notwithstanding the cluster of books that in the first half of the thirties experimented with montage, the influence of this tendency was at most short-lived. Certainly, none of these books has retained a place in the official memory of the Great Depression and its cultural forms. In those thirties photo books that have been remembered and that now occupy a central position in both general cultural history and photographic history—notably the books by Margaret Bourke-White, Dorothea Lange and Walker Evans—the single photographic image has acquired a new significance as the fundamental unit of communication.

Margaret Bourke-White and Erskine Caldwell's exposé of the living conditions of southern sharecroppers, *You Have Seen Their Faces*, figures chronologically as the first in the late 1930s trend of social documentary books featuring the work of a single photographer. Initially published in 1937, this book enjoyed such commercial success that it soon was reprinted in large and small paperback formats. Not only are social contrasts minimized in this text, but also the visual layout is keyed to the separation of distinct photographic exposures. The immediate reason for this new emphasis on the sanctity and centrality of photographic evidence is that the book serves as a showcase for an established photojournalist, and that such a layout emphasizes the aesthetic qualities of each image and the act of seeing as the photographer's singular work and skill. Actually, in this relatively early book by one documentary photographer, the authorial principle is not fully realized in the design; the layout consists primarily of single images on a page, yet the images are not consistently centered and, in a few instances, the pages are composed of a number of obvious fragments of larger exposures (fig. 26). However, compared with the earlier books that were editorial compilations, the layout of *You Have Seen Their Faces* is radically cleaned up, inviting intense scrutiny of each image. There is another difference in the effect of the book's treatment of social conditions of the Depression, a difference that, along with the oft-noted sensationalism of Bourke-White's views, may have contributed to the book's popularity: the generous white spacing, in addition to maintaining traditional notions of authorship, graphically projects the idea of a distinctly contained space and subjectivity of each figure represented.

In some respects, Dorothea Lange's and Paul Taylor's *American Exodus* (1939) returns to a more heterogeneous format. Their book not only reproduces news clippings along with photographs but, for added emphasis, it enlarges relevant portions of text (fig. 27). However, the photographs were not similarly worked on but were presented unaltered. The layout is not particularly precious; the borders, for example, are neither prominent nor consistent (fig. 28). Indeed, the pictures are often "bled" laterally so that

fig. 26
Margaret Bourke-White
"College Grove Tennessee," page layout
from Erskine Caldwell and Margaret
Bourke-White, *You Have Seen Their Faces*
(New York, 1937). n.p.

College Grove, Tennessee

"Now it says right here in the Big Book that you'll be sorely regretful on Judgment Day if you don't show yourself on the side of the Lord."

YOUNG SHARECROPPER ON $5 A MONTH "FURNISH"

"Hit's a hard get-by. The land's just fit fer to hold the world together.
We think the landlord ought to let the government have this land and
build it up, but he's got money and he don't believe in that way. Be-
tween Buck Creek and Whitewater Creek nobody can make a living."

NEIGHBOR: "A piece of meat in the house would like to scare these chil-
dren of mine to death."

Macon County, Georgia, July 16, 1937

14

COUPLE, BORN IN SLAVERY

"I remember when the Yankees come through, a whole passel of 'em,
hollerin', and told the Negroes you're free. But they didn't get nothin'
'cause we had carried the best horses and mules over to the gulley."

Plantation with 28 families abandoned in 1924 after the boll weevil
struck.

Greene County, Georgia, July 20, 1937

15

fig. 29 (pages 172–173)
Endpapers from Dorothea Lange and
Paul Schuster Taylor, *An American Exodus*
(New York, 1939).

IF I COULD GET ME A PIECE OF LAND I'D GO TO DIGGIN IT WITH MY HANDS

TEXAS AND DON'T OWE OR OWN A THIN DIME BACK THERE ★ HE'S ALWAYS B

US ★ WE DRIED OUT THERE THREE YEARS HAND RUNNIN ★ THAT YEAR TH

TOR'S AS STRONG AGAINST US AS THE DROUGHT ★ WE MADE A DOLLAR WO

TRY—THEY RUN IT, WHAT I MEAN ★ THEM MEN THAT'S DOIN THE TALKIN

RENTERS OUT OF THEIR PLACES AND SCATTERING THEM ALL OVER ★ THEY DC

RIGHT SMART CHEAPER ★ THEY TAKE THE REDUCTION MONEY AND KICK U

WAS RAISED ON IT ★ ALL WE GOT TO START WITH IS A FAMILY OF KIDS ★

★ SEEMS LIKE PEOPLE HERE IS CRAZY ABOUT CALIFORNIA—THEY GO IN DRO

WORLD WAS SO WIDE. FATHER TO SON: NO, BUT I KNEW WHAT I WAS GOIN T

SIT BACK THERE AND LOOK TO SOMEONE TO FEED US ★ LIVIN A BUM'S LIFE S

A LIVIN EVEN THIS KIND OF A LIVIN BEATS STARVIN TO DEATH. BACK THERE

BLOWED OUT, EAT OUT, TRACTORED OUT ★ YESSIR, WE'RE STARVED STALLED

DON'T HAVE TO GO TO THE GOVERNMENT MAN FOR WHAT BREAD YOU EAT I

CHECK WHAT'S THAT BUT RELIEF? ★ WE AIN'T NO PAUPERS. WE HOLD OURSEL

CHANST TO MAKE AN HONEST LIVING LIKE WHAT WE WAS RAISED ★ SHE SA

GITS DOWN TO YOUR LAST BEAN YOUR BACKBONE AND YOUR NAVEL SHAKES D

HAVEN'T NOTHIN TO GO BACK TO ★ I COULDN'T DO NOTHIN IF I WENT BAC

HARM ★ WE TRUST IN THE LORD AND DON'T EXPECT MUCH ★ WE GOT EN

I'D BRING UP A BUNCH OF KIDS LIVING THIS WAY ★ I'VE WROTE BACK THAT

★ THEY SAY WE TOOK WORK CHEAP BUT YOU'VE GOT TO TAKE WORK CHEAP A

WANT YOU OUT OF THE WAY ★ I WAS BORN AND RAISED A 100 PERCENT AMER

MY FAMILY ★ WE LIVE MOST ANYWHERE IN GENERAL WHERE THERE'S WORK

WOULD ROT IF WE DIDN'T COME ★ BROTHER, HIT'S PICK SEVENTY-FIVE CEN

ELSE ★ MY BOYS ARE AMERICAN CITIZENS. IF WAR WAS DECLARED THEY'D

CITIZENS BECAUSE WE MOVE AROUND WITH THE FRUIT TRYIN TO MAKE A LIVI

OF THINGS ARE GOIN ON NOW THAT DIDN'T USETER DO ★ I COME FROM

FARMER AND HE CAN'T GET A FARM ★ THAT DROUGHT PUT THE FIXINS TO

G COME AND FOUND US BLANK ★ HERE'S WHAT I THINK ON IT—THE TRAC-

ROM DAWN TILL YOU JUST CAN'T SEE ★ THE MONEY MEN GOT THAT COUN-

E COUNTRY IS THE BIG LANDOWNERS ★ THE FARMALL IS KNOCKING OUR

OP TO SHUT THE DOOR THEY JUST WALK OUT ★ HE CLAIMS TRACTORS IS

ND BUY FARMALLS ★ WE CAN WORK THIS LAND AS GOOD AS ANYBODY. WE

ED TELL OF THIS HERE IRRIGATION, PLENTY OF WATER AND PLENTY TO EAT

HE'S GOT THE OREGON ITCH ★ SON TO FATHER: YOU DIDN'T KNOW THE

E FOR BREAKFAST ★ THIS IS A HARD LIFE TO SWALLOW BUT I JUST COULDN'T

AKES A BUM OUT OF YOU. YOU GET STARTED AND YOU CAN'T STOP ★ MAKIN

E TO STARVE TO DEATH ★ NIGH TO NOTHIN AS EVER I SEE ★ BURNED OUT,

TRANDED ★ I WOULDN'T HAVE RELIEF NO WAY IT WAS FIXED ★ IF YOU

BETTER ★ LOTS OF EM HARP ABOUT THE WPA RELIEF. BUT THE BIG PLOW-UP

BE WHITE FOLKS. WE DON'T WANT NO RELIEF. BUT WHAT WE DO WANT IS A

Y DIDN'T YOU STAY THERE—WHEN I SAYS I COME FROM TEXAS ★ WHEN YOU

SEE WHICH GITS IT ★ YOU EAT IT UP FASTER THAN YOU CAN MAKE IT ★ I

THIS LIFE IS SIMPLICITY BOILED DOWN ★ A PICTURE OF ME CAIN'T DO NO

TROUBLES WITHOUT GOING COMMUNIST ★ CHRIST I'LL DIE BEFORE I'LL SAY

WELL AND SUCH AS THAT, BUT I NEVER HAVE WROTE THAT WE LIVE IN A TENT

DIDN'T WANT NO RELIEF ★ WHEN THEY GET THROUGH WORKING YOU THEY

FOUGHT AND I'M PROUD OF IT THINKIN I WAS HELPIN THE GOVERNMENT AND

IN'T HARDLY FAIR. THEY HOLLER THAT WE AIN'T CITIZENS BUT THEIR FRUIT

TON OR STARVE. ★ BROTHER, HIT'S PICK SEVENTY-FIVE CENT COTTON OR

O FIGHT NO MATTER WHERE THEY WAS. I DON'T SEE WHY WE CAN'T BE

HUMAN BEING HAS A RIGHT TO STAND LIKE A TREE HAS A RIGHT TO STAND

[30] I have not uncovered the etymology of "bleed" and "gutter" in printers' parlance, but the terms commonly employed to refer to the page and the manner of marking it make clear alllusions to topography and the body. The gutter is a longstanding printer's term, but the bleeding of images (in effect, the printing of images without margins to the edges of the page) was a fairly novel term and graphic practice in the early 1930s, according to M. F. Agha's short account of the subject, "About Margins and Bleeds," *American Printer* 100:33 (March 1935), pp. 30–31.

fig. 30
Designer unknown
"523-To-8," photomontage from *Life*, vol. 2, no. 1, Janurary 4, 1937, pp. 42–43.

fig. 31
Double-page spread from a story on Hollywood, in *Life*, May 3, 1937, pp. 32–33. [All photographs by Alfred Eisenstaedt except for the photograph by Peter Stackpole in the lower left corner of the grid, and for the photograph by Martin Munkasci in the lower right corner of the grid]

they meet in the "gutter."[30] However, the effect of such juxtapositions is usually offset by disparate vertical edges, horizon lines, or backgrounds—visual disparities that effectively maintain the integrity of each shot, each frame, and, by extension inside the frame, the distinct individuality of each person, each space. A fairly extreme form of reassemblage appears on the fly-leaf (fig. 29), but the montage is of quotes rather than of pictures, leaving intact the visual evidence and in so doing implying that the visual space was more resistant to this type of collectivization.

The separation of visual and verbal elements reaches its quintessential form in the presentation of Walker Evans's work. In both *American Photographs* (1938) and *Let Us Now Praise Famous Men* (1941), the apportionment of a single picture per page (with liberal amounts of space reserved for borders on all sides) has achieved the absolute finality and stability of law. Yet if the quality of order is what Evans masterfully distills in his photography and its presentation, we see in other, less individually-authored forms of photographic media a similar tendency towards simplicity and clarity, stability and order.

Concern with authorship arguably pushes this tendency further, but it is not the only reason for its widespread application. The move toward simplicity and order must be considered as a broader cultural trend, one that is clearly discernible in high, low, and middling graphic forms in the U.S. during the late thirties. In the major U.S. picture magazines that were instantaneous successes in the second half of the Depression, one finds the same tendency towards simplicity and order. In magazines like *Life*, photomontage appears only rarely (and the issue of individual authorship was hardly a high priority in the Time, Inc. offices of Henry Luce). The montage technique was not unknown to *Life*'s editors and art directors, who borrowed freely from earlier European innovations in photojournalism, but they used it very selectively. A photomontage appears quite prominently, for example, in an early *Life* issue from January, 1937, at the time of Roosevelt's second inauguration (fig. 30). Although *Life* magazine began publication at the tail end of 1936, after Roosevelt had been

523-TO-8

LOOK AT CRYSTAL SPRINGS DAM

THIS generation has a rendezvous with destiny," cried Franklin Roosevelt last June at the end of the Democratic National Convention in Philadelphia. But for three months he let the generation wait. He gave them drought tours, centennial openings, flood control trips — a non-political campaign until six weeks before election. Then he gave them a full measure of destiny. While a lugubrious Landon Special fruitlessly criss-crossed the country, crowds jammed the railroad stations of New England, men roared themselves hoarse and women fainted in milling mobs in a mighty acclamation of a popular President. By day and night, under sun and rain from the capitol at Denver to the capitol at Boston, Franklin Roosevelt was a triumphant hero with a smile of silver and a voice of gold. When it was over, had he reported to Congress on the state of the nation, he might have summed it all up in his record-breaking electoral college vote: 523-to-8.

BEVERLY HILLS HIGH SCHOOL

HOLLYWOOD STREET SCENES

[31] As one business writer noted in an essay that featured Luce and his new magazine: "*Life*'s unobtrusive but effective layouts have set the style for all picture magazines. Luce scorns tricky, artificial layouts as 'cookie shapes.' Although *Life* never shies from the truth, it plays down sensationalism; pictures are intrinsically so starkly real that sensationalism often violates good taste." Robert Pearson, "Magazines," *Shell Progress*, March 1940, p. 20.

[32] Christopher Phillips, "The Judgment Seat of Photography," in Richard Bolton, ed., *The Contest of Meaning* (Cambridge, MA, 1989), pp. 23–34.

fig. 32
Installation photograph of Farm Security Administration exhibit, *Faces of America*, 1942
Courtesy of Prints and Photographs Division, Library of Congress, Washington, D.C.

re-elected by an overwhelming landslide, publisher Henry Luce's support of the Republican candidate, Alf Landon, was well known. The fairly exceptional use of photomontage at the time of the inauguration might be construed as the editors' means of proclaiming their affiliation with the people, although the frenetic quality of the montage perhaps should be read as an insinuation of the president's demagogic appeal. *Life*'s strategy in this case was diametrically opposed to that of *The Greatest Show on Earth*, which depicted the second inauguration in a very staid, monumental fashion, by enlarging one photograph of the event to fill a double-page spread (see fig. 25 on page 166).

As *Life* developed a formulaic style, the practice of photomontage all but disappeared. Indeed, publisher Henry Luce made a point of touting this fact as if it were proof of the magazine's innate honesty and dignity.[31] Single black-and-white cover photos were a prominent part of the magazine's signature style, and stories inside the magazine tended to use many more full-page pictures than did its European predecessors (fig. 31). This kind of "star" treatment obviously flattered its subjects and no less its photographers, but surely, too, readers found such an orderly presentation both simple and in more profound ways reassuring. As the camera pried deeper into the lives of ordinary individuals, the spacing between pictures provided a crucial compensatory boundary, implying that the private sphere was being maintained even as it was converted by mass media into public spectacle.

There was a close connection between the design of magazines and of photographic exhibitions in the thirties. Christopher Phillips has drawn this connection in his discussion of Edward Steichen's curatorial practice in the forties and fifties. However, a similar relationship had developed already in the pre-war era.[32] In the increasingly self-conscious design of photographic exhibits in the thirties, the frame of each photographic rectangle had grown more pronounced, while at the same time the individual rectangles were being subsumed in larger grid-like configurations (fig. 32). This was particularly true of the spate of documentary exhibits and panels produced by the Farm Security Administration (FSA), the major source of New Deal

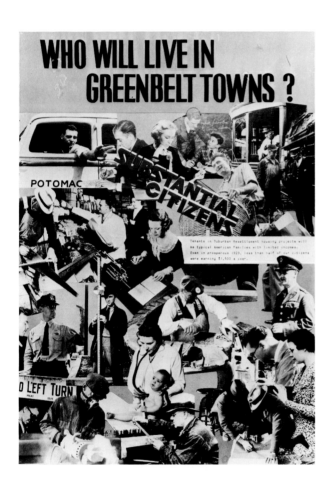

fig. 33
Designer unknown
Information panel on Greenbelt Towns
prepared by the Resettlement Administration 1935
modern print from archival negative
Courtesy of Prints and Photographs
Division, Library of Congress,
Washington, D.C.

fig. 34
Designer unknown
(possibly Edwin Rosskam)
Information panel on camps for migratory
workers, prepared by the Farm Security
Administration 1941
modern print from archival negative
Courtesy of Prints and Photographs
Division, Library of Congress,
Washington, D.C.

2. AERIAL SURVEY, KANKAKEE COUNTY, ILLINOIS

This is a type of photography that has been made possible by recent technological developments. (*Agricultural Adjustment Administration, United States Department of Agriculture*)

fig. 35
"Aerial Survey, Kankakee County, Illinois,"
reproduced as Pl. 2, in Roy E. Stryker and
Paul H. Johnstone, "Documentary
Photographs," in Caroline F. Ware, ed.,
The Cultural Approach to History
(New York: Columbia University, 1940),
n.p. [following p. 324].

photographic publicity. Although photomontage was used by the FSA when it was a fledgling New Deal operation (initially called the Resettlement Administration), between 1935 and 1940 this office refined its publicity techniques, in the process spurning photomontage in favor of the grid. (For an example, compare the layout of two information panels, figs. 33, 34.)

The FSA's increasingly standardized use of a grid-like form of presentation was hardly a random choice. The chief of FSA photography, Roy Stryker, made clear his affinity for this model as a symbolic matrix of harmonious social relations. In his role as government picture editor, Stryker constantly exhorted his photographers to get closeups— the "individual case method"—and also to get the longest possible topographic views.[33] Had his budget been bigger, Stryker probably would have organized an aerial unit, since he loved the aerial views that began to be disseminated in the 1930s. In the only article he published in this period on documentary photography, Stryker, though limited to nine illustrations, chose to include one aerial view made outside his agency (fig. 35). To emphasize the documentary value of such a diagrammatic image, Stryker explained that "every culture puts its stamp upon the terrain and creates its own landscape." His choice of a Midwest view allowed him to make a point of the "independent farmsteads, squared fields and highways"[34]—a landscape, in other words, where the modern meshed well with the Jeffersonian tradition of individual small landowners.

On the ground, up close, even Stryker expressed doubts about the social benefits of this liberal model, and doubts as well about the strength of this model in a period of accelerated change. To one of his photographers, Jack Delano, working in rural New England at the end of 1940, Stryker wrote:

> You probably have already noted the tendency for this whole thing to grow into a chaotic mess, stretching itself along back roads. Buildings are improvised and the whole thing becomes an eyesore. *But* the people are independent . . . unregimented, and not under the thumb of bureaucrats. If Mr. X's house and buildings are an eyesore, well by God they are his and this is the basis of rugged Americanism. . . . I fear, more than I can

say, the impact of planning and control on this country. We are so inexperienced, so inept at it. Our tradition is so much that of every man for himself and—the capitalist get all of his.[35]

Written in late 1940, the observation already reflects the mounting wartime pressures toward greater planning and control. Once the government declared war, the ideological priority placed on rugged individualism was temporarily set aside. Not surprisingly, the change in political climate engendered radical alterations in cultural forms. In terms of the practice of photography and graphic design, what seems most significant is that accompanying this ideological shift was a temporary adjustment downward in the cultural status of straight photography.

With the policy objective of full-scale mobilization of the domestic population, not only did the official iconographic agenda shift from the agrarian to the industrial sector of society, but corresponding to the new political crisis the presentational style turned anew to photomontage. The stylistic reversal reveals an unstated but well-understood potential of montage: to express a sense of crisis and simultaneously to drive home the importance of cooperation and self-sacrifice for the sake of national unity.

The federal government in the early forties commissioned a number of large photographic murals on the kind of grand scale that lent itself to montage production. But the revival of montage in this period was hardly limited to such projects as the truly monumental mural installed in New York's Grand Central Station to promote the Treasury Department's war bonds drive (fig. 36). A similar montage rhetoric governed the layout of the letters page in the August, 1941, issue of *McCall's*, reinforcing the editorial for that issue urging patriotic sacrifice by women (fig. 37); it is even more conspicuous in the design of numerous wartime government posters that invoked the spirit of collectivity (fig. 38). We find this same rejection of the grid in favor of a more dynamic flow in the Museum of Modern Art's major wartime exhibition, *Road to Victory* (fig. 39). Considered in isolation, the installation of *Road to Victory* may appear to owe more to European than American sources, especially as it was designed by Herbert Bayer

[33] "Distance is the great thing in our land," Stryker exhorted in a letter to Jack Delano, April 30, 1941; Stryker was equally adamant about the need for long shots of the land in a May 22, 1939, letter to Russell Lee; copies of both letters in Stryker Personal file, University of Louisville Photographic Collection, Louisville, KY.

[34] Roy E. Stryker and Paul H. Johnstone, "Documentary Photographs," in Caroline F. Ware, ed., *The Cultural Approach to History* (New York, 1940), p. 329.

[35] Roy Stryker to Jack Delano, Nov. 11, 1940; letter in Jack Delano's personal archive, Rio Piedras, P.R.

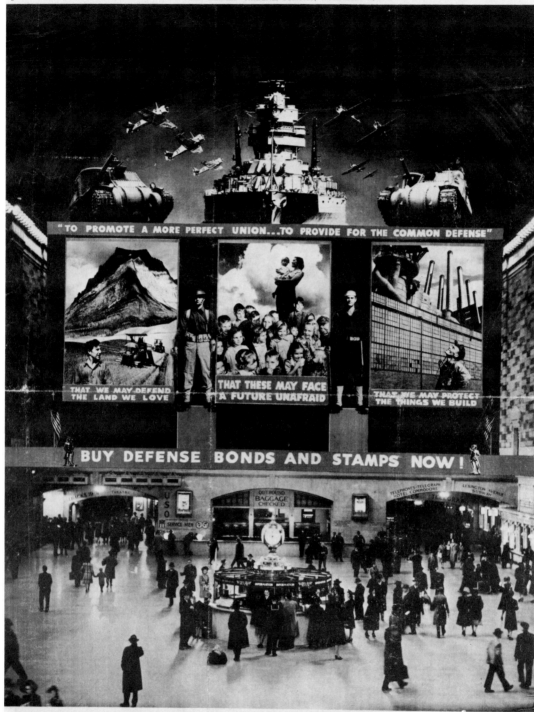

"TO PROMOTE A MORE PERFECT UNION...TO PROVIDE FOR THE COMMON DEFENSE"

THAT WE MAY DEFEND THE LAND WE LOVE

THAT THESE MAY FACE A FUTURE UNAFRAID

THAT WE MAY PROTECT THE THINGS WE BUILD

BUY DEFENSE BONDS AND STAMPS NOW!

World's Greatest Photo-Mural Dramatizes Our Defense Effort In the Grand Central Terminal

This is the way the giant photo-mural to further the sale of American defense bonds and stamps will appear today after the noon ceremonies in Grand Central. Most dramatic appeal yet conceived by the defense savings staff of the Treasury Department, it is in line with the urgings of those who have suggested more use of striking photography in the whole defense effort.

Nearly 100 feet high and 118 feet wide, it will mask the entire east wall of the upper level and will be mounted on a steel framework. To create this photo-montage, experts of the Farm Security Administration, under the direction of Edwin Rosskam, examined 20,000 photographs and chose twenty-two. To make the huge prints for mounting in sections,

FSA cameras on tracks were called into play. The enlargements are of many diameters, and in the case of the children pictured in the center, the original negative was comparably not so big in the rest of one child's eye. The figures of the soldier and the sailor are 32 feet high and the tanks are twice as large as the real tanks.

Many states are represented. The mother and child are from Idaho, the children were pictured in California, the sky over the industrial plant is from Vermont, the mountain is "Going-To-the-Sun" in Montana, the worker is from Boulder Dam, the soldier from Fort Belvoir, Va., and the sailor from the Navy Yard in Washington. Traffic experts estimate that during 1942 the mural will be seen 242,500,000 times.

U. S. Treasury Department, Defense Savings, New York

fig. 36
Installation view by FSA photographer
Arthur Rothstein of FSA mural designed by
Edwin Rosskam and commissioned by the
U.S. Treasury Department
December 14, 1941
modern print from archival negative
Courtesy of Prints and Photographs
Division, Library of Congress,
Washington, D.C.

fig. 37
Layout framing letters to the editor on the
theme of preparedness in *McCall's*, August,
1941, pp. 12–13.

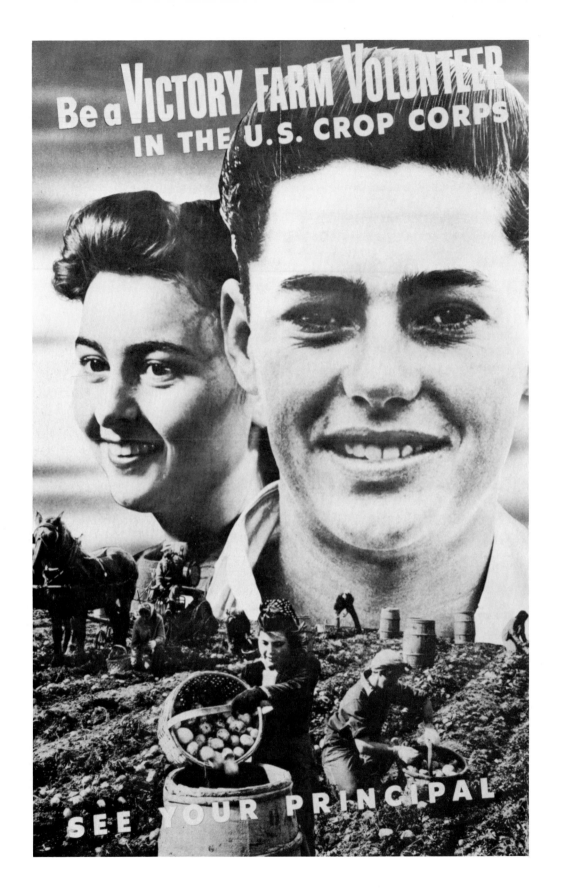

fig. 38
Artist unknown
"Be a Victory Farm Volunteer," (poster for
U.S. Department of Agriculture) c. 1943
Courtesy of Prints and Photographs
Division, Library of Congress,
Washington, D.C.

fig. 39
Samuel H. Gottscho
Installation view of the ehibit "Road to
Victory," organized by Edward Steichen
and designed by Herbert Bayer,
May 21–October 4, 1942, The Museum of
Modern Art, New York.
Courtesy of The Museum of Modern Art,
New York

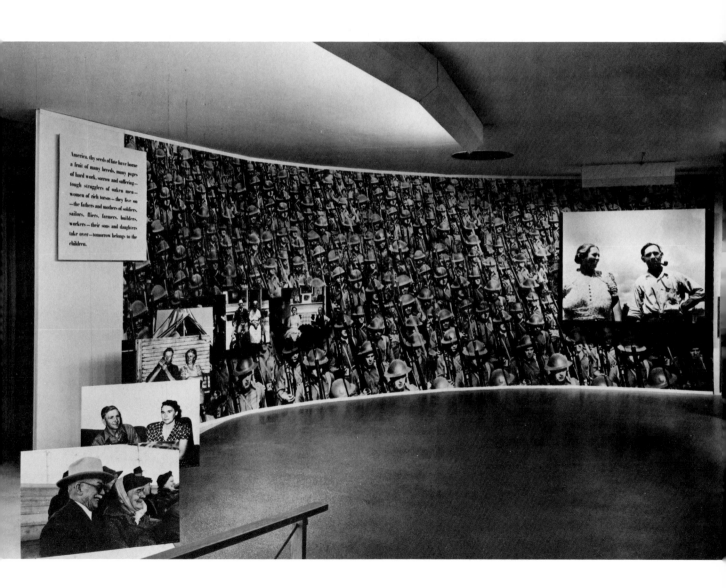

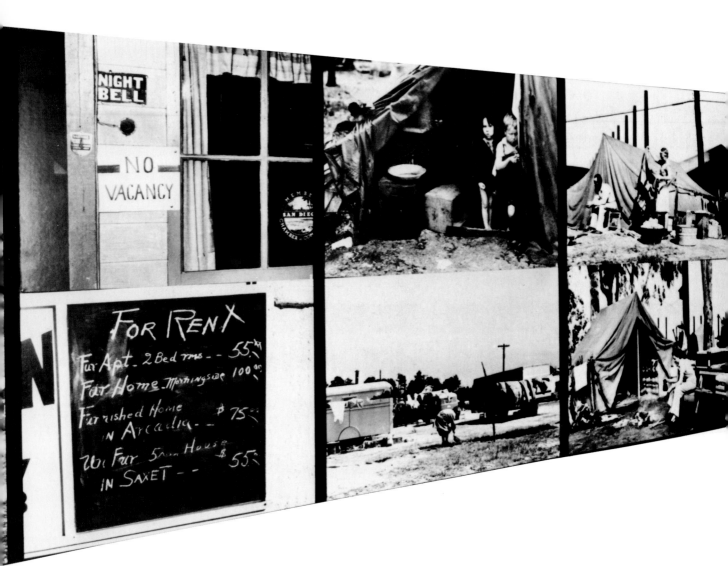

fig. 40
Samuel H. Gottscho
Installation view of "Wartime Housing,"
exhibit organized by Eliot F. Noyes with
the assistance of Alice Carson
and Don E. Hatch. April 22–June 21, 1942,
The Museum of Modern Art, New York.
Courtesy of The Museum of Modern Art,
New York

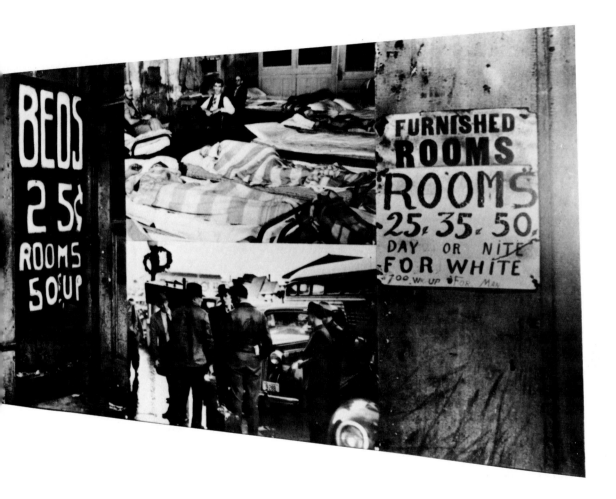

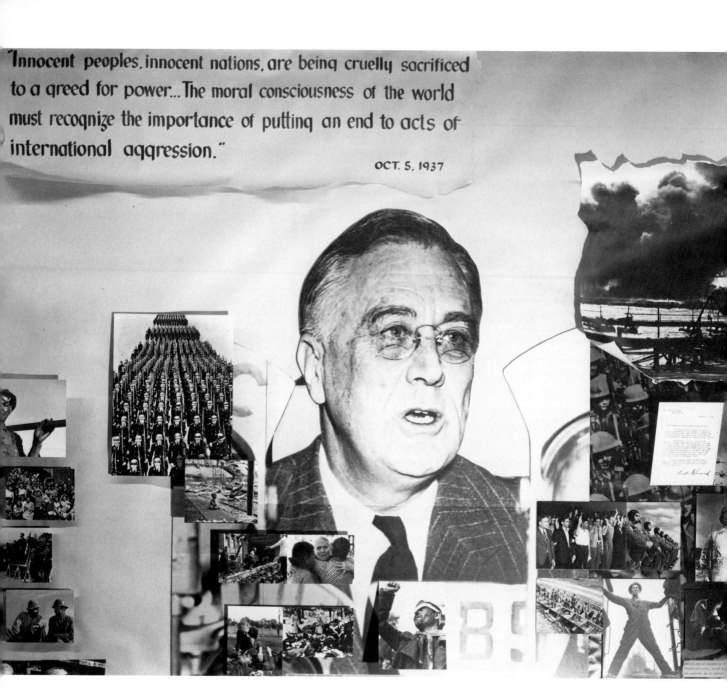

"Innocent peoples, innocent nations, are being cruelly sacrificed to a greed for power... The moral consciousness of the world must recognize the importance of putting an end to acts of international aggression."

OCT. 5, 1937

fig. 41
Detail of 80-foot long mural designed for the "Tribute to President Roosevelt Exhibition," which was installed in New York in 1944 in the last month of FDR's campaign for re-election; the photographic portion of the exhibition was organized by a committee that Paul Strand chaired.
Courtesy of Center for Creative Photography, Tucson

who had emigrated quite recently from Germany. Yet the use of photomontage was nearly as prominent in a concurrent, more modest (though no less crisis-oriented) MoMA exhibition on wartime housing (fig. 40), and this latter exhibit was designed in-house by curator Eliot F. Noyes with the assistance of Alice Carson and Don E. Hatch. Photomontage also reappears in wartime photographic publicity featured in *Life*, as well as in the 80-foot mural, designed by Paul Strand and Leo Hurwitz, that dominated an exhibition organized in 1944 in support of Roosevelt's re-election to an unprecedented fourth term (fig. 41).[36]

It should be noted that there were strict iconographic limits to this resurgent montage practice, and they pertain especially to the matter of race relations, that particularly difficult—and some have argued, distinctly American—dilemma. If wartime montages signified a cultural melting pot spawned by dire necessity, most of the melting pot montages included only whites in the patriotic crucible. The notable exceptions were a few montages by Alexander Alland, for these depicted far greater diversity of American types brought into harmonious, close contact. Nearly all of these were commissioned by an obscure and short-lived progressive organization, the Common Council for American Unity, and none of the commissioned graphics appear to have enjoyed broad public exposure.[37]

Even at the height of wartime, montage still did not supplant altogether the normative organizing principle of the grid. In a photo essay appearing in the *Christian Science Monitor* (fig. 42), the text proposed that gas rationing had revived old-fashioned, small-town neighborliness without conceding that wartime rationing actually made it more imperative to live in close proximity to urban industrial centers. Yet the contradictions in this argument were far less apparent than the striking presentation of visual evidence: disparate horse-and-buggy scenes spaced at even intervals along the top of the double-page spread. Such spacing conformed to the even pattern of fence posts that appeared to prop up all other elements in the largest view spanning both pages. If Jack Delano, the photographer of the fenced-in New England tableau, was playing with the rules of pictorial balance and myths of Yankee rectitude,

[36] See the photomontage by Lotte Jacobi, "V=Victory," that *Life* published as one prize-winning entry in a wartime publicity competition; *Life*, Nov. 24, 1941, p. 13. On the 1942 MoMA exhibit "Road to Victory," see the contemporaneous discussion of its montage-like installation in Barbara Morgan's essay, *op. cit.*, p. 2863. Two recent discussions of this exhibition are found in Christopher Phillips, "The Judgment Seat of Photography," and in Benjamin H.D. Buchloh, "From Faktura to Factography," in Richard Bolton, ed., *The Contest of Meaning*, (Cambridge, MA, 1989), pp. 26–27, 76-77 respectively. On the Strand mural, see Elizabeth McCausland, "Artists' Tribute to President Roosevelt," *Springfield Sunday Union and Republican*, Oct. 29, 1944, 4C, and a brief description in the *New York Times*, Oct. 22, 1944, II:4.

[37] Some discussion of this work may be found in Bonnie Yochelson's *The Committed Eye: Alexander Alland's Photography* (Museum of the City of New York, 1991.). Unfortunately, I only learned of this catalog as my essay was going to press. Nevertheless, further work in the area of montage and its discontents would do well to pursue the specific, volatile social visions that the composite photograph threatened to introduce to the highly regulated social and symbolic landscape.

"DEEP IN THE HEART OF TEXAS" MIDDLETOWN, CONN. "THE SQUARE," MARENGO, IOWA INCIDENT: ENTERPRISE, ALA. BUSY DAY, PORT GIBSON, MISS. BLIZZARD, BRATTLEBORO, VT. TRAIN TIME, CONNELLSVILLE, PA. MARKET DAY, CAMDEN, TENN.

Is the Small Town Coming Back?

By R. H. Markham

THE WAR MAY RESTORE importance to the small town, which has served as the main source of American tradition. Transportation restrictions will keep a fairly large proportion of Americans at home during coming months, and home for more than half of them is found in or near a small town.

To be sure, official statistics say that 56 per cent of us are "urban," but that only means we live in cities of more than 2,500 inhabitants each. And a population of 2,500 indicates a pretty small town. In far more than half of our States, the small town and country population decidedly predominates. The Western Newspaper Union in a recent "ad" stated that about 70,000,000 of us are country people. A third of our States haven't a single city with as many as 100,000 inhabitants, while almost another third have only one such city each. Of our 70,000 settlements, only 92 have as many as 100,000 inhabitants each.

The smallest village of all, as listed in the geography, is Bicycle, N. D. And it is no tandem, either. It is recorded as having one inhabitant. Auto, W. Va., is 25 times as large, while Wagontown, Pa., is twice

as large as the Auto and Bicycle combined. Oregon has a Wagontire. It is as small it would hardly fit a caddycar. How would you address them in a patriotic speech? Would you say "Dear Wagontires, let's get going"? Altogether, the Wagontires are just enough for one wagon with two spares. Suppose that town had been Autotire instead of Wagontire! It might have been salvaged right off the map.

Strange to say, the 130 Big towns in the United States, from Big Arm to Big Woods, are very small, while many of the 80 Littles are fairly large. Little Rock, indeed, is a couple of thousand times larger than Bigstone—both are in Dixie.

Although fewer than half of us are now officially listed as "rural," as compared to 95 per cent 150 years ago, most writers describing America have pointed out that our basic tradition derives from self-governing small towns. Our best symbol is often said to be the Town Meeting. Instead of a sword or spear, a cracker barrel is our leading insignia. Neighborliness, friendliness, calling each other by first names, shirt sleeves, absence of social classes, respect for church, disdain for

titles, reducing Doctors to "Doc" and Professors to "Profs"—all small town traits—are believed to be vital elements in our democracy.

One reason for our present social and political crisis appears to be the losing of our small town brotherly, neighborly, family outlook. As the small town ties weakened, so did self-discipline, rugged individualism, family cohesion, church loyalty, according to the findings of many sociologists.

Now we are tending to return to the small town. That tendency began a decade ago and may be hastened by the war. The corner grocery, which almost vanished, may reappear. Farmers will need it. Family parties will be revival, because there will be no way to drive long distances to city movies. The small church will again have a vital community role to perform. Neighbors will again gather to make community plans. Housewives will once more borrow flour from one another, while their husbands will borrow tools. Let's hope they return them.

But the small town, which is being revived, is by no means the same as of yore.

Many improvements have been made and are being made. Butter is not hanging in so many wells as formerly, many lamps have been replaced by electric bulbs, worn-out fields are being reclaimed. Agricultural schools in a score of ways, have transformed farming, stock raising and living conditions. F. S. A. has helped many small farmers to get started again, some of the dilapidated houses have been replaced, many more good gardens are noticeable. Picnic grounds have been improved, one sees many new bridges, hard roads have put an end to much dust and mud, in some places small industries have been established.

There is, also, a counter-movement. War plants, army camps, and government jobs are taking not a few people out of small towns. Just what kind of an equilibrium will result, one dare not say. But it appears certain that a revival of small town activities and relationships will help counterbalance the tensions, strains and family dislocations raised by the war. That may help the Nation acquire a sounder view of fundamental values and seek virtue capable of healing and uplifting us.

188

the designer of the double-page was treating the fence far more reverently, as the letter of the law, as the boundary shoring up tradition.

Particularly in American mass media, the form of the grid helped impose a rational, modern order on heterogeneous graphic elements; but it also resonated as a figure of republican spatial organization that had shaped the basic development of both country and city in America.[38] By the twentieth century, the two-dimensional matrix could barely indicate the dense vertical development of metropolitan centers—one reason why Europeans frequently adopted montage to signify urbanism. But in a country where physical expansiveness still served as an enduring source of national pride—where, consequently, the plight of destitute farmers was far more common a visual symbol of national crisis than the plight of industrial workers—the unaltered, "natural" rectilinear photograph presented in and set off by the orderly structure of the grid graphically articulated the space and strength of liberal individualism. Like the aphorism "Good fences make good neighbors," the stable authority of straight photography helped contain the impulse to pursue "Something there is that doesn't love a wall...."

In its collaborative character, the preparation of this essay resembles the typical process of montage production. A number of curators, archivists, bibliophiles, artists, writers, and friends proved invaluable, generously sharing with me a host of images, information, ideas, and criticisms. I am particularly indebted to Grace M. Mayer, Amy Rule, Sylvia Wolf, Eumie Imm, James Wyman, Anthony Montoya, Michael Dawson, Stephen White, Sherry Milner, Ernest Larsen, Allan Sekula, Steve Callis, Maud Lavin, Christopher Phillips, Amy Dru Stanley, Annetta Kapon, Lisa Freiman, Matthew Teitelbaum, and Ute Eskildsen.

[38] On the formative role of the grid in American urban design, see Elizabeth Blackmar, *Manhattan for Rent, 1785–1850* (Ithaca, 1989), pp. 6, 77, 94–99.

fig. 42
"Is the Small Town Coming Back?" from *Christian Science Monitor*, Weekly Magazine Section, July 25, 1942, pp. 8–9. Courtesy of the Division of Prints and Photographs, Library of Congress, Washington, D.C.

Sally Stein teaches in the art history department at University of California, Irvine. Her essays on the visual culture of the twenties and thirties include studies of women's magazines and the emergence of color photography. She is coauthor of *Official Images: New Deal Photography*, and author of a monograph on FSA photographer Marion Post Wolcott.

Bibliography

Ades, Dawn. *Dada and Surrealism Reviewed*. Arts Council of Britain, 1978.

————. *Photomontage*. London: Thames and Hudson, 1986.

————.*The Twentieth Century Poster: Design of the Avant-Garde*. Walker Art Center, Minneapolis and Abbeville Press, New York.

Akademie der Kunste, Berlin. *John Heartfield*. Cologne: DuMont, 1990.

Art into Life: Russian Constructivism 1914–1932. The Henry Art Gallery, University of Washington and Rizzoli, New York, 1990.

Benson, Timothy. *Raoul Hausmann and Berlin Dada*. Ann Arbor: UMI Research Press, 1987.

Bergius, Hanne. *Das Lachen Dadas: Die Berliner Dadaisten und ihre Aktionen*. Giessen: Anabas-Verlag, 1989.

Bois, Yve-Alain, "El Lissitzky: Radical Reversibility," *Art in America*, (April 1988):160–181.

Bolton, Richard, ed. *The Contest of Meaning: Critical Histories of Photography*. Cambridge, MA: The MIT Press, 1989.

Brecht, Bertolt. *Brecht on Theater*. New York: Hill and Wang, 1964.

Buchloh, Benjamin H.D. "Allegorical Procedures: Appropriation and Montage in Contemporary Art," *Artforum XXI, no. 1*, Sept. 1982, pp. 43–56.

Cohen, Arthur A. *Herbert Bayer: The Complete Work*. Cambridge, MA: MIT Press, 1984.

Diedrich, Reiner and Grubling,Richard. "Sozialismus als Reklame: Zur faschistischen Fotomontage." In *Die Dekoration der Gewalt*, edited by Berthold Hinz et al. pp. 123–136. Giessen, Anabas-Verlag, 1979.

Einstein, Albert. *Relativity, The Special and General Theory: A Popular Exposition*, translated by Robert Lawson. New York: Crown Publishers, 1961.

Eisenstein, Sergei. *Film Form*, edited and translated by Jay Leyda. New York: Harcourt Brace and World, 1949.

————————. *Film Sense*. edited and translated by Jay Leyda. New York: Harcourt Brace and World, 1942.

————————. *Izbranie proizvedenia*, vols. 1–6. Moscow: Izdatel'stvo Iskusstvo, 1964.

El Lissitzky: Experiments in Photography. New York: Houk/ Friedman Gallery, 1991.

El Lissitzky: 1890–1941. Eindhoven: Municipal Van Abbemuseum, 1990.

Elliott, David, ed. *Alexander Rodchenko*. Oxford: Museum of Modern Art, 1979.

Eskildsen, Ute. *Fotografie in deutschen Zeitschriften 1924–933*. Stuttgart: Institut für Auslandsbeziehungen, 1982.

Fraser, James and Heller, Stephen. *The Malik Verlag 1916–1947*. New York: Goethe House, 1984.

Gassner, Hubertus. *Rodchenko Photographien*. Munich: Schirmer/ Mosel, 1972.

Gustav Klutsis: Retrospective. Kassel: Museum Fridericianum, 1991.

Hannah Höch: Eine Lebenscollage. 2 vols. Edited by Cornelia Thater-Schulz. Berlin: Berlinische Galerie and Argon Verlag, 1989.

Hannah Höch 1889–1978: Ihr Werk, Ihr Leben, Ihre Freunde. Berlin: Berlinische Galerie and Argon Verlag, 1989.

Hays, K. Michael. "Photomontage and Its Audiences, Berlin, Circa 1922." *Harvard Architecture Review VI* (1987): 19–31.

Henderson, Linda Dalrymple. *The Fourth Dimension and Non-Euclidean Geometry in Modern Art*. Princeton University Press, 1983.

Kern, Stephen. The Culture of Time and Space, 1880–1918. Cambridge, MA: Harvard University Press, 1983.

Khan- Magomedov, S. O. *Rodchenko: The Complete Work*, Cambridge, MA: The MIT Press, 1987.

Korth, Fred G. "Making Photomontages in the Enlarger." *American Photography* (Jan. 1937): 22–26.

Kracauer, Siegfried. *Das Ornament der Masse*. Frankfurt am Main: Suhrkamp, 1963.

Die Fotomontage: Geschichte und Wesen einer Kunstform. Ingolstadt, Kunstverein Ingolstadt, 1969.

Lacoste, Patrick. *L'étrange cas du Professeur M: Psychanalyse à l'écran*. Paris: Editions Gallimard, 1990.

Larned, W. Livingston. "The Illustration within an Illustration." *Printers' Ink*. (June 28, 1928): 127–133.

———. "Plotting out the Kaleidoscopic Picture." *Printers' Ink*. (March 10 1927): 117–25.

Lavin, Maud. "Androgyny, Spectatorship, and the Weimar Photomontages of Hannah Höch." *New German Critique* 51 (Fall 1990): 62–86.

Leclanche-Boulé, Claude. *Typographies et photomontages constructivistes en USSR*. Paris: Papyrus, 1984.

Lewis, Beth. *Grosz/Heartfield: The Artist as Social Critic*. Minneapolis: University of Minnesota Press, 1980.

Lodder, Christina. *Russian Constructivism*. New Haven: Yale University Press, 1983.

Lusk, Charlotte Irene. *Montagen in Blaue: Laszlo Moholy-Nagy: Fotomontagen und Collagen, 1922–1943*. Giessen, Anabas-Verlag, 1980.

Maier, Charles S. "Between Taylorism and Technocracy: European ideologies and the vision of industrial productivity in the 1920s," in *The Journal of Contemporary History* 5 (1970): 227–61.

Morgan, Barbara. "Photomontage." In *Miniature Camera Work*, edited by Willard D. Morgan and Henry M. Lester, pp. 11145–166.New York: Morgan and Lester, 1938.

———. "Photomontage." In *The Complete Photographer: An Encyclopedia of Photography*, edited by Willard D. Morgan, Vol. 8 (1943): 2853-2866.

Oginskaia, Larisa. *Gustav Klutsis, Sovetsky Khudozhnik*. Moscow, 1981.

Phillips, Christopher, ed. *Photography in the Modern Era: European Documents and Critical Writings, 1913–1940*. New York: The Metropolitan Museum of Art and Aperture, 1989.

Pitts, Terence. *Photography in the American Grain*. Tuscon, AZ: Center for Creative Photography, 1988.

Sell Tower, Beeke. *Envisioning America: Prints, Drawings, and Photographs by George Grosz and His Contemporaries, 1915–1933*. Cambridge, MA: Busch-Reisinger Museum, 1990.

Siepmann, Eckhard. *Montage: John Heartfield, Vom Club Dada zur Arbeiter-Illustrierten-Zeitung*. Berlin: Elefanten Press, 1977.

Sloterdijk, Peter. *Critique of Cynical Reason*. Minneapolis: University of Minnesota Press, 1987.

Sobieszek, Robert. "Composite Imagery and the Origins of Photomontage, Pt. 1: The Naturalistic Strain." *Artforum*, (Sept. 1978): 58–65; "Pt. 2: The Formalist Strain," *Artforum*. (Oct. 1978): 40–45.

———. *The Art of Persuasion: A History of Advertising Photography*. New York: Harry N. Abrams, 1988.

Stein, Sally. "The Composite Photographic Image and the Composition of Consumer Idealogy." In *Art Journal* 41 (Spring 1981): 39–45.

Taylor, Richard and Christie, Ian, eds. *The Film Factory: Russian and Soviet Cinema in Documents 1896–1939*. London: Routeledge & Kegan Paul, 1988.

Tschichold, Jan. *Die neue Typographie*. Berlin: Bildungsverband der Deutscher Buchdrucker, 1928.

Tucholsky, Kurt and Heartfield, John. *Deutschland, Deutschland über Alles*. Berlin: Neuer Deutscher Verlag, 1929.

Tupitsyn, Margarita. "Gustav Klutsis: Between Art and Politics." In *Art in America* (January 1991): 41–47.

———. "Gustav Klutsis: Scenarios of Authorial Pursuits." In *The Print Collector's Newsletter*, Vol. XXII (Nov.–Dec. 1991): 161–166.

Vertov, Dziga. *Kino-Eye: The Writings of Dziga Vertov*, ed. by Annette Michelson. Berkeley: University of California Press, 1984.

Wayne, Cynthia. *Dreams, Lies, and Exaggerations: Photomontage in America*. College Park: University of Maryland, 1991.

Wechser, Herta. *Collage*. New York: Abrams, 1968.

Catalogue of Exhibition Works

Editor's note:

Montage and Modern Life has been designed to underline never-ending contrasts in a wide variety of materials. The exhibition is divided into nine sections, each of which acknowledges new concerns in early 20th century life:

1. Speed Up: Modern Industrial Assembly
2. War Machines
3. The City
4. Rapid Transit/Global Visions
5. The New Woman and the Rationalization of Everyday Life
6. The Artist's Engagement with the Mass Media
7. The Body Refigured
8. The Political Spectrum of Montage
9. Film

Within each of these sections, photographs, posters, magazines, and various other objects are combined to highlight and contrast montage practice in the Soviet Union, Germany, and the United States. These objects are set in clusters which oscillate between the order of the grid and the purposeful chaos of shocking juxtapositions. At points within the exhibition, the grid is used to underline the dominant design aesthetic of the 1930s, and to allow a wide variety of objects to be placed in surprising relation to each other–in some cases posters next to books, in others photographs next to advertising cards. And yet, in its arrangement, the exhibition continually challenges the dominance of the grid in much the way that montage practice itself challenged the aesthetic of standardization in the years between World War I and World War II. Many of the objects and images in the exhibition are grouped in clusters which use overlapping images, asymmetry, and a purposeful stacking of images to recreate the dislocation of montage itself, a sense that images are being seen in a way they have never been seen before.

Within each of the nine categories objects are listed in chronological order. Artists are designated by the country in which they were born or were most active. (The exceptions are Piet Zwart and Paul Schuitema who were Dutch and worked primarily in the Netherlands.) Measurements are listed so that height precedes width. These dimensions are unframed and listed in inches except where noted otherwise. Photographs from archival negatives (refered to henceforth as modern prints from archival negatives) have been made for exhibition purposes–sizes vary. Finally, in some cases, specific page numbers have been listed for publications because of their particular relevance to exhibition categories, however quite often the entire publication is pertinent to the subject of photomontage.

I. SPEED UP: MODERN INDUSTRIAL ASSEMBLY

USA

Photographer unknown
documentary photograph of *Driving Off the Assembly Line, Highland Park* 1914
modern print from archival negative (#833-997)
Courtesy of the Henry Ford Museum, Edison Institute

Photographer unknown
documentary photograph of *General View of the Line, Highland Park* 1914 modern print from archival negative (#833–987)
Courtesy of the Henry Ford Museum, Edison Institute

Photographer unknown
documentary photograph of *A Day's Output of Ford Model T's. Hghland Park Factory* 1915
modern print from archival negative (#0-716)
Courtesy of the Henry Ford Museum, Edison Institute

Photographer unknown
documentary photograph of *Ford Motor Company, Highland Park Factory Employees* 1915
modern print from archival negative (#833-700)
Courtesy of the Henry Ford Museum, Edison Institute

Photographer unknown
documentary photograph of *Ford V-8 Engine Assembly, River Rouge Factory* c. 1930
modern print from archival negative (#833-68057-105)
Courtesy of the Henry Ford Museum, Edison Institute

Photographer unknown
In Memory of Ida Brayman 1913
postcard 5 3/8 x 3 1/2
Courtesy of Gotham Book Mart, New York

Lewis Hine
Making Human Junk c. 1915
modern print from archival negative of poster
Courtesy of Prints and Photographs Division,
Library of Congress, Washington, D.C. (LC-262 46392)

Designer unknown
"Martyrs to Science," advertisement for General Motors in *National Geographic*, November 1929, vol. 56, no. 5, unpaginated
Courtesy of The Institute of Contemporary Art, Boston

William Rittase
Photomontage c. 1930
toned gelatin silver print 16 x 13
Courtesy of Howard Greenberg, New York

Charles Sheeler
Industry (mural maquette) 1932
modern print from archival negative
Courtesy The Institute of Contemporary Art, Boston

George Platt Lynes
"American Landscape," in Lincoln Kirstein and Julien Levy, *Murals by American Painters and Photographers* (New York: Museum of Modern Art, 1932)
exhibition catalogue
Courtesy of University of Los Angeles Arts, Architecture, and Urban Planning Library, Los Angeles, California

George Platt Lynes
documentation photograph of "American Landscape," in Lincoln Kirstein and Julien Levy, *Murals by American Painters and Photographers*, 1932
vintage gelatin silver print 9 7/16 x 4 15/16
Courtesy of The Museum of Modern Art, New York

Luke Swank
Steel Plant c. 1932
gelatin silver print, toned brown 10 1/2 x 20 1/2
Courtesy of The Art Institute of Chicago,
The Julien Levy Collection, Gift of Jean and Julien Levy

Luke Swank
Untitled (Industry-Steel Mill Triptych) c. 1935
photographic mural design 7 11/16 x 4 5/8; 9 9/16 x 7 1/2; 7 11/16 x 4 5/8
Courtesy of The Carnegie Museum of Art, Pittsburgh;
Gift of The Carnegie Library of Pittsburgh

Luke Swank
Untitled (Industry-Steel Mill Triptych) c. 1935
photographic mural design 7 3/4 x 4 3/4; 9 1/2 x 7 5/8; 7 11/16 x 4 1/2
Courtesy of The Carnegie Museum of Art, Pittsburgh;
Gift of The Carnegie Library of Pittsburgh

Designer unknown
"Time-Tested Paint," advertisement in *Saturday Evening Post*, April 10, 1937
p. 107
Courtesy of The Institute of Contemporary Art, Boston

Leslie Beaton
"The increasing ingenuity of the tools of industry and increasing length of the lines," in S.A. Spencer, with art direction by Leslie Beaton, *The Greatest Show on Earth* (Garden City: Doubleday Doran and Company, 1938)
pp. 108–109
Private Collection

GERMANY

Photographer unknown
"Spulenwickelei in der Kleinmotorenfabrik" (Spool-Rollers in the Small Motor Factory/documentary photograph of Behrens' early factories) May 23, 1906
modern print from archival negative
Courtesy of AEG Aktiengesellschaft

Photographer unknown
"Montage of Motors in the Small Motor Factory of AEG, Berlin" (documentary photograph of Behrens' early factories) 1911
modern print from archival negative
Courtesy of AEG Aktiengesellschaft

Max Burchartz and Johannes Canis
Werbemappe Bochumer Verein für Bergbau und Gußstahlfabrikation
(Bochumer Union for Miners Building and Cast Steel Factory) 1925
portfolio with 8 printed folders 11 4/5 x 8 1/4
Courtesy of Fotografische Sammlung, Museum Folkwang, Essen, Germany

Designer unknown
"Konfuzius oder Ford? Der Zusammenstoss chinesischer Kultur und amerikanischer Zivilisation" (Confucius or Ford? The Collision of Chinese Culture and American Civilization), in *Uhu*, October 1925, pp. 21–22
modern print from archival negative
Courtesy of Bildarchiv Staatliche Museen Preußischer Kulturßesitz, Berlin, Germany

John Heartfield
endpapers for J. Dorfmann, *Im Lande der Rekordzahlen* (In the Land of Record Profits) (Vienna/Berlin, 1927)
Courtesy of Special Collections Department, Northwestern University Library, Evanston, Illinois

Alice Lex Nerlinger
Arbeiten, Arbeiten, Arbeiten (Work, Work, Work) 1928
gelatin silver print 8 x 6 3/4
Courtesy of the San Francisco Museum of Modern Art,
Gift of Robert Shapazian

Willinger
"Mercedes-Benz: Der Wagen für Grosse Fahrt"
(Mercedes-Benz: The Car for Long Trips),
advertisement in *Deutsche Kunst und Dekoration* 1928
12 x 9 framed
Courtesy of Burkhard Sülzen, Berlin, Germany

Designer unknown
"Deutschlands Wiederaufstieg in den letzten Jahren"
(Germany's Rise Again in Recent Years), in *Berliner
Illustrierte Zeitung (BIZ)* , no. 46, 11 November 1928,
p. 1957
modern print from archival negative
Courtesy of Institut für Zeitungsforschung, Dortmund

Piet Zwart
three pages from *Catalogue NKF, Niederlandische
Kabelfabrik* (Dutch Cable Factory): "The Reliable Nerve
Centers," "Electricteit Bouurt Steden," "The World is
Only a Few Minutes Wide" 1928–29
brochure 12 1/2 x 9 1/2
Courtesy of Ex Libris Gallery, New York

Piet Zwart
Catalogue NKF, Niederlandische Kabelfabrik
(Dutch Cable Factory) 1928–29
brochure [English version] 12 1/2 x 9 1/2
Courtesy of Haags Gemeentemuseum, Den Haag,
The Netherlands

Piet Zwart
Catalogue NKF, Niederlandische Kabelfabrik
(Dutch Cable Factory) p. 29
1928–29
brochure, 12 1/2 x 9 1/2
Private Collection

Paul Schuitema
"Proefdruk omslag reclamebockje Toledo-Berkel
Snelwegers" (Print cover for advertisement series,
Toledo-Berkel Snelwegers) in *Series of Advertisements
for Berkel*, p. 288 undated
bookprint 7 4/5 x 5 2/5
Courtesy of Haags Gemeentemuseum, Den Haag,
The Netherlands

Paul Schuitema
"Reclameblad, The Berkel always-true wonder scale,"
in *Series of Advertisements for Berkel*, p. 317 undated
bookprint 11 4/5 x 8 3/4
Courtesy of Haags Gemeentemuseum, Den Haag,
The Netherlands

Paul Schuitema
"Proefdruk adresboek, Toledo-Berkel Mij," in *Series of
Advertisements for Berkel*, p. 293 undated
bookprint 9 1/2 x 6 1/5
Courtesy of Haags Gemeentemuseum, Den Haag,
The Netherlands

USSR

Gustav Klutsis
The Electrification of the Entire Country 1920
vintage gelatin silver print 6 3/4 x 4 1/2
Private Collection

Yuri Rozhkov
design for Vladimir Mayakovskii's poem, *Temporary
Monument to the Workers of Kursk for the Ore Output*
1923–24
portfolio of 16 posters 19 1/4 x 13 2/5
Courtesy of Fotografishe Sammlung,
Museum Folkwang, Essen, Germany

Gustav Klutsis
Plan of the Socialist Offensive (Schedule of Figures for
the Five Year Plan) 1929
photocollage 19 x 13 7/10
Collection of Merrill C. Berman

Gustav Klutsis
Plan of the Socialist Offensive 1929–30
poster design 7 3/8 x 5 7/16
Courtesy of Gilman Paper Company

Dmitry Debabov
title page in *USSR in Construction*, no. 1, 1930
Courtesy Natan Fedorowskij-Avantgarde Galerie, Berlin

Gustav Klutsis
In the Storm of the Third Year of the Five Year Plan
1930
poster 34 1/2 x 24 1/3
Private Collection

Gustav Klutsis
In the Storm of the Third Year of the Five Year Plan
1930
photomontage 9 1/4 x 8 3/4
Courtesy of Walker, Ursitti, McGinniss, New York

El Lissitzky
Workers and Smokestacks c. 1930
vintage gelatin silver print 5 7/8 x 7 5/8
Courtesy of Houk Friedman, New York

Aleksandr Rodchenko
Untitled c. 1935, (reprinted in 1963)
poster 31 1/2 x 21
Courtesy of Natan Fedorowskij-Avantgarde Galerie,
Berlin

Elizaveta Ignatovich
*The Struggle for the Polytechnical School is the Struggle
for the Five Year Plan* 1931
lithograph 20 3/16 x 28 1/4
Collection of Merrill C. Berman
exhibited in Boston only

Gustav Klutsis
Building Socialism Under the Banner of Lenin 1931
lithograph 42 1/4 x 28 1/2
Collection of Merrill C. Berman
exhibited in Boston only

Gustav Klutsis
We Shall Provide Millions of Qualified Workers 1931
photomontage 8 1/2 x 6 1/4
Private Collection

Gustav Klutsis
We Shall Provide Millions of Qualified Workers 1931
vintage gelatin silver print 4 3/4 x 3 1/4
Private Collection

Varvara Stepanova
The Country of Building 1932
photomontage 11 x 8
Collection of Alex Lachmann, Cologne

Aleksandr Deineka and Ivan Shagin
"Pioneer Children at Collective Farms," in *MTS*, no. 3,
1934
inside back cover 14 9/16 x 10 3/8
Collection of Sergei Bugaev

Valentina Kulagina
Kunst Ausstellung der Sowjetunion 1934
poster 50 x 35
Collection of Alex Lachmann, Cologne

N. S. Troshin
"Dneproges—The Great Monument to Lenin...,"
in *USSR in Construction*, no. 3, 1934, unpaginated
Collection of Sergei Bugaev

Aleksandr Rodchenko and Varvara Stepanova
"En route vers U.S.S.R..."
USSR in Construction, no. 8, 1936 [French version]
16 1/4 x 11 3/4
Collection of Sergei Bugaev

II. WAR MACHINES

USA

W. I. Heskel
Over the Top with Uncle Sam 1918
photolithographic poster 19 3/4 x 15 1/4
Private Collection

Lewis Jacobs
Untitled c. 1930
photomontage 7 x 7 3/4
Courtesy of Howard Greenberg, New York

Designer unknown
"Au Revoir," in Laurence Stallings, *The First World War:
A Photographic History* (New York: Simon and
Schuster, 1933), pp. 11–12
Courtesy of The Institute of Contemporary Art, Boston

Alexander Alland
Untitled (Anti-War Montage) 1936
photomontage 11 x 14
Courtesy of the Estate of Alexander Alland, Sr.

Lester Beall
Power for Defense c. 1940
poster 30 x 40 1/2
Courtesy of Prints and Photographs Division,
Library of Congress, Washington, D.C.

Photographer unknown
"World's Greatest Photomural Dramatizes our Defense
Effort in the Grand Central Terminal," in *New York
Herald Tribune*, Sunday, December 14, 1941
modern print from archival negative
(#USF 344 7744-2B)
Courtesy of Prints and Photographs Division,
Library of Congress, Washington, D.C.

John Collier
Tinsley and Rosskam Working on Mural 1941
modern print from archival negative
(#LS-USF 34-81652-D)
Courtesy of National Archives, Washington, D.C.

Designer unknown
"Defense mural in Grand Central Station," in *New York
Herald Tribune*, Sunday, December 14, 1941
mounted gravure reproduction 15 1/2 x 22 1/4
Courtesy of Prints and Photographs Division,
Library of Congress, Washington, D.C.

Designer unknown
center panel of Grand Central defense mural, cover for
Survey Graphic, January 1942
original tearsheet 8 1/2 x 11 1/2
Courtesy of Prints and Photographs Division,
Library of Congress, Washington, D.C.

Samuel H. Gottscho
installation photographs of the exhibition *Wartime
Housing*, April 22–June 21, 1942, organized and
designed by Eliot F. Noyes, with Alice Carson
and Don Hatch, The Museum of Modern Art, New York
modern print from archival negative
(MMA#15478, #15479)
Courtesy of The Museum of Modern Art, New York

Albert Fenn
installation photographs of the exhibition *Road to Victory*, May 21–October 4, 1942, organized by Edward Steichen, designed by Herbert Bayer.
modern print from archival negative (MMA#1822-72, #14401)
Courtesy of The Museum of Modern Art, New York

Samuel H. Gottscho
installation view photographs of the exhibition *Road to Victory*, May 21–October 4, 1942, organized by Edward Steichen, designed by Herbert Bayer.
modern print from archival negative (MMA#15381, #15382, #15506)
Courtesy of The Museum of Modern Art, New York

Artist unknown
Be a Victory Farm Volunteer c. 1943
US Department of Agriculture poster 73 3/4 x 22 1/2
Courtesy of Prints and Photographs Division, Library of Congress, Washington, D.C.

GERMANY

Laszlo Moholy-Nagy
Militarism 1924
gelatin silver photomontage 7 1/16 x 5 1/16
Collection of the J. Paul Getty Museum, Malibu, Califorina; Arnold H. Crane Collection

Photographer unknown
"Opfer des Weltkrieges" (Victim of the World War), cover for *Der Rote Stern*, vol. 1, no. 5, 5 August 1924
16 x 11 1/4 x 1/8
Courtesy of Institut für Zeitungsforschung, Dortmund

John Heartfield
"Der Sinn von Gerf" (The Meaning of Geneva), cover for *AIZ*, vol. 11, no. 48, 27 November 1932
Collection of Anna Lundgren, New York

John Heartfield
"Nach Zwanzig Jahren!" (Twenty Years Later!), in *AIZ*, vol. 13, no. 37, 13 September 1934, pp. 592–93
Collection of Robert Brand, Philadelphia

John Heartfield
Ein gefährliches Eintopfgericht (A Dangerous Hotpot) 1934
photomontage 17 7/10 x 13 1/2
Courtesy of Akademie der Künste zu Berlin

USSR

Valentina Kulagina
Road to October 1929
poster 41 x 29
Collection of Alex Lachmann, Cologne

Valentina Kulagina
To the Defense of the USSR 1929
poster 35 x 27
Collection of Alex Lachmann, Cologne

Artist unknown
"Strengthen the Defense of the USSR," in *Rabis*, no. 44, 20 November 1930
brochure cover 9 15/16 x 7 3/32
Collection of Sergei Bugaev

Gustav Klutsis
Anti-Imperialist Exhibition 1931
poster 54 1/2 x 41 1/4
Collection of Merrill C. Berman

Gustav Klutsis
Anti-Imperialist Exhibition 1931
poster design (photomontage with gouache and pencil on paper)
14 3/4 x 10 1/4
Collection of Merrill C. Berman

Varvara Stepanova
endpapers for Vladimir Mayakovskii, *Threatening Laughter*, (Moscow/Leningrad, 1932)
9 5/8 x 8 7/16
Collection of Sergei Bugaev

Varvara Stepanova
Strengthen the Defense as You Can 1931–32
photomontage 10 x 7
Collection of Alex Lachmann, Cologne

A. Vrublevsky
cover for *Arsenal of Anti-Soviet War* (Moscow, 1933)
7 11/16 x 5 1/4
Collection of Sergei Bugaev

El Lissitzky
Workers-Peasants Red Army (Moscow, 1934)
photo album 11 3/8 x 16
Courtesy of Natan Fedorowskij-Avantgarde Galerie, Berlin

Solomon Telingater
"The Clock that Measures War," in Ilya Feinberg, *1914*, (Moscow: MTP, 1934), p.50
9 3/4 x 7
Collection of Elaine Lustig Cohen

III. THE CITY

USA

Illustrator unknown
"The insurance companies and the savings banks...", in Joseph French Johnson, *We and Our Work*, (New York: The American Viewpoint Society, 1923) p. 154
Private Collection

Berenice Abbott
"New York," in *Murals by American Painters and Photographers* (New York: Museum of Modern Art, 1932)
exhibition catalogue
Courtesy of David Stang, Cambridge

Thurman Rotan
Skyscrapers c. 1932
gelatin silver print, toned brown 4 1/2 x 8 3/4
Courtesy of The Art Institute of Chicago, The Julien Levy Collection, Gift of Jean and Julien Levy.
In addition, a modern print from Thurman Rotan's archival negative has been produced for display purposes. Courtesy of Keith DeLellis, New York

Edward Steichen
The Maypole (Empire State Building) 1932
gelatin silver print 16 3/5 x 13 1/2
Collection of the International Museum of Photography at George Eastman House; Bequest of Edward Steichen by Direction of Joanna T. Steichen

John Paul Pennebaker
Chicago World's Fair 1933–34
Fresson prints, composite triptych 13 2/5 x 22 2/5
Collection of the International Museum of Photography at George Eastman House; Gift of 3M Company: ex-collection Louis Walton Sipley

Leigh Irwin
"Skyways to New York," in Gilbert Seldes, editor, and Leigh Irwin, photographic editor, *This is New York* (New York: David Kemp, 1934), pp. 32–33
Private Collection

Leigh Irwin
"The sea and the land are levied upon to feed the city's millions," in Gilbert Seldes, editor, and Leigh Irwin, photographic editor, *This is New York* (New York: David Kemp, 1934) pp. 16–17
Private Collection

Edward Steichen
Hell Below c. 1935
gelatin silver print 9 1/2 x 5 4/5
Collection of the International Museum of Photography at George Eastman House; Bequest of Edward Steichen by Direction of Joanna T. Steichen

Alexander Alland
Newark of the Past 1936
photomontage on board, study for larger mural
38 1/2 x 22 1/2
Courtesy of the Estate of Alexander Alland, Sr.

Alexander Alland
Newark of the Present 1936
photomontage on board, study for larger mural
38 1/2 x 21
Courtesy of the Estate of Alexander Alland, Sr.

Alexander Alland
Old and New Newark (photomural, Newark Public Library) 1937
modern print from archival negative (#69-AN-10-P188)
Courtesy of National Archives, Washington, D.C.

Alexander Alland
Approach to Manhattan (Riker's Island, New York) 1937
copy photograph of mural 3 13/16 x 9 3/16
Courtesy of the Estate of Alexander Alland, Sr.

Alexander Alland
Approach to Manhattan (sketch for photo mural, Riker's Island, New York) 1937
modern print from archival negative (#69-AN-10-P1603)
Courtesy of National Archives, Washington, D.C.

Gordon Coster
World War Veteran, American Army, 20 Years Later c. 1937
gelatin silver print 16 x 20
Collection of Keith de Lellis, New York

Barbara Morgan
City Street 1937
silver print 13 3/4 x 18 1/4
Courtesy of Willard and Barbara Morgan Archives, Morgan Press, Dobbs Ferry, New York

Barbara Morgan
City Shell 1938
silver print 13 7/16 x 18 1/2
Courtesy of Willard and Barbara Morgan Archives, Morgan Press, Dobbs Ferry, New York

Lester Beall
Slums Breed Crime c. 1940
poster 29 1/2 x 40
Courtesy of Prints and Photographs Division, Library of Congress, Washington, D.C.

Designer unknown
"Is the Small Town Coming Back?" in the *Christian
Science Monitor* Weekly Magazine Section,
July 25, 1942
double-page spread mounted on board
framed 23 1/2 x 16 3/4
Courtesy of Prints and Photographs Division,
Library of Congress, Washington, D.C.

Artist unknown
Life by the Square Foot vs. Life by the Acre undated
modern print from archival negative
(#USF 344-1752-ZB)
Courtesy Prints and Photographs Division,
Library of Congress, Washington, D.C.

Artist unknown
Which Playground for Your Child? Greenbelt or Gutter
undated
modern print from archival negative (#USF 34-1026-C)
Courtesy Prints and Photographs Division,
Library of Congress, Washington, D.C.

GERMANY

Paul Citroën
Metropolis 1923
modern color print 30 x 24 (original size)
Courtesy Prentenkabinet der Rijksuniveritat Leiden,
The Netherlands

Designer unknown
Millionwerte (Worth Millions) c. 1925
poster 32 5/8 x 23 3/4
Collection of Merrill C. Berman

Willi Baumeister
Die Wohnung (The Home) 1927
offset lithograph 44 3/4 x 32 3/8
Courtesy of The Museum of Modern Art, New York.
Gift of Philip Johnson

Designer unknown
"Factory/Product, Steel Everywhere," advertisement for
steel in *BIZ*, no. 28, 8 July 1928, p. 1196
modern print from archival negative
Courtesy of Institut für Zeitungsforschung, Dortmund

Designer unknown
"Drunter und drüber: Eindrücke aus der Weltstadt
Berlin" (Over and Above: Impressions of the Metropolis
Berlin), in *Kölnische Illustrierte Zeitung*, vol. 3, no. 50,
15 December 1928, pp. 1588–89
modern print from archival negative
Courtesy of Sammlung Universitäts und Stadtbibliothek,
Köln

Laszlo Moholy-Nagy
Prospectus Cover Design for Housing Development
Exhibition, *Would you like to own your own home?*
c. 1928–29
collage of gelatin silver and photomechanical prints
16 13/16 x 19 7/16
Collection of the J. Paul Getty Museum, Malibu,
California

Josef Hausenblas
"Tour Eiffel," photomontage in *MSA (Mezinárodni
soudobá architektura)*, no. 1, Karl Teige, ed.
(Prague: Odeon, 1929) p. 33
Courtesy of Ars Libri Ltd., Boston

Laszlo Moholy-Nagy
Backdrop for theater performance *The Businessman
of Berlin* 1929
gelatin silver photomontage 3 1/4 x 6 9/19
Collection of the J. Paul Getty Museum, Malibu,
California

Designer unknown
Fertigkleidung der Weg zum Erfolg (Ready to Wear
Clothing: The Way to Success) 1929
poster 55 1/8 x 39 2/5
Collection of Burkhard Sülzen, Berlin, Germany

Laszlo Moholy-Nagy
60 Fotos, ed. by Franz Roh (Berlin, W. Germany:
Kinkhardt and Biermann, Verlag Publishers, 1930)
Courtesy of Ars Libri Ltd., Boston

Joost Schmidt
Prospekte für das Verkehrsbüro der Stadt Dessau
(Prospectus for the Traffic Bureau of the City of Dessau)
1930
brochure 9 x 9 1/4 unfolded
Courtesy of Bauhaus-Archiv, Berlin

Georg Trump
City (a new notebook of H. Berthold A.G. Berlin)
undated
sample book framed 11 1/2 x 8 1/4
Courtesy of Ex Libris Gallery, New York

USSR

Gustav Klutsis
Dynamic City 1919
vintage gelatin silver print 11 x 9
Private Collection

Aleksandr Rodchenko
cover for Vladimir Mayakovskii, *Paris*, (Moscow: Spark
of the Revolution, 1925)
6 3/4 x 5
Collection of Elaine Lustig-Cohen

El Lissitzky
The Runner in the City c. 1926
collage gelatin silver print 5 3/16 x 5 1/16
Courtesy of The Metropolitan Museum of Art,
Ford Motor Company Collection, Gift of Ford Motor
Company and John C. Waddell, 1987
exhibited in Boston only

Valentina Kulagina
"We are Building," cover for *Red Niva*, no. 45, 1929
11 1/2 x 8 1/2
Collection of Alex Lachmann, Cologne

Designer unknown
cover for *Construction of Moscow*, no. 11, 1929
11 1/2 x 9
Courtesy of Natan Fedorowskij-Avantgarde Galerie,
Berlin

Designer unknown
cover for *Construction of Moscow*, no. 12, 1929
11 1/2 x 9
Courtesy of Natan Fedorowskij-Avantgarde Galerie,
Berlin

El Lissitzky
dust jacket for Richard Neutra, *Amerika* (Vienna, 1930)
11 3/8 x 8 15/16 x 1/2
Courtesy of The Resource Collection of the Getty Center
for the History of Art and the Humanities

Designer unknown
cover for *Construction of Moscow*, no. 11, 1930
11 1/2 x 9
Courtesy of Natan Fedorowskij-Avantgarde Galerie,
Berlin

Gustav Klutsis
Display stands on Tverskoi Boulevard (Moscow, 1931)
vintage gelatin silver print
4 3/8 x 3 1/4
Private Collection

Artist unknown
front and back cover for *Construction of Moscow*,
no. 2, 1931
brochure 11 1/2 x 8 1/4
Collection of Paul A. Judelson, New York

Artist unknown
front and back cover for *Construction of Moscow*,
no. 11, 1931
brochure 11 5/8 x 11 3/8
Collection of Sergei Bugaev

Gustav Klutsis
Untitled (detail of agit construction in honor of the
building of *Dneproges*, installation in Sverdlov Square,
Moscow) 1932
vintage gelatin silver print 6 3/4 x 9 1/4
Private Collection

El Lissitzky
The Current is Switched On c. 1932
vintage gelatin silver print 2 1/2 x 4
Private Collection

El Lissitzky
"The Current Is Switched On," in *USSR in Construction*,
no. 10, October 1932, pp. 36–37
Courtesy of Harvard College Library, Widener

Artist unknown
"Automobile Plant at Volga," double-page spread
in *USSR in Construction*, no. 3, 1933
Collection of Sergei Bugaev

IV. RAPID TRANSIT/
GLOBAL VISIONS

USA

Designer unknown
"Now Crack Trains....," advertisement for Carrier
Engineering Corporation in *Fortune*, vol. 2, no. 4,
October 1930, p. 25
13 3/4 x 11
Private Collection

Edward Steichen
"Aviation" (Radio City Music Hall mural), in *American
Photography*, July 1933, p. 407
Courtesy of The Institute of Contemporary Art, Boston

Edward Steichen
Aviation (Radio City Music Hall mural) c. 1935
modern print of installation photograph
Courtesy of Rockefeller Center,
© Rockefeller Group, Inc.

Wyatt Davis
*Detail of sketch for proposed photo mural, Newark
Airport* 1936-37
modern print from archival negative (#69 AG-395)
Courtesy of National Archives, Washington, D.C.

Wyatt Davis and Dmitri Kessel
Proposed photo mural. Newark Airport 1937
modern print from archival negative (#69-AG-1125)
Courtesy of National Archives, Washington, D.C.

Designer unknown
"A Mile Stretches when it's Stop and Go," advertise-
ment for Shell in *Life*, vol. 4, no. 23, June 6,1938, p. 8
Courtesy of The Institute of Contemporary Art, Boston

C. F. Henken
"I Made a Travelog Lampshade," article in *American
Photography*, vol. 34, no. 10, October 1940,
pp. 712–718
Courtesy of The Institute of Contemporary Art, Boston

195

GERMANY

Photographer unknown
"Die Schwarze Gefahr in Südafrika" (The Black Peril in South Africa), in *BIZ*, no. 39, 26 September 1926, pp. 1237–8
modern print from archival negative
Courtesy of Institut für Zeitungsforschung, Dortmund

Hannah Höch
Denkmal II–Eitelkeit (Monument II–Vanity) (Ethnographic Museum Series) 1926
collage 10 x 6 1/2
Courtesy of Eva-Maria Rössner, Backnang, Germany

Designer unknown
"Saccho and Vanzetti, Der Dollar Imperialismus bestimmt den Kurs! (The Imperial Dollar Determines the Currency!), in *Der Rote Stern*, vol. 4, no. 19, September 1927
25 1/5 x 19 7/10
Courtesy of Institut für Zeitungsforschung, Dortmund

Designer unknown
"The Little Globetrotter," photograph in *Das Magazin*, Berlin, vol. 4, no. 48, August 1928, p. 2530
9 1/8 x 6 1/2
Private Collection

Hansa Luftbild und Bildstelle des Pr. Min.
"Nordsee–Inseln von oben" (Northsea Island from Above), in *Die Illustrierte Zeitung (DIZ)*, 8 June 1929, no. 23, vol. 5, p. 555
14 1/2 x 10 3/10
Courtesy of Fotografishe Sammlung, Museum Folkwang, Essen, Germany

Designer unknown
"Das Auto aus allen Perspektiven" (The Car from all Perspectives, photographs by Alfred Eisenstadt), in *Der Welt Spiegel*, vol. 31, no. 10, 8 March 1931, p. 15
15 3/4 x 11 2/5 x 1 2/5
Courtesy of Institut für Zeitungsforschung, Dortmund

Photographer unknown
"An der Goldküste" (On the Gold Coast), in *DIZ*, no. 22, 1931, p. 641
modern print from archival negative
14 1/2 x 10 3/4
Courtesy of Institut für Zeitungsforschung, Dortmund

Photographer unknown
"Schwarze Modedamen-Afrikanische Portraits" (Black Female Models-African Portraits), in *DIZ*, no. 45, 1931, p. 1261
modern print from archival negative
Courtesy of Institut für Zeitungsforschung, Dortmund

USSR

Gustav Klutsis
The Development of Transportation, The Five Year Plan 1929
gravure 28 7/8 x 19 7/8
Courtesy of The Museum of Modern Art, New York. Purchase fund, Jan Tschichold Collection
exhibited in Boston only

Artist unknown
cover for *Story about a Big Plan*, (Moscow: State Publishing House, 1930)
Collection of Sergei Bugaev

Gustav Klutsis
Metro 1935
photomontage 23 1/2 x 34
Courtesy of Walker, Ursitti, McGinniss, New York

V. THE NEW WOMAN AND THE RATIONALIZATION OF EVERYDAY LIFE

USA

Artist unknown
Hotel St. Claire c. 1906
postcard 5 3/8 x 3 1/2
Private Collection

Illustrator unknown
"Specimen Recipe Card," in Mrs. Christine Frederick, *The New Housekeeping*, 1913, facing p. 150
modern print from archival negative
Private Collection

Lejaren à Hiller
"Why Women Buy Goetz Satin," advertising tearsheet for Goetz Silk Manufacturing Company 1917
modern print from archival negative
Courtesy of the Archives Center, National Museum of American History, Smithsonian Institution, Washington, D.C.

Lejaren à Hiller
"It Brings them Back," advertising tearsheet for Goetz Silk Manufacturing Company 1918
modern print from archival negative
Courtesy of the Archives Center, National Museum of American History, Smithsonian Institution, Washington, D.C.

Alfred Stieglitz
Portrait of Dorothy True #3 1919
chloride print 9 1/2 x 7 1/2
Courtesy of The Art Institute of Chicago, The Alfred Stieglitz Collection

Designer unknown
"Born by the Wings of a Thanksgiving Turkey," cover for *New York Times Midweek Pictorial*, vol. 24, no. 14, November 25, 1926
Private Collection

Designer unknown
"Boy Scout Rider," cover for *New York Times Midweek Pictorial*, vol. 29, no. 5, March 23, 1929
Private Collection

Edward Steichen
"Kiss Killer grins in court room," front page of *The Daily Mirror*, November 5, 1928, reproduced in Fred J. Ringl, editor, *America as Americans See It* (New York Literary Guild, 1932) facing p. 295
Courtesy of The Institute of Contemporary Art, Boston

Gordon Coster
Radiator, Furnace on Chess Board c. 1929
gelatin silver print 14 x 11
Collection of Keith DeLellis, New York

Designer unknown
"Visible Eyelets, shoe/city," advertisement in *Vanity Fair*, January 1929, p. 16
Courtesy of The Institute of Contemporary Art, Boston

Designer unknown
"International Sterling," advertisement in *Vanity Fair*, March 1929, p. 125
Courtesy of The Institute of Contemporary Art, Boston

Designer unknown
"Krementz self-adjustable watch band," advertisement in *National Geographic*, vol. 56, no. 5, November 1929
Courtesy of The Institute of Contemporary Art, Boston

Designer unknown
advertisement for Pepsodent in *National Geographic*, vol. 56, no. 5, November 1929
Courtesy of The Institute of Contemporary Art, Boston

Will Connell
Untitled (advertisement for Double X Cleanser) 1930
original photograph (box 7, #22)
Courtesy of Department of Special Collections, University Research Library, University of California, Los Angeles

Walker Evans
Portrait of Berenice Abbott c. 1930
vintage gelatin silver print 4 3/8 x 2 1/2
Courtesy of The Art Institute of Chicago, Gift of David C. and Sarajean Ruttenberg

Designer unknown
"The Kaleidoscopic Review of this Modern World," in *Vanity Fair*, vol. 35, no. 7, March 1931, p. 16
The Institute of Contemporary Art, Boston

Bruehl-Bourges (Anton Bruehl and Fernand Bourges)
"America's Greatest Stag Party," advertisement for Arrow shirts in *Color Sells: Examples of Color Photography*, (New York: Conde Nast, 1935)
Courtesy of the University of Los Angeles Arts, Architecture, and Urban Planning Library, Los Angeles, California

Gordon Coster
Untitled (Reflection in Platter) c. 1935
gelatin silver print 14 x 11
Collection of Keith DeLellis, New York

Will Connell
Untitled c. 1937
advertisement from the series *Chevrolet Stylizing* (box 16, no. 42–49)
Courtesy of Department of Special Collections, University Research Library, University of California, Los Angeles

Designer unknown
"Let's see what happens on this fellow's chin," advertisement for Schick razors in *Life*, vol. 4, no. 5, January 31, 1938, p. 8
Private Collection

Leo Lances
Gymnastics (photomural for the WPA community and health building at the World's Fair, New York) 1939
modern print from archival negative (#69-AN-863-16)
Courtesy of National Archives, Washington, D.C.

Robert Mishell
"I Made a Mural," article in *American Photography*, October 1939, vol. 33, no. 10, pp. 721–727, with photographs documenting mural installation, including "Mural Installed"
Courtesy of The Institute of Contemporary Art, Boston

Designer unknown
"Mary—they won't know this room when we're all finished with it!" advertisement for Armstrong linoleum in *Ladies Home Journal*, vol. 56, no. 10, October 1939, p. 5
Private Collection

Byron Browne
Recreation and Sports (photomural for the dayroom of the Chronic Disease Hospital, New York) 1940
modern print from archival negative (#69-AN-85-3966)
Courtesy of National Archives, Washington, D.C.

Designer unknown
"A New Freedom for Secretaries!" advertisement for
L.C. Smith typewriters in *Fortune*, vol. 21, no. 2,
February 1940, p. 157
Courtesy of The Institute of Contemporary Art, Boston

Designer unknown
"Women and carrots," advertisement for the National
Association of Ice Industries in *McCalls*, vol. 68, no. 10,
July 1941, inside front cover
Courtesy of The Institute of Contemporary Art, Boston

Wynn Richards
Untitled (Saks corset advertisement) c. 1942
cut out maquette of photomontage 8 x 6 3/8
Courtesy of Howard Greenberg, New York

GERMANY

Laszlo Moholy-Nagy
Chute 1923
collage of photogravure reproductions on paper
with ink and painted additions 25 1/2 x 19 1/2
Courtesy of the Museum of Modern Art, New York;
Gift of Mrs. Sibyl Moholy-Nagy

Photographer unknown
"Verschönerungschirurgie" (Plastic Surgery), in *BIZ*,
no. 14, 4 April 1926, p. 446, modern print from
archival negative
Courtesy of Institut für Zeitungsforschung, Dortmund

Paul Simmel
"Ford übernimmt die Herstellung von Tillergirls.
Tagesproduktion: 15,000" (Ford Takes Over the
Production of Tillergirls. Daily Production: 15,000),
illustration in *BIZ*, no. 13, 28 May 1926, p. 411
modern print from archival negative
Courtesy of Institut für Zeitungsforschung, Dortmund

Photographer unknown
"Neue Tanzsterne: Die reizenden Zwillingsschwestern
Dodge, die in Berlin in der Haller-Revue auftreten
werden" (New Dance Stars: The Lovely Dodge
Twins...), in *BIZ*, no. 33, 1926, p. 1028
modern print from archival negative
Courtesy of Institut für Zeitungsforschung, Dortmund

Photographer unknown
"Drei Jahre Tillergirls in Berlin" (Three Years of
Tillergirls in Berlin), in *BIZ*, no. 43, 23 October 1927,
pp. 1739–41
14 2/5 x 10 3/5 x 2
Courtesy of Institut für Zeitungsforschung, Dortmund

Marianne Brandt
Sport-sport 1928
collage 13 x 19 3/4
Collection of Merrill C. Berman

Designer unknown
"Bub oder Mädel? Unsere neue Preisfrage und Lösung"
(Guy or Girl? Our New Contest and Prize), in *BIZ*,
no. 21, vol. 37, 21 May 1928, p. 912
Courtesy of Institut für Zeitungsforschung, Dortmund

Ova Cigarette advertising campaign in *BIZ* 1928–30:

> Photographer unknown
> "Quality Testing in Ova Factory, Cigarettes and
> Female Factory Workers," in *BIZ*, no. 12,
> 18 March 1928, p. 475
> modern print from archival negative
> Courtesy of Institut für Zeitungsforschung,
> Dortmund

Photographer unknown
"Women Working in Ova Factory in White
Garb," in *BIZ*, no. 13, 25 March 1928,
pp. 536–7
modern print from archival negative
Courtesy of Institut für Zeitungsforschung,
Dortmund

Photographer unknown
"Men Working Machines at Ova," in *BIZ*, no. 14,
31 March 1928, p. 571
modern print from archival negative
Courtesy of Institut für Zeitungsforschung,
Dortmund

Photographer unknown
"Two Women Working in Ova Factory," in *BIZ*,
no. 31, 31 July 1930, p. 1379
modern print from archival negative
Courtesy of Institut für Zeitungsforschung,
Dortmund

Photographer unknown
"Ova Workers Relaxing Together," in *BIZ*,
no. 36, 7 September 1930, p. 1587
modern print from archival negative
Courtesy of Institut für Zeitungsforschung,
Dortmund

Designer unknown
"Hier stimmt etwas nicht!" (Something's Wrong Here
[Leni Riefenstahl reading]), cover for *Kölnische
Illustrierte Zeitung*, vol. 1, 21 April 1928
modern print from archival negative
Courtesy of Sammlung Universitäts und Stadtbibliothek,
Köln

Photographer unknown
"Welcher Beruf schuf diese Hände?" (Which Profession
Produced these Hands?), in *DIZ*, no. 17, vol. 5,
27 April 1929, p. 414
14 1/2 x 10 3/5
Courtesy of Fotografische Sammlung, Museum
Folkwang, Essen, Germany

Designer unknown
"500 Frauen nach Ihrer Wahl" (500 Women after Your
Choice), article in *Uhu*, no. 8, May 1929, pp. 76–85
modern print from archival negative
Courtesy of Kunstbibliothek Staatliche Museen
Preußischer Kulturbesitz, Berlin

Designer unknown
"500 Männer nach Ihrer Wahl" (500 Men after Your
Choice), article in *Uhu*, no. 11, August 1929,
pp. 52–60
modern print from archival negative
Courtesy of Kunstbibliothek Staatliche Museen
Preußischer Kulturbesitz, Berlin

Photographer unknown
"Die Vermännlichung der Frau" (The Masculinization
of Woman), in *BIZ*, no. 35, vol. 33, 31 August 1929,
pp. 997–8
modern print from archival negative
Courtesy of Institut für Zeitungsforschung, Dortmund

Designer unknown
"Frauen fahren Rekord" (Women's Racing Record),
cover for *DIZ*, no. 35, vol. 5, 31 August 1929
14 1/2 x 10 3/5
Courtesy of Fotografische Sammlung, Museum
Folkwang, Essen, Germany

Designer unknown
"Liebespaar im Schaufenster" (Couple in Shop
Window), in *BIZ*, no. 29, 1930, p. 1328
14 1/2 x 11 x 4/5
Courtesy of Institut für Zeitungsforschung, Dortmund

Alice Lex Nerlinger
Seamstress c. 1930
gelatin silver print 6 1/2 x 4 3/4
Courtesy of The Art Institute of Chicago, The Julien
Levy Collection, Gift of Jean Levy and the Estate of
Julien Levy

Artist unknown
cover for *Die Neue Linie* December 1930
framed 14 1/2 x 10 1/2
Courtesy of Ex Libris Gallery, New York

ringl + pit (Ellen Auerbach and Grete Stern)
Fragment of a Bride's Veil 1930
vintage gelatin silver print 7 x 9
Courtesy of Studio ringl + pit, Photo Ellen Auerbach

Designer unknown
"Berufstätige Frauen!" (For Professional Women!),
advertisement for Creme Mouson in *DIZ*, no. 4, vol. 6,
25 January 1930, p. 81
14 1/2 x 10 3/5
Courtesy of Fotografische Sammlung, Museum
Folkwang, Essen, Germany

Hannah Höch
Die Starken Männer (The Strong Man) 1931
collage 9 3/5 x 5 3/10
Courtesy of Institut für Auslandsbeziehungen, Stuttgart,
Germany

Baron Adolphe de Meyer
advertisement for Elizabeth Arden in *Die Dame*,
June 1931
modern print from archival negative
Courtesy of Kunstbibliothek, Staatliche Museen
Preußischer Kulturbesitz, Berlin

ringl + pit (Ellen Auerbach and Grete Stern)
Komol 1931
modern gelatin silver print 13 1/2 x 9 1/8
Courtesy of Studio ringl + pit, Photo Grete Stern
and Ellen Auerbach

Designer unknown
"Zwei Welten..." (Two Worlds), advertisement for
Eukotol Skin Cream in *Münchner Illustrierte Presse*,
no. 5, 31 January 1932, p. 105
14 1/2 x 10 3/4 x 2 2/5
Courtesy of Institut für Zeitungsforschung, Dortmund

Photographer unknown
"With the help of this apparatus...," in *BIZ*, no. 46,
1932, p. 1531
15 x 11 x 1 2/5
Courtesy of Institut für Zeitungsforschung, Dortmund

USSR

Aleksandr Rodchenko
"Photomontage for Poem by Vladimir Mayakovskii,"
in *Pro Eto* (Moscow: State Publishing House, 1923)
9 x 12 1/2
Collection of the International Museum of Photography
at George Eastman House

Aleksandr Rodchenko
Photomontage for Poem by Vladimir Mayakovskii 1923
gelatin silver photomontage 4 x 2 3/4
Collection of the J. Paul Getty Museum, Malibu,
Califorinia

Aleksandr Rodchenko
"Photomontage for Long Poem by Vladimir
Mayakovskii," in *Pro Eto* 1923
gelatin silver photomontage 9 5/16 x 6 3/8
Collection of The J. Paul Getty Museum, Malibu,
California

Designer unknown
cover of L. M. Vasilevsky, *Hygiene of a Young Woman*,
(Moscow, 1925)
6 3/8 x 5
Courtesy of Natan Fedorowskij-Avantgarde Galerie,
Berlin

Aleksandr Rodchenko
cover for Vladimir Mayakovskii, *Syphillis*,
(Moscow, Gudok, 1926)
6 3/4 x 5 1/8
Courtesy of Ex Libris Gallery, New York

Varvara Stepanova
The Irony of Fate c. 1926
collage 10 1/8 x 8 1/2
Collection of Elaine Lustig Cohen

Designer unknown
cover for *Woman's Magazine*, no. 11, (Moscow, 1927)
13 1/2 x 10 1/4
Courtesy of Natan Fedorowskij-Avantgarde Galerie,
Berlin

Designer unknown
cover for *Production Magazine*, no. 19, 1928
11 1/2 x 8 3/8
Courtesy of Natan Fedorowskij-Avantgarde Galerie,
Berlin

Designer unknown
cover for *Woman's Magazine*, no. 11, 1928
Collection of Sergei Bugaev

Gustav Klutsis
cover for B.A. Bogomazova, *Cultural Work Among
House Female Workers*, (Moscow: State Publishing
House, 1929)
7 1/4 x 4 1/2
Courtesy of Natan Fedorowskij-Avantgarde Galerie,
Berlin

Gustav Klutsis
cover for E. Overlakh, *Status of Women Working in
Germany*, (Moscow: State Publishing House, 1929)
6 1/2 x 4 1/2
Courtesy of Walker, Ursitti, McGinniss, New York

Designer unknown
cover for *Woman's Magazine*, no. 1, (Moscow, 1929)
13 1/2 x 10 1/4
Courtesy of Natan Fedorowskij-Avantgarde Galerie,
Berlin

Designer unknown
cover for *Woman's Magazine*, no. 4, (Moscow, 1929)
13 1/2 x 10 1/4
Courtesy of Natan Fedorowskij-Avantgarde Galerie,
Berlin

Designer unknown
cover for *Woman's Magazine*, no. 5, (Moscow, 1929)
13 1/2 x 10 1/4
Courtesy of Natan Fedorowskij-Avantgarde Galerie,
Berlin

Designer unknown
cover for *Woman's Magazine*, no. 10, (Moscow, 1929)
13 1/2 x 10 1/4
Courtesy of Natan Fedorowskij-Avantgarde Galerie,
Berlin

Designer unknown
cover for *Woman's Magazine*, no. 11, (Moscow, 1929)
13 1/2 x 10 1/4
Courtesy of Natan Fedorowskij-Avantgarde Galerie,
Berlin

Georgii Echeistov
cover for *Collective Agriculture*, no. 21–22, 1930
photomontage 9 3/8 x 6 3/8
Courtesy of Natan Fedorowskij-Avantgarde Galerie,
Berlin

Valentina Kulagina
*International Day of Women-Workers is the Fighting
Day of the Proletariat* 1931
poster 39 x 28
Collection of Alex Lachmann, Cologne

Valentina Kulagina
Women-Workers Strengthen the Shock Brigades 1931
poster 38 x 27
Collection of Alex Lachmann, Cologne

Valentina Kulagina
Forward to the New Victories c. 1931
photograph 23 1/2 x 17 1/2
Courtesy of Walker, Ursitti, McGinniss, New York

Boris Ignatovich
"It's Great to Live in Our Country," in *Ogonyok*
(special edition magazine), (Moscow, 1934), p. 5
11 3/8 x 8 3/8
Courtesy of Natan Fedorowskij-Avantgarde Galerie,
Berlin

Valentina Kulagina
"May 1st Regards to the Winners of Collective Farm
Fields," in *MTS*, no. 3, 1934 unpaginated
Collection of Sergei Bugaev

El Lissitzky
"Uzbeck Woman," in *USSR in Construction*, no. 2,
1934
16 1/2 x 11 3/4
Collection of Sergei Bugaev

Designer unknown
"One Day on the Milk Farm," in *MTS*, no. 12, 1935,
pp. 28–9
14 9/16 x 10 3/8
Collection of Sergei Bugaev

VI. THE ARTIST'S ENGAGEMENT
WITH MASS MEDIA

USA

Edward Steichen
Strange Interlude 1928
gelatin silver print 9 3/4 x 7 5/8
Collection of the International Museum of Photography
at George Eastman House; Bequest of Edward Steichen
by Direction of Joanna T. Steichen

Edward Steichen
Charlie Chaplin 1931
gelatin silver photomontage 6 1/2 x 13 3/4
Collection of the International Museum of Photography
at George Eastman House; Bequest of Edward Steichen
by Direction of Joanna T. Steichen

Edward Steichen
"Charlie Chaplin," in *Vanity Fair*, vol. 36, no. 3, May,
1931, pp. 46–47
Courtesy of The Institute of Contemporary Art, Boston

Edward Steichen
Martha Graham montage c. 1931
gelatin silver photomontage 6 x 13 3/8
Collection of the International Museum of Photography
at George Eastman House; Bequest of Edward Steichen
by Direction of Joanna T. Steichen

Will Connell
California in the Palm of your Hand 1936
original photograph (box 16, no. 51)
Courtesy Department of Special Collections, University
Research Library, University of California, Los Angeles

Will Connell
Food c. 1936
original photograph (box 16, no. 50)
Courtesy of Department of Special Collections,
University Research Library, University of California,
Los Angeles

Will Connell
Phantom Audience 1936
original photograph (box 16, no. 52)
Courtesy of Department of Special Collections,
Univesity Research Library, University of California,
Los Angeles

Edward Steichen
Carl Sandburg montage 1936
toned gelatin silver photomontage 13 4/5 x 16 4/5
Collection of the International Museum of Photography
at George Eastman House; Bequest of Edward Steichen
by Direction of Joanna T. Steichen

GERMANY

Raoul Hausmann
Mynona 1919
collage 10 x 8
Collection of Merrill C. Berman

Willi Baumeister
Kopf (Head) 1923
collage 27 1/2 x 9 4/5
Courtesy of Graphischen Sammlung Staatsgalerie,
Stuttgart
exhibited in Boston

Kurt Schwitters
Die Neue Gestaltung in der Typographie
(The New Design in Typography) c. 1923
brochure in envelope 5 7/8 x 4 1/4
Collection of Elaine Lustig Cohen

Herbert Bayer
Ziegler and Wieland c. 1923–28
letterhead 11 5/8 x 8 1/4
Collection of Elaine Lustig Cohen

Herbert Bayer
Entwurf eines Kiosks für Zeitungsverkauf (Design for a
News Stand) 1924
tempera, photomontage, collage 25 3/8 x 13 5/8
Courtesy of Bauhaus-Archiv, Berlin

Max Burchartz
Gestaltung der Reklame (Design of Advertisement)
1924
folded paper 11 3/8 x 9
Collection of Elaine Lustig Cohen

Werner Graff
"Die Notwendigkeit einer neuen Technik"
(The Necessity of a New Technique), in Richter,
G, Berlin, no. 3, June 1924
Courtesy of The Museum of Modern Art Library,
New York

Kurt Schwitters
"Foto-Typographie Merz-Werbe Karte"
(Merz advertising card) c. 1925
letterpress 5 x 6 7/16
Courtesy of The Museum of Modern Art, New York.
Gift of Philip Johnson, Jan Tschichold Collection

Joost Schmidt
Junkers-Nachrichten 1926
11 5/8 x 8 1/4
Collection of Elaine Lustig Cohen

John Heartfield
dustjacket for Upton Sinclair, *Petroleum*, (Berlin: Malik
Verlag, 1927)
Collection of Merrill C. Berman

Laszlo Moholy-Nagy
Malerei Fotografie Film, Bauhausbücher 8
(Munich: Albert Langen, 1927) Courtesy of
The Museum of Modern Art Library, New York

Georg Trump
Bielefeld 1927
photomontage with collage (maquette) 23 1/8 x 18
Collection of Merrill C. Berman

Herbert Bayer
cover for *Bauhaus*, no. 1, 1928
Courtesy of Bauhaus-Archiv, Berlin

Herbert Bayer
Dorland 1928
advertising brochure 11 7/8 x 8 3/4
Collection of Merrill C. Berman

Max Burchartz
*Tanzfestspiele—Zum zweiten deutschen
Tänzerkongress* (Dance Festival—The Second German
Dance Convention) 1928
letterpress and gravure 35 1/4 x 32 3/4
Courtesy of The Museum of Modern Art, New York.
Purchase fund, Jan Tschichold Collection
exhibited in Boston only

Walter Dexel
Sonderschau Neue Typographie (Special Exhibition,
New Typography) 1928
offset lithograph 8 1/4 x 11 1/2
Courtesy of The Museum of Modern Art, New York.
Gift of Philip Johnson, Jan Tschichold Collection

John Heartfield
cover for Upton Sinclair, *Die Goldne Kette* (The Golden
Chain), (Berlin: Malik Verlag, 1928)
7 1/2 x 5 1/6 x 1 1/4
Courtesy of The Resource Collection of the Getty Center
for the History of Art and the Humanities

Paul Schuitema
Aan Onze Agenten (To Our Agents) April 1928
Berkel advertisement framed 12 x 8
Courtesy of Ex Libris Gallery, New York

Paul Schuitema
De Nieuwe Snelweger (The New Motorway User)
April 1928
Berkel advertisement 6 1/2 x 12 1/4
Courtesy of Ex Libris Gallery, New York

Paul Schuitema
Een Trouwe (A Wedding) April 1928
Berkel advertisement framed 9 x 7 1/2
Courtesy of Ex Libris Gallery, New York

Piet Zwart
Hulp bij koop (Help with Purchase) 1928
brochure framed 11 3/4 x 8 1/4
Courtesy of Ex Libris Gallery, New York

Willi Baumeister
"Untitled" (soccer montage), in Werner Graeff,
Es kommt der neue Fotograf! (Here Comes the New
Photograph!), (Berlin: Verlag Hermann Reckendorf,
1929) p. 77
Courtesy of Ars Libri Ltd., Boston

John Heartfield and George Grosz
"Dada-Merika" (Plate No. 8), in Franz Roh and
Jan Tschichold, editors, *Foto-Auge* (Stuttgart:
Akademischer Verlag Dr. Fritz Wedekind and Co.,
1929)
Courtesy of Ars Libri Ltd., Boston

John Heartfield
dust jacket for John dos Passos, *Drei Soldaten*
(Three Soldiers), (Berlin: Malik Verlag, c. 1929)
7 3/8 x 4 3/4 x 1
Courtesy of The Resource Collection of the Getty Center
for the History of Art and the Humanities

Johannes Mohlzahn
Wohnung und Werkraum (Home and Workplace) 1929
gravure 23 3/4 x 33
Courtesy of The Museum of Modern Art, New York.
Purchase fund, Jan Tschichold Collection

Johannes Mohlzahn
Wohnung und Werkraum (Home and Workplace) 1929
poster 23 5/8 x 32 3/4
Courtesy of The Museum of Modern Art, New York.
Gift of Philip Johnson, Jan Tschichold Collection

Designer unknown
promotional cards for Franz Roh and Jan Tschichold,
editors, *Foto-Auge*, 1929
Collection of Merrill C. Berman

Willi Baumeister
cover for *Gefesselter Blick* (The Fascinated Gaze)
Heinz and Bodo Rasch, editors, (Stuttgart: Verlag
Dr. Zaugg and Co., 1930)
10 1/4 x 8 3/8
Courtesy of the Haags Gemeentemuseum, Den Haag,
The Netherlands

Herbert Bayer
Die Neue Adler Schreibmaschine (The New Adler
Typewriter) 1930
letterhead 11 5/8 x 8 1/4
Collection of Elaine Lustig Cohen

Max Burchartz
"6 Millionen Fahrkarten—Prospekt für die Stadt
Dortmund" (Six Million Tickets—brochure for the City
of Dortmund), in Heinz and Bodo Rasch, editors,
Gefesselter Blick, (Stuttgart: Verlag Dr. Zaugg and Co.,
1930) p. 29
10 1/4 x 8 3/8
Collection of Elaine Lustig Cohen

Max Burchartz
Bochumer Verein... c. 1930
promotional brochure 11 7/8 x 8 3/4
Collection of Merrill C. Berman

César Domela
*Entwurf einer Reklame—Druckgraphik für die Firma
Ruthsspeicher* (Design of an Advertisement—Graphic
Print for the Ruthsspeicher Firm) 1930
bookprint 58 5/8 x 81 7/8
Courtesy of the Haags Gemeentemuseum, Den Haag,
The Netherlands

Georg Trump
letterhead for ring "neue werbegestalter" c. 1930
11 1/2 x 8 1/4
Collection of Elaine Lustig Cohen

Max Burchartz
Internationale Ausstellung Kunst der Werbung, Essen
(International Exhibition: The Art of Advertising, Essen)
1931
offset lithograph 4 1/8 x 5 7/8
Courtesy of The Museum of Modern Art, New York. Gift
of Philip Johnson, Jan Tschichold Collection

Max Burchartz
Kunst der Werbung (The Art of Advertising) 1931
poster 22 7/8 x 32 1/2
Collection of Merrill C. Berman

César Domela et al
Fotomontage, (Berlin, 1931)
exhibition catalogue
Collection of the International Museum of Photography
at George Eastman House; Gift of Paul Vanderbilt

César Domela et al
Fotomontage, (Berlin, 1931)
exhibition catalogue
Collection of Flip Bool

César Domela et al
cover for *Fotomontage*, (Berlin, 1931)
exhibition catalogue
Collection of Merrill C. Berman

César Domela
Terrar Dum Prosim 1931
brochure 5 3/4 x 8 1/4
Collection of Elaine Lustig Cohen

Herbert Bayer
Blendax toothpaste 1932
letterhead 11 5/8 x 8 1/4
Collection of Elaine Lustig Cohen

Hans Schmidt and Hannes Meyer
Schweizer Städtebauer bei den Sowjets
(Swiss City Builders in Soviet Russia) c. 1932
framed 9 x 6 1/4
Courtesy of Ex Libris Gallery, New York

Paul Schuitema
"Workers' Demonstration,"
probably 20 September 1932, The Hague
vintage gelatin silver print 8 x 10
Courtesy of Prof. Dr. P. Zwart

Paul Schuitema
cover for *Links Richten*, no. 2, October 1932
9 1/2 x 6 1/4
Courtesy of the Haags Gemeentemuseum, Den Haag,
The Netherlands

Paul Schuitema
*1932, Opfer vom Polizeivorgehen gegen die
Protestkundgebung von Arbeitlosen in Rotterdam*
(Victims of Police Actions Against the Protests of the
Unemployed in Rotterdam) 22 December 1932
modern print 8 x 10
Collection Prentenkabinet der Rijksuniveritat Leiden,
Nederland

Herbert Bayer
Bayer Type Berthold (Berlin, 1933)
offset lithograph 8 1/8 x 8 1/8
Courtesy of The Museum of Modern Art, New York.
Gift of Philip Johnson, Jan Tschichold Collection

Herbert Bayer
Dortland Sport (Stahlern Geschen) 1936
pamphlet 8 1/4 x 5 3/4
Collection of Elaine Lustig Cohen

Paul Schuitema
Zesde Internationaale Congres (Sixth Congress
International) 10-20 June 1936
pamphlet framed 8 1/4 x 5 3/4
Courtesy of Ex Libris Gallery, New York

Jan Tschichold
Transito Moderne letter voor slagregels
(Type Specimen) undated
folded brochure 10 3/4 x 7 3/4
Courtesy of Ex Libris Gallery, New York

Paul Schuitema
Op School undated
folded flyer framed 6 1/4 x 11
Courtesy of Ex Libris Gallery, New York

Piet Zwart
"door middel van tijdschrift en courant," in *Reklame*
undated
framed 9 x 12 1/2
Courtesy of Ex Libris Gallery, New York

Piet Zwart
"machinezetsel monotype," in *Reklame* undated
framed 9 x 12 1/2
Courtesy of Ex Libris Gallery, New York

Piet Zwart
Umschlagentwurf für Anton de Kom, Wij slaven von Suriname undated
photocollage 11 x 7 3/4
Courtesy of the Haags Gemeentemuseum, Den Haag, The Netherlands

USSR

P. Galadzhev
cover of W. Groess, *One Minute, 1000 Episodes, 10,000 Faces, 100,000 Kilometers*, (Moscow: The Storehouse, 1922–23)
photomontage 6 3/4 x 5 1/8
Courtesy of Ex Libris Gallery, New York

El Lissitzky
Untitled (Superimposed Portrait) 1924–1930
gelatin silver print 6 3/10 x 4 3/5
Courtesy of The Museum of Modern Art, New York; Gift of Shirley C. Burden and David H. McAlpin, by exchange

El Lissitzky and Hans Arp, editors
Die Kunstismen (The Isms of Art) XI, 1925
Courtesy of Ars Libri Ltd., Boston

El Lissitzky
Pelican Drawing Ink 1925
advertising poster 17 1/2 x 12 3/4
Collection of Merrill C. Berman

Gustav Klutsis and Sergei Senkin
"Untitled" (two illustrations for the Sixth Congress of the Unions) in *Herald of Labor*, no. 1, (Moscow, 1925)
10 x 6 3/4
Private Collection

Gustav Klutsis and Sergei Senkin
cover for *In Memory of Dead Leaders*, (Moscow, 1927)
13 1/2 x 10 1/4
Courtesy of Natan Fedorowskij-Avantgarde Galerie, Berlin

Designer unknown
Sovetsko Foto, no. 11, 1927
10 x 7
Courtesy of Natan Fedorowskij-Avantgarde Galerie, Berlin

Yuri Botscharow
"Die Entwicklung der Russischen Pressa" (The Development of the Russian Press), in *Pressa* 1928
exhibition catalogue 7 x 5 1/4
Courtesy of Photografishe Sammlung, Museum Folkwang, Essen, Germany

Vasili Ermilov
Design for Pressa Exhibition c. 1928
vintage gelatin silver print 15 3/4 x 11 3/4
Courtesy of Natan Fedorowskij-Avantgarde Galerie, Berlin

El Lissitsky
cover for *Pressa* 1928
exhibition catalogue 11 1/4 x 8 3/4
Courtesy of Fotografische Sammlung Museum Folkwang, Essen, Germany

El Lissitzky
cover for *Pressa* 1928
exhibition catalogue 11 1/4 x 8 3/4
Collection of Merrill C. Berman

El Lissitzky
"The Constructor," cover for Franz Roh and Jan Tschichold, editors, *Foto-Auge* (Stuttgart: Akademischer Verlag Dr. Fritz Wedekind and Co., 1929)
Courtesy of The Museum of Modern Art, New York

S. Lodygin
"Our Five Year Plan," in *Thirty Days*, no. 5, 1929, pp. 4–5
10 1/4 x 6 1/2
Courtesy of Natan Fedorowskij-Avantgarde Galerie, Berlin

Aleksandr Rodchenko
"A Trip to the Country," in *Thirty Days*, no. 8, 1929, pp. 24–25
10 x 6 3/8
Courtesy of Natan Fedorowskij-Avantgarde Galerie, Berlin

Aleksandr Rodchenko
Let's Go, no. 6, (Moscow, 1929)
13 1/2 x 10 1/4
Courtesy of Natan Fedorowskij-Avantgarde Galerie, Berlin

Sergei Senkin
"What was, what is, what will be," in *Thirty Days*, no. 10, 1929, pp. 34–35
10 x 6 3/8
Courtesy of Natan Fedorowskij-Avantgarde Galerie, Berlin

Aleksandr Rodchenko
cover for *Radio-Listener*, no. 15, (Moscow, 1930)
12 x 9
Collection of Alex Lachmann, Cologne

Valentina Kulagina
cover design for A. Tarasov-Radionov, *October* c. 1930
photomontage 9 x 13
Courtesy of Natan Fedorowskij-Avantgarde Galerie, Berlin

Solomon Telingater
cover for *The World is Given to Kirsanov* (Georgia: TBC, 1930)
8 x 3 5/8
Courtesy of Ex Libris Gallery, New York

Aleksandr Rodchenko
cover for *Moscow is Speaking*, no. 8, (Moscow, 1931)
12 x 9
Collection of Alex Lachmann, Cologne

Solomon Telingater
cover for Vladimir Mayakovskii, *At the Top of My Voice*, (Moscow-Leningrad: State Publishing House, 1931)
7 x 4 1/2
Collection of Alex Lachmann, Cologne

Gustav Klutsis
cover for *For Proletarian Art*, no. 5 (Moscow: IZOGIZ, 1932)
11 1/2 x 8 1/2
Private Collection

Gustav Klutsis
Pravda 1933
printed newspaper 26 x 19 1/2
Courtesy of Walker, Ursitti, McGinniss, New York

Gustav Klutsis
Pravda 1933
photomontage 26 1/2 x 19 1/2
Courtesy of Walker, Ursitti, McGinniss, New York

Gustav Klutsis
Pravda 1933
photomontage 25 1/2 x 19 3/4
Courtesy of Walker, Ursitti, McGinniss, New York

Gustav Klutsis
Untitled (Workers meeting in the streets of Moscow. Posters by Gustav Klutsis) c. 1932
vintage gelatin silver print 3 1/2 x 4 3/4
Private Collection

Sergei Tretiakov and Solomon Telingater
cover for *John Heartfield* (Moscow: OGIZ, 1936)
12 x 9
Collection of Alex Lachmann, Cologne

VII. THE BODY REFIGURED

USA

Young and Rubicam, Inc.
advertisement in *Fortune*, vol. 5, no. 1, January 1932, p. 77
Courtesy of The Institute of Contemporary Art, Boston

Designer unknown
"The Front Page of 1934–35: World Forces that are Making History," photomontage in M. Lincoln Schuster, ed., *Eyes on the World* (New York: Simon and Schuster, 1935), p. 13
Courtesy of The Institute of Contemporary Art, Boston

GERMANY

Paul Schuitema
Centrale Bond Transportarbeiders (Central Bond Transport Workers) 1930
poster 45 1/4 x 30
Private Collection, The Netherlands

John Heartfield
"Wer Bürgerblätter liest wird blind und taub"
(Who Reads Bourgeois Newspapers Becomes Blind and Deaf), in *AIZ*, vol. 9, no. 6, 1930, p. 103
Courtesy of IVAM Centro Julio González–Marco Pinkus Collection. Valencia, Spain

Hannah Höch
Der Kleine P G (Parteigenosse) (The Little Party Comrade) 1931
collage 19 2/5 x 13 1/2
Courtesy of Graphischen Sammlung Staatsgalerie Stuttgart
exhibited in Boston only

Herbert Bayer
Lonely Metropolitan 1932
modern print 13 x 10 3/4
Courtesy of Mrs. Joella Bayer

Herbert Bayer
Self Portrait 1932
photomontage 14 x 11
Courtesy of Mrs. Joella Bayer

Designer unknown
"Mengelberg dirigiert Brahms" (Mengelberg directs
Brahms), in *BIZ*, vol. 42, no. 24, 18 June 1933, p. 860
modern print from archival negative
Courtesy of Institut für Zeitungsforschung, Dortmund

John Heartfield
"Alle Fäuste einer Geballt" (All Fists Clenched Into
One), in *AIZ*, vol. 13, no. 40, 4 October 1934, p. 633
Collection of Robert Brand, Philadelphia

USSR

Aleksandr Rodchenko
cover for *LEF*, no. 2, (Moscow, April–May, 1923)
Collection of W. Michael Sheehe, New York

Aleksandr Rodchenko
Materialization of Fantasy 1927
offset lithograph 6 7/8 x 5 3/16
Courtesy of The Museum of Modern Art, New York.
Gift of Philip Johnson, Jan Tschichold Collection

El Lissitzky
cover design for *Notes of a Poet* (Moscow: GIKHL,
1928)
designed paper covers employing photomontage
of Hans Arp 6 7/8 x 5
Courtesy of Ex Libris Gallery, New York

El Lissitzky
Russian Exhibition 1929
poster (proof) 49 x 35 1/4
Courtesy Barry Friedman, Ltd.

Brigade KGK
*Free the Working Hands of the Collective Farms
for Industrialization* c. 1930
poster 39 3/4 x 27 1/2
Collection of Merrill C. Berman

Gustav Klutsis
*Let Us Fulfill the Plan of the Great Projects
(Fulfilled Plan, Great Work)* 1930
gravure 46 3/4 x 33 1/4
Courtesy of The Museum of Modern Art, New York.
Purchase fund, Jan Tschichold Collection
exhibited in Boston only

Gustav Klutsis
Let Us Fulfill the Plan of the Great Projects 1930
vintage gelatin silver print 5 x 3
Courtesy of Walker, Ursitti, McGinniss, New York

Gustav Klutsis
Let Us Fulfill the Plan of the Great Projects 1930
photomontage 5 1/4 x 3 3/4
Courtesy of Walker, Ursitti, McGinniss, New York

Gustav Klutsis
*Poster Design for a Project of the Socialist Plan
with Lenin and Stalin* 1930
gelatin silver photomontage with graphite and black
and white gouache
4 1/2 x 3 1/4
Collection of the J. Paul Getty Museum, Malibu,
California

Gustav Klutsis
We Will Build Our Own World 1930
vintage gelatin silver print 6 1/2 x 4 3/4
Courtesy of Walker, Ursitti, McGinniss, New York

El Lissitzky
Artists' Brigade, no. 4, (Moscow: IZOGIZ, 1931)
12 1/4 x 8 1/2
Courtesy of Ex Libris Gallery, New York

VIII. THE POLITICAL SPECTRUM OF MONTAGE

USA

Attributed to Lewis W. Hine
National Refugee Service undated
gelatin silver photomontage 10 x 19 3/8
Collection of the International Museum of Photography
at George Eastman House; Gift of the Photo League,
New York: ex-collection Lewis Wickes Hine

Hugo Gellert
"What's it all about?" photomontage composition in
New Masses, vol. 4, no. 2, July 1928, p. 16
Courtesy of Harvard College Libraries, Widener

Artist unknown
"Where science and industry plan and balance and
create all things for the sake of all men,"
in Charles Cross, editor, *A Picture of America* (New
York: Simon and Schuster, 1932) pp. 76–77
Courtesy of University of California, Los Angeles, Arts,
Architecture and Urban Planning Library, Los Angeles,
California

Designer unknown
cover of Charles Cross, editor, *A Picture of America*
(New York: Simon and Schuster, 1932)
Courtesy of Stephen White Collection II

Artist unknown
endpapers for *The New Dealers*, (New York: Simon
and Schuster, 1934)
Courtesy of The Institute of Contemporary Art, Boston

Artist unknown
"Suddenly in Miami...," in Pare Lorentz, *The Roosevelt
Year* (New York and London: Funk and Wagnalls Co.,
1934) pp. 12–13
Courtesy of The Institute of Contemporary Art, Boston

Artist unknown
Information Panel on Greenbelt Towns 1935
modern print from archival negative (#3147-2B
from files of the U.S. Department of Agriculture Farm
Security Administration)
Courtesy Prints and Photographs Division,
Library of Congress, Washington, D.C.

Imogan Cunningham
Hoover and Roosevelt c. 1935
gelatin silver print (photographed collage) 9 7/8 x 7 3/4
Courtesy of the Center for Creative Photography,
University of Arizona

Designer unknown
"Letters from America," in *McCalls*, vol. 68, no. 11,
August 1941, article, pp. 12–13, 102
Courtesy of The Institute of Contemporary Art, Boston

Emily Newman
Allies for a Big Job c. 1942
poster 21 x 19 1/4
Courtesy of Prints and Photographs Division,
Library of Congress, Washington, D.C.

Designer unknown
"First Blood–Industrial Strife the World Over,"
in M. Lincoln Schuster, editor, *Eyes on the World*
(New York: Simon and Schuster, 1935) pp. 14–15
Private Collection

Artist unknown
*Acres and Acres of Wasted Worn-Out Land Purchased
by the Resettlement Administration* 1936
modern print from archival negative
(#USF 344-3584-ZB)
Courtesy Prints and Photographs Division,
Library of Congress, Washington, D.C.

Barbara Morgan
Protest 1937
silver print 17 5/8 x 13 3/4
Courtesy of Willard and Barbara Morgan Archives,
Morgan Press, Dobbs Ferry, New York

Designer unknown
"523 to 8," in *Life*, vol. 2, no. 1, January 4, 1937,
pp. 42–43
Courtesy of The Institute of Contemporary Art, Boston

Leslie Beaton
"Who Has 128 Million Mouths to Feed and Could Feed
200 Million," in S.A Spencer, *The Greatest Show on
Earth* with art direction by Leslie Beaton (New York,
Garden City: Doubleday, Doran, and Co.1938)
pp. 28–29
Courtesy of The Institute of Contemporary Art, Boston

Lester Beall
Rural Electrification Administration c. 1940
US Department of Agriculture poster 30 x 40
Courtesy Prints and Photographs Division,
Library of Congress, Washington, D.C.

Photographer unknown
*National Youth exhibit building, Illinois State Fair,
Springfield, Illinois* August 1941
modern print from archival negative (#119-S-11G-2)
Courtesy of National Archives, Washington, D.C.

Designer unknown
dustjacket for Arthur Raper and Ira de A. Reid,
Sharecroppers All (Chapel Hill: University of North
Carolina Press, 1941)
Courtesy of North Carolina Collection, University
of North Carolina Library at Chapel Hill

Designer unknown
Our America c. 1942
Small Treasury Department poster 10 x 13 1/2
Courtesy of Prints and Photographs Division,
Library of Congress, Washington, D.C.

John Heartfield
"Twenty Years After," in Willard D. Morgan,
The Complete Photographer, vol. 8, issues 43–48,
1942–1943, p. 2864
Courtesy of The Institute of Contemporary Art, Boston

GERMANY

John Heartfield
Jedermann sein eigner Fussball (Everyone his own
soccerball), vol. 1, no. 1, 15 February 1919
Collection of Merrill C. Berman

John Heartfield
cover for Franz Jung, *Die Eroberung der Maschinen*
(The Conquest of Machines), (Berlin: Malik Verlag,
1923)
Courtesy of Library, Florham-Madison Campus,
Fairleigh Dickinson University

Designer unknown
cover for *Der Rote Stern*, vol. 4, no. 22, October 1927
modern print from archival negative
Courtesy of Institut für Zeitungsforschung, Dortmund

John Heartfield
"5 Finger hat die Hand" (Five Fingers has the Hand),
cover for *Die Rote Fahne*, 13 May 1928
17 3/4 x 12 1/4 x 2
Courtesy of Institut für Zeitungsforschung, Dortmund

John Heartfield
5 Finger hat die Hand (Five Fingers has the Hand)
1928
poster 39 1/2 x 29 1/4
Collection of Merrill C. Berman

John Heartfield
5 Finger hat die Hand (Five Fingers has the Hand)
1928
postcard 5 3/4 x 3 1/2
Collection of Merrill C. Berman

Artist unknown
Film promotion for *AIZ* c. 1928–32
archival film footage on videotape
Private Collection

Designer unknown
"Zwei Welten" (Two Worlds), in *Der Rote Stern*, vol. 5,
no. 24, November 1928
modern print from archival negative
Courtesy of Dortmund Institute of Newspaper Research

John Heartfield
cover for Kurt Tucholsky, *Deutschland, Deutschland
über alles* (Germany, Germany, Above Everything),
(Berlin: Neuer Deutscher Verlag, 1929)
Courtesy of Library, Florham-Madison Campus,
Fairleigh Dickinson University

Herbert Bayer
"Zieh Dich aus und Du bist Grieche" (Undress and You
are Greek), in *Uhu*, no. 12, vol. 6, September 1930,
pp. 28–32
9 7/8 x 12 5/6
Private Collection

Designer unknown
"Untitled photomontage," in *Die Illustrierter Beobacher*,
9 August 1930, p. 539
modern print from archival negative
Courtesy of Columbia University Libraries

Designer unknown
"Untitled photomontage," cover for *Die Illustrierter
Beobacher*, 13 September 1930
modern print from archival negative
Courtesy of Columbia University Libraries

John Heartfield
"Zwangslieferantin von Menschenmaterial Nur Mut!
Der Staat braucht Arbeitslose und Soldaten!" (Forced
Supplier of Human Ammunition! Take Courage!
The State Needs Unemployed and Soldiers!) in *AIZ*,
vol. 9, no. 10, 1930, p. 183
Courtesy of IVAM Centro Julio González–Marco Pinkus
Collection. Valencia, Spain

Artist unknown
"Sie schießen auf dich, Arbeiterfrau" (They are
Shooting at you, Working Woman), in *Der Weg der
Frau* , no. 3, August 1931, pp. 16–17
modern print from archival negative
Courtesy of Institut für Zeitungsforschung, Dortmund

John Heartfield
"Adolf der Ubermensch: Schluckt Gold und redet
Blech" (Adolf the Superman: Swallows Gold and Spouts
Junk), in *Arbeiter Illustrierte Zeitung (AIZ)*, vol. 11,
no. 29, 17 July 1932, p. 675
framed 11 1/2 x 15 1/2
Collection of Douglas Walla, New York

Designer unknown
"Die verlorenen Stimmen" (The Lost Votes),
cover for *Münchner Illustrierte Presse*, vol. 9, no. 11,
13 March 1932
modern print from archival negative
Courtesy of Institut für Zeitungsforschung, Dortmund

Designer unknown
cover for *Der Arbeiter Fotograf*, vol. 6, no. 10,
October 1932
framed 11 x 8 1/2
Courtesy of Ex Libris Gallery, New York

Contrasting depictions of concentration camps:

> Designer unknown
> "Im Konzentrationslager Oranienburg bei Berlin"
> (In the Concentration Camp Oranienburg near
> Berlin), in *BIZ*, no. 17, 30 April 1933, p. 634
> modern print from archival negative
> Courtesy of Institut für Zeitungsforschung,
> Dortmund

> Designer unknown
> "Dachau wie es in Wirklichkeit ist" (Dachau as it
> Really is), article in *AIZ*, 1 March 1934
> Courtesy of Kent Fine Art, New York

Designer unknown
"Sonderheft der tag der Nationalen Arbeit: Die Große
Rede des Reichskanzlers" (Special Issue: The Day
of National Work, The Great Speech of the
Reich-Chancellor), in *BIZ*, 1 May 1933, p. 17
14 3/8 x 11 x 1 1/2
Courtesy of Institut für Zeitungsforschung, Dortmund

John Heartfield
"Göring the Executioner of the Third Reich," cover for
first edition in *AIZ*, vol. 12, no. 36, 14 September 1933
photogravure on newsprint from original photomontage
15 1/8 x 11 1/8
Courtesy of IVAM Centro Julio González–Marco Pinkus
Collection. Valencia, Spain

Herbert Bayer
cover for *Die Kamera* (Berlin, 1934)
exhibition catalogue
Courtesy of Bauhaus-Archiv, Berlin

Designer unknown
"Der Tag der Machtübernahme durch Adolf Hitler
(The Day Adolf Hitler took Power), in *Münchner
Illustrierte Presse*, no. 5, 4 February 1934, p. 115
14 3/8 x 10 3/4
Courtesy of Institut für Zeitungsforschung, Dortmund

John Heartfield
"Die drei Weisen aus dem Sorgenland" (Three Wise
Men from the Land of Worries), photomechanical
reproduction, cover for *AIZ*, 3 January 1935
15 x 10 1/2
Collection of the International Museum of Photography
at George Eastman House; Museum Purchase,
ex-collection Barbara Morgan

Karl Vanek
"Vater werden war nicht schwer…" (To Become a
Father was not Difficult…), photomechanical
reproduction, cover for *AIZ*, 25 April 1935
15 1/8 x 10 1/2
Collection of the International Museum of Photography
at George Eastman House; Museum Purchase;
ex-collection Barbara Morgan

Karl Vanek
"Zwei Führer und eine Krippe, zwei Masken und ein
Kopf!" (Two Leaders and One Crib–Two Masks
and One Head), photomechanical reproduction,
cover for *AIZ*, 16 May 1935
15 x 10 1/2
Collection of the International Museum of Photography
at George Eastman House; Museum Purchase;
ex-collection Barbara Morgan

Karl Vanek
"Und richten Sie die Gewehre gegen die
Sowjetunion…" (And You Point the Guns at the Soviet
Union), photomechanical reproduction, cover for *AIZ*,
6 June 1935
15 x 10 1/4
Collection of the International Museum of Photography
at George Eastman House; Museum Purchase;
ex-collection Barbara Morgan

Karl Vanek
"Abrechnung folgt" (Settlement Follows), photome-
chanical reproduction, cover for *AIZ*, 13 June 1935
15 x 10 1/4
Collection of the International Museum of Photography
at George Eastman House; Museum Purchase;
ex-collection Barbara Morgan

John Heartfield
"Auch ein Propagandaminister" (Also a Minister of
Propaganda), photomechanical reproduction, cover
for *AIZ*, 22 August 1935
15 x 10 1/2
Collection of the International Museum of Photography
at George Eastman House; Museum Purchase,
ex-collection Barbara Morgan

John Heartfield
"Goebbels-Rezept" (Goebbles Recipe), in *AIZ*, vol. 14,
no. 43, 24 October 1935, p. 688
Courtesy of Special Collections Department,
Northwestern University Library, Evanston, Illinois

John Heartfield
"Hurra die Butter ist alle!" (Hurrah the butter is gone!),
in *AIZ*, vol. 14, no. 51, 19 December 1935, p. 816
framed 11 1/2 x 15 1/2
Collection of Douglas Walla, New York

John Heartfield
"Bevor der Krieg euch fällt" (Before the War Kills You),
cover for *AIZ* c. 1935
photomechanical reproduction 15 x 10 1/2
Collection of the International Museum of Photography
at George Eastman House; Museum Purchase;
ex-collection Barbara Morgan

John Heartfield
Diagnose c. 1935
photomechanical reproduction 15 7/8 x 10 3/8
Collection of the International Museum of Photography
at George Eastman House; Museum Purchase;
ex-collection Barbara Morgan

John Heartfield
Fantasie Zweier Ostpaktjäger (Fantasy of Two East Pact
Hunters) 1935
photomechanical reproduction 15 x 10 1/2
Collection of the International Museum of Photography
at George Eastman House; Museum Purchase;
ex-collection Barbara Morgan

John Heartfield
Knut Hamsuns Kandidaten für den Friedensnobelpreis
(Knut Hamsun's Candidates for the Nobel Peace Prize)
1935
photomechanical reproduction 15 x 10 1/2
Collection of the International Museum of Photography
at George Eastman House; Museum Purchase;
ex-collection Barbara Morgan

John Heartfield
Uniformfassen für den Reichstag zu Worms (Fetching
Uniforms for the Parliament of Worms) c. 1935
photomechanical reproduction 15 x 10 1/2
Collection of the International Museum of Photography
at George Eastman House; Museum Purchase;
ex-collection Barbara Morgan

Herbert Bayer
cover for *Deutschland Ausstellung* (Exhibition of
Germany), Berlin, 1936
exhibition catalogue 8 1/2 x 8 1/4
Courtesy of Bauhaus-Archiv, Berlin

Herbert Bayer
Deutschland Ausstellung, Berlin, 1936
exhibition catalogue 8 1/2 x 8 1/4
Private Collection

Cas Oorthuys and Jo Voskuil
Affiche Tentoonstelling de Olympiade Onder Dictatuur
(exhibition poster for the Olympics under Nazi
patronage) 1936
22 5/8 x 16 1/4
Collection of Merrill C. Berman

Designer unknown
"Untitled photomontage," centerfold in *Illustrierier Film-
Kurier*, special issue: Leni Riefenstahl's "Triumph des
Willens" (Triumph of the Will), Autumn 1936
11 1/2 x 18
Private Collection

Designer unknown
"Die Nation steht geschlossen hinter mir" (The Nation
Stands Firmly Behind Me), in *AIZ*, vol. 12, no. 27,
1933, p. 467
Courtesy of IVAM Centro Julio González–Marco Pinkus
Collection. Valencia, Spain

USSR

Gustav Klutsis
*The History of the All Union Communist Party of
Bolsheviks* (from a series of illustrations) 1924
vintage gelatin silver print 10 x 7 1/4
Private Collection

Gustav Klutsis
*The History of the All Union Communist Party of
Bolsheviks* (from a series of illustrations) 1924
modern reprint of vintage gelatin silver print
Private Collection

Gustav Klutsis and Sergei Senkin
design for *Lenin and Children* 1924
8 7/8 x 7 1/8
Collection of Elaine Lustig Cohen

Aleksandr Rodchenko
illustrations for the *History of the Soviet Communist
Party of Bolsheviks* 1926
5 posters from a series of 24 30 x 21
Courtesy of Natan Fedorowskij-Avantgarde Galerie,
Berlin

Gustav Klutsis
USSR—The Shock Brigade of the World Proletariat
1931
poster 13 1/2 x 9 3/4
Courtesy of Walker, Ursitti, McGinniss, New York

Gustav Klutsis
USSR—The Shock Brigade of the World Proletariat
1931
vintage gelatin silver print 6 1/2 x 4 3/4
Private Collection

Gustav Klutsis
*The Reality of Our Program is Real People, It's You
and Me* 1932
watercolor and collage, poster design
Collection of Merrill C. Berman

Gustav Klutsis
*Glory to the World Giant, Dneproges, which Began Its
Work* 1932
poster 59 x 42 7/10
Collection of Merrill C. Berman

Gustav Klutsis
The Victory of Socialism in Our Country is Guaranteed
1932
poster 81 x 57
Collection of Alex Lachmann, Cologne

Vasili Elkin
Glory to the Red Army c.1933
poster 13 1/2 x 9 1/2
Courtesy of Walker, Ursitti, McGinniss, New York

Gustav Klutsis
Hotel Moscow 1933
photomontage 4 1/2 x 14 1/2
Collection of Merrill C. Berman

Gustav Klutsis
Hotel Moscow 1933
brochure insert 6 x 11 3/4
Collection of Merrill C. Berman

Gustav Klutsis
Untitled (photomontage on a light bulb) 1933
vintage gelatin silver print 5 1/2 x 6 3/4
Private Collection

Gustav Klutsis
decorations for *Hotel Moscow* 1 May 1934
vintage gelatin silver print 4 1/2 x 7 1/2
Private Collection

El Lissitzky
"Regards to Growing Cadres of Proletarian
Intelligensia," in *USSR in Construction*, no. 6, 1934
unpaginated
Collection of Sergei Bugaev

Gustav Klutsis
October to the World c. 1935
photomontage 10 1/2 x 8
Courtesy of Walker, Ursitti, McGinnis, New York

Gustav Klutsis
Untitled (Stalin and Politbureau Members) 1935
altered photomontage 15 x 22
Courtesy of Walker, Ursitti, McGinnis, New York

El Lissitzky
cover for *Illustrated Newspaper*, no. 5, 10 March, 1939
18 3/16 x 12 1/8
Collection of Sergei Bugaev

El Lissitzky
"Fifth Session of the Supreme Soviet of the USSR,"
USSR in Construction, no. 2–3, 1940 unpaginated
Collection of Sergei Bugaev

IX. FILM

USA

Designer unknown
The Moving Picture Hero of My Heart 1916
sheet music cover
13 1/2 x 10 1/2
Courtesy of The Institute of Contemporary Art, Boston

Nickolas Muray
Ingrid Bergman Montage (Casablanca) c. 1942
cover for *Modern Screen*
black and white and color photomontage
17 3/8 x 16 5/8
Collection of the International Museum of Photography
at George Eastman House; Gift of the Muray Family

Will Connell
Find c. 1933
vintage gelatin silver print 13 7/8 x 10 15/16
Courtesy of Stephen White Collection II

Will Connell
Still Man 1933
vintage gelatin silver print 16 15/16 x 14 1/8
Courtesy of Stephen White Collection II

Will Connell
"Plot," "Find," "Make-up," and "Still-man,"
in *In Pictures: A Hollywood Satire* (New York:
T. J. Maloney, Inc., 1937) pp. 28, 52, 58,
and 68 respectively
Courtesy of Stephen White Collection II

GERMANY

Raoul Hausmann
Dada-Cino 1920
montage 12 2/5 x 8 4/5
Private Collection, Switzerland

Hans Richter
three vintage film stills from *Inflation* c. 1924
Courtesy of Robert Shapazian, Los Angeles

Hans Richter
vintage film still from *Ghosts before Breakfast* 1927–28
Courtesy of Robert Shapazian, Los Angeles

Hans Richter
vintage film still from *Film Study* 1926
Courtesy of Robert Shapazian, Los Angeles

Hans Richter
two vintage film stills from *Vormittagsspuk* 1927–28
Courtesy of Robert Shapazian, Los Angeles

Jan Tschichold
Die Frau ohne Namen (The Woman Without a Name)
1928
poster 48 x 33 4/5
Collection of Merrill C. Berman

Piet Zwart
ITF Internationale Tentoonstelling op Film Gebied
(ITF International Exhibition on Film) 1928
poster 42 1/4 x 30 5/8
Collection of Merrill C. Berman

Laszlo Moholy-Nagy
Prospectus Design for the Werkbund Exhibition,
Film und Foto 1929
collage 6 3/16 x 12 5/16
Collection of the J. Paul Getty Museum, Malibu,
California

Paul Schuitema
Film Liga 1929
pamphlet framed 12 1/2 x 9 1/2
Courtesy of Ex Libris Gallery, New York

Jan Tschichold
Film und Foto 1929
exhibition poster 32 1/2 x 22 3/4
Collection of Merrill C. Berman

Designer unknown
Film und Foto 1929–31
exhibition catalogue
8 1/8 x 5 7/8
Collection of Merrill C. Berman

Piet Zwart
"De Geluids film" (The Sound Film), dustwrapper for
Film, no. 10, 1931
framed 8 3/4 x 9
Courtesy of Ex Libris Gallery, New York

Piet Zwart
"Het Linnen Venster", dustwrapper for *Film*, no. 1,
1931
framed 9 x 6 3/4
Courtesy of Ex Libris Gallery, New York

Piet Zwart
"Nederlandesche Filmkunst" (Dutch Cinema),
dustwrapper for *Film*, no. 3, 1931
framed 9 x 6 3/4
Courtesy of Ex Libris Gallery, New York

Piet Zwart
"Franse Filmkunst" (French Cinema), dustwrapper for
Film, no. 6, 1931
framed 8 3/4 x 9
Courtesy of Ex Libris Gallery, New York

Piet Zwart
"Amerikanische Filmkunst" (American Cinema),
dustwrapper for *Film*, no. 2, undated
Courtesy of Ex Libris Gallery, New York

Piet Zwart
"Amerikanische Filmkunst" (American Cinema),
dustwrapper for *Film*, no. 7,
undated
Collection of W. Michael Sheehe, New York

USSR

Gustav Klutsis
cover design for *Kino Front*, no. 2–3, 1926
Courtesy of Natan Fedorowskij-Avantgarde Galerie,
Berlin

Aleksandr Rodchenko
One Sixth of the World 1926
brochure cover 9 x 10
Collection of Merrill C. Berman

Aleksandr Rodchenko
One Sixth of the World 1926
poster 42 3/4 x 27 9/16
Collection of Merrill C. Berman

K. Vyalov
cover design for *Soviet Cinema*, no. 2, 1926
Courtesy of Natan Fedorowskij-Avantgarde Galerie,
Berlin

K. Vyalov
cover design for *Soviet Cinema*, no. 3, 1926
Courtesy of Natan Fedorowskij-Avantgarde Galerie,
Berlin

Designer unknown
"One Sixth of the World," cover for Dziga Vertov,
editor, *Soviet Screen*, no. 42, October 1926
Collection of Sergei Bugaev

Varvara Stepanova
cover design for *Soviet Cinema*, no. 4, 1927
Courtesy of Natan Fedorowskij-Avantgarde Galerie,
Berlin

Varvara Stepanova
cover design for *Soviet Cinema*, no. 5-6, 1927
Courtesy of Natan Fedorowskij-Avantgarde Galerie,
Berlin

Grigorii Borisov and Nikolai Prusakov
I am in a Big Hurry to See Khaz Push 1928
poster 28 3/8 x 42 1/2
Collection of Merrill C. Berman

Vladimir and Georgii Stenberg
The Eleventh 1928
poster 39 7/8 x 26 3/4
Collection of Merrill C. Berman

Aleksandr Rodchenko
cover for *Novyi LEF*, no. 1, 1928
9 x 6
Collection of Merrill C. Berman

Vladimir and Georgii Stenberg
Symphony of a Big City 1928
poster 41 x 27 1/4
Collection of Merrill C. Berman

Varvara Stepanova
cover design for *Soviet Cinema*, no. 1, 1928
Courtesy of Natan Fedorowskij-Avantgarde Galerie,
Berlin

Varvara Stepanova
cover design for *Soviet Cinema*, no. 2-3, 1928
Courtesy of Natan Fedorowskij-Avantgarde Galerie,
Berlin

Vladimir and Georgii Stenberg
Man with a Movie Camera 1929
poster 41 1/8 x 26 1/8
Courtesy of Tamar Cohen

Varvara Stepanova and Aleksandr Rodchenko
design montage in *Soviet Cinema* (Moscow: Voks,
1935)
Collection of Sergei Bugaev

X. FILM PROGRAM

I. *Program A.*, "The Fall of the Romanov Dynasty,"
 Esther Shub. 1927. b&w. 100 min.
 Program B., "Strike," Sergei Eisenstein. 1925.
 b&w. 120 min.
 Program C., "The Man With the Movie Camera,"
 Dziga Vertov. 1929. b&w. 90 min.

II. *Program A.*, "Uberfall," Erno Metzner. 1929.
 b&w. 18 fps. 22 min.
 "Variety," E.A. Dupont. 1925. b&w. 18 fps.
 Program B., "Metropolis," Fritz Lang. 1927.
 b&w. 18 fps. 135 min.
 Program C., "Berlin: Symphony of a Great City,"
 Walter Ruttmann. 1927. b&w. 24 fps. 53 min.

III. *Program A.*, "October," Sergei Eisenstein. 1928.
 b&w. 18 fps. 149 min.
 Program B., "The Crowd," King Vidor. 1928.
 b&w. 18 fps. 98 min.
 Program C., "Brothers," Werner Hochbaum.
 1929. b&w. sound. 24 fps. 63 min.

IV. *Program A.*, "The General," Buster Keaton.
 1927. b&w. 24 fps. 79 min.
 Program B., "The Iron Horse," John Ford. 1924.
 b&w. 24 fps. 110 min.
 Program C., "Blue Express," ("China Express"),
 Ilya Trauberg. 1929. b&w. 18 fps. 90 min.
 "The Bridge," Joris Ivens. b&w. 24 fps. 12 min.

V. *Program A.*, "Oscar Fischinger Program III,"
 Oscar Fischinger. 1932–53. b&w and color.
 10 min.
 "Ballet Mecanique," Fernand Leger. 1924. b&w.
 18 fps. 15 min.
 "Mechanical Principles," Ralph Steiner. 1931.
 b&w. 18 fps. 11 min.
 "Philips-Radio" (Industrial Symphony),
 Joris Ivens. 1931. b&w. sound. 36 min.
 Program B., "Turksib," Victor Turin. 1929. b&w.
 18 fps. 70 min.
 Program C., "The General Line,"
 Sergei Eisenstein. 1929. b&w.

VI. *Program A.*, "Kino Pravda," Dziga Vertov. 1922.
 b&w. 18 fps. 17 min.
 "The Path Newsreel: 1917–1931." b&w. silent
 and sound. 18 fps. plus 3 min. sound. 24 fps.
 for final two subjects. 16 min.
 "Film and Photo League: Program I."
 1931–1932. b&w. 24 fps. 32 min.
 Program B., "Film and Photo League:
 Program II." 1931–34. b&w. 24 fps. 35 min.
 German Newsreels:
 "National Socialist Party Day in Nuremberg."
 1933. 4 min.
 "Young Germany Cheers the Führer." 1933.
 2 min.
 Nazi Propaganda Films:
 "Blutendes Deutschland" (Concluding
 Sequence), Johannes Haussler. 5 min.
 "Hans Westmar, Einer von Vielen. Ein Deutsches
 Schicksal aus dem Jahre 1929," Franz Wenzler.
 1933. 8 min.
 Program C., "Men and Jobs," Alexander
 Macheret. 1932. b&w. sound.

VII. *Program A.*, "Enthusiasm: Symphony of the
 Donbass," Dziga Vertov. 1931 b&w. sound.
 67 min.
 Program B., "Kuhle Wampe," Slatan Dudow.
 1932. b&w. sound. 73 min.
 Program C., "Gold Diggers of 1933," Mervyn
 LeRoy. b&w. sound.

VIII. *Program A.*, "Three Songs of Lenin," Dziga
 Vertov. 1933. b&w. sound. 68 min.
 Program B., "Triumph of the Will,"
 Leni Riefensthal. 1935. b&w. sound. 120 min.
 Program C., "March of Time," b&w. sound.
 60 min.

Lenders to the Exhibition

AEG Firmenarchiv

Akademie der Künste der Berlin

Alexander Alland, Jr.

Pierre Aproxine

Ars Libri Ltd., Boston

The Art Institute of Chicago

Ellen Auerbach

Bauhaus-Archiv, Berlin

Mrs. Joella Bayer

Merrill C. Berman

Sergei Bugaev

Robert Brand

Carnegie Museum of Art, Pittsburgh

Center for Creative Photography, Tucson, Arizona

Elaine Lustig Cohen

Tamar Cohen

Keith deLellis, New York

Ex Libris Gallery, New York

Fairleigh Dickenson University

Natan Fedorowskij, Avantgarde Galerie, Berlin

Henry Ford Museum, Edison Institute

Houk Friedman, New York

Galerie Gmurzynska, Cologne

The Getty Center, Santa Monica, California

J. Paul Getty Museum, Malibu, California

Gilman Paper Company Collection

Gotham Book Mart, New York

Haags Gemeentemuseum, The Hague, The Netherlands

Harvard College Library, Cambridge, MA

Howard Greenberg Gallery, New York

Institut für Auslandsbeziehungen, Stuttgart

Institut für Zeitungsforschung der Stadt Dortmund

International Museum of Photography at George Eastman House, Rochester, New York

IVAM Centre Julio Gonzalez, Valencia, Spain

Paul A. Judelson, New York

Kent Gallery, New York

Alex Lachmann, Cologne

Prints and Photographs Division, Library of Congress, Washington, D.C.

Anna Lundgren, New York

The Metropolitan Museum of Art, New York

Willard and Barbara Morgan Archives

Museum Folkwang, Essen, Germany

The Museum of Fine Arts, Houston

The Museum of Modern Art, New York

National Archives, Washington, DC

National Museum of American History, Smithsonian Institution

Northwestern University Library, Evanston, Illinois

Photofind Gallery, New York

Prentekabinet der Rijksuniveritat, Leiden

Eva-Maria Rössner

San Francisco Museum of Modern Art

Robert Shapazian, Los Angeles

W. Michael Sheehe, New York

Staatliche Museen Preußischer Kulturbesitz, Berlin

David Stang, Cambridge

Staatsgalerie, Stuttgart

Burkhard Sülzen, Berlin

Universitäts-und Stadtbibliothek, Cologne

University of California, Los Angeles Library

University of North Carolina, Chapel Hill Library

Walker, Ursitti, McGinniss, New York

Douglas Walla, New York

Stephen White, Los Angeles

Professor Dr. P. Zwart

Private Collections

We gratefully acknowledge the following individuals and institutions for their permission to reproduce various photographs and photomontages:

Aperture Foundation, Inc., Paul Strand Archive © 1971 pp. 129, 186

The Christian Science Monitor p. 188

Doubleday, A division of Bantam Doubleday Dell Publishing Group, Inc., New York pp. 62–3, 164–65, 166

Henry Holt and Company, New York p. 129

The Leo Hurwitz Estate, New York p.186

Hattula Moholy-Nagy, Ann Arbor, Michigan p. 6

Rockefeller Center, © Rockefeller Group, Inc. p. 152 (top)

Schick p. 145

Smith Corona Corporation, New Canaan, Connecticut p. 143

UPI Bettman, New York p. 175

AP Wide World Photos, Inc. p. 175

Young & Rubicam Inc., New York p. 142